W9-ACY-015

THE CIRCLE OF MONTPARNASSE
JEWISH ARTISTS IN PARIS
1905-1945

N 6850 .S55 1985
Silver, Kenneth E.
The Circle of Montparnasse

THE CIRCLE OF MONTPARNASSE
JEWISH ARTISTS IN PARIS
1905-1945

BY KENNETH E. SILVER AND ROMY GOLAN

with contributions by

Arthur A. Cohen, Billy Klüver, and Julie Martin

The Jewish Museum, New York

Universe Books, New York

RITTER LIBRARY
BALDWIN-WALLACE COLLEGE
WITHDRAWN

The Circle of Montparnasse: Jewish Artists in Paris 1905–1945 was funded by major grants from the National Endowment for the Arts, a Federal agency, and the Joe and Emily Lowe Foundation, Inc. This project was also made possible through the Eugene and Estelle Ferkauf Foundation; the Louis and Anne Abrons Foundation; the Minnesota, New York and Texas Committees, and other generous contributors. Transportation provided by **Lufthansa** German Airlines.

This catalogue was published with the assistance of the J. Paul Getty Trust

Exhibition Coordinator: Susan Tumarkin Goodman
Exhibition Assistant: Harley Spiller
Editor: Stephen R. Frankel
Graphic Designer: Kay Douglas
Installation Design: Breslin/Mosseri Architecture and Design

Cover Illustration: Amedeo Modigliani
Self-Portrait, 1919 (detail)
oil on canvas
39½ × 25½ in. (100 × 64.5 cm)
Museu de Arte Contemporanea, University of São Paulo; Gift of Yolanda Penteado and Francisco Matarazzo Sobrinho.

Photo Credits
Portrait of Adolphe Basler by Kisling, and *Return from Fishing* by Gottlieb, both by Raymond Asseo. *Woman with Goat (The Shepherdess)* by Lipsi, by Claude Le Van. *The Guitar Player (On the Cafe Terrace)* by Zadkine, by Ch. Delepaire. *Bettina Bedwell* by Rattner, by Eric Pollitzer. *The Accordeonist (Portrait of Per Krohg)* by Orloff, by Venus Mercenaire. *Equestrian* by Orloff, by Laurent Sully Jaulmes. *Jew with Torah* by Chagall, by Avraham Hay. Exterior of Soutine's studio, by Dr. Ernst-Gerhard Guse.

Published in the United States of America in 1985 by Universe Books
381 Park Avenue South, New York, N.Y. 10016

© 1985 The Jewish Museum, New York
under the auspices of The Jewish Theological Seminary of America

All rights reserved. No part of this publication may be reproduced, stored in a retrieval system, or transmitted, in any form or by any means, electronic, mechanical, photocopying, recording, or otherwise, without prior permission of the publishers.

85 86 87 88 89 / 10 9 8 7 6 5 4 3 2 1
Printed in Japan
Library of Congress Cataloging in Publication Data
Silver, Kenneth.
 The Circle of Montparnasse.
 Bibliography: p.
 1. Artists, Jewish—France—Paris. 2. Artists, Expatriate—France—Paris. 3. Montparnasse (Paris, France)—Intellectual life. I. Golan, Romy. II. Cohen, Arthur Allen, 1928- . III. Klüver, Billy, 1927- IV. Martin, Julie. V. Title.
N6850.S55 1985 704'.03924044361 85-8418
ISBN 0-87663-480-3
ISBN 0-87663-880-9 (pbk.)

CONTENTS

ACKNOWLEDGEMENTS

The Circle of Montparnasse: Jewish Artists in Paris 1905–1945 is the second in a series of three exhibitions intended to celebrate and explore the phenomenon of the influx of Jewish artists to the world capitals of London, Paris, and New York at the beginning of the 20th century. The series began in 1983 when the Jewish Museum mounted The Immigrant Generations: Jewish Artists in Britain 1900–1945 and will conclude with an exhibition based on the experience of the immigrant artist on the Lower East Side of New York.

The exploration of this theme, and its various international manifestations, is intrinsic to the ongoing activities of the Jewish Museum. We must acknowledge the significant role of the immigrant experience in shaping the identity of the American Jew today. Through exhibitions, special events, and educational programs, the Museum is continually addressing the interrelation between the great influx of immigrant Jews to America within a relatively short span of time and their remarkable contributions to contemporary culture.

In planning this exhibition there were two main goals. One was to place the artists who emigrated to Paris in the early decades of the century in a social, historical, and esthetic context. The other was to examine the artists' shared experiences and their impact on a collective identity. This task was made possible when the Museum invited Professor Kenneth Silver, of the Fine Arts Department of New York University, to serve as guest curator and apply his expertise in the area of early 20th-century French art to creating a new understanding of art made by Jews in Paris between 1905 and 1945.

While the core group of artists represented includes some familiar names such as Chagall, Lipchitz, Modigliani, Soutine, and Pascin, a number of other artists are also included whose paintings and sculpture, although less known to the general public, made a significant contribution to the artistic vitality of Montparnasse. The work of Orloff, Kisling, Marcoussis, Miestchaninoff, and others, brought to light in this exhibition, furthers our understanding of a lively artistic community, and the esthetic and stylistic concerns that were at issue.

While there were two world wars and tremendous social change, Paris for most of the first half of the 20th century remained the avant-garde center of the Western world. It was a city able to absorb and give shelter to both revolutionary and conservative artists. Many lived in neighborhoods where languages and customs from the old country were mixed with those of new generations. Cafés, galleries, and rooms were set aside as meeting places for discussion of new esthetic theories. Dealers, collectors, and critics joined together and museums offered fine examples of both modern and traditional art. Animated exchanges revolved around the new modes of portraying reality.

For the Jewish emigré artists who converged in the Montparnasse section of Paris during the first decades of the century, the broad spectrum of artistic possibilities to which they were exposed provided the optimum environment for realizing their preferred genres. There has long been attributed to these particular artists a mutuality of influences, tastes, and expression, and they were traditionally grouped together and were known as the "Jewish School of Paris." In reality, they created a varied profile, coming from diverse backgrounds that ranged from the poor orthodox East European shtetl to the assimilated well-to-do European home. Within the rich and vibrant environment of Paris, the Jewish artists encouraged and nurtured one another.

In addition to the artists' individual talents and sensibilities, their work remains the creation of individuals whose output manifests the sum of their personal experiences. Unquestionably the phenomena of immigration, especially by artists from Eastern Europe to the

West, must be acknowledged in any consideration of this period. The uprooting from the close-knit, smaller Jewish communities to the vast heterogeneous city of Paris, the tensions between traditional and new ways of life, as well as World War II with its death camps, are factors that have been heavily weighed in the interpretation and analysis of the work itself.

The painting and sculpture included in our 1983 British exhibition had not been acquired widely by collectors beyond the areas where it was created, and hence, borrowing was confined primarily to Britain for that show. The international reputation of the artists included in the current exhibition, however, accounts for the dispersal of work far beyond the city in which it was created. The exhibition's organization has thus been a lengthy process of research and securing of loans. Because the availability of works has in many ways determined the shape of the exhibition, we are extremely grateful to those individuals and institutions who understood the importance of this exhibition and agreed to participate.

Like all group shows of artists from abroad, the present exhibition necessitated an enormous amount of research, travel, and coordination (in this case, there were shipments of artworks from sixty-two sites). *The Circle of Montparnasse* could not, therefore, have been brought to the United States without the generous support of the National Endowment for the Arts, a Federal agency, which initially recognized the value of this first historical documentation of the circle of Montparnasse. A further contribution was kindly given by the Joe and Emily Lowe Foundation, Inc. We are very grateful to those individuals who helped raise funds for the exhibition: Beverly Goldfine, Jane Overman, Sandra Weiner and Cyvia Wolff.

To bring together works by little-known and well-known artists alike entails much evaluation and reconsideration. We owe our thanks to Kenneth Silver who, with his assistant Romy Golan, undertook the difficult task of research, selection, and realization of the exhibition. We are grateful for their fresh, innovative approach to a subject central to the concerns of The Jewish Museum. Their original research, writing, and designation of the Jewish artists of Montparnasse into a specific group has never before been systematically attempted in a museum exhibition and catalogue. The scholarship by Silver and Golan on the circle of Montparnasse thus provides a major contribution to the field and the basis for further interpretation, research, and study. Presented here are Kenneth Silver's in-depth essay and perceptive texts by Romy Golan, Arthur A. Cohen, Billy Klüver, and Julie Martin, for which we are very grateful. They elucidate the lives of the artists themselves, their milieu in Paris, and enchance our understanding of Jewish artists living in Paris.

The exhibition would not have been possible without the cooperation of the entire Jewish Museum staff, which worked diligently in the many stages of organization. I acknowledge with gratitude the encouragement of Joan Rosenbaum, Director. In addition to her initial support and continued involvement, her advice and guidance at key stages in the exhibition's realization was invaluable. I am particularly grateful to Harley Spiller, whose persistence, patience, and intelligence were crucial in the realization of this project. Thanks also to Caren Levine for her efficient and willing help with the many aspects of preparing the catalogue and the exhibition. I wish to acknowledge and thank the staff members of the following departments for their expert assistance in the creation of this exhibition: Administration, Education, Broadcast Archive, Development, Operations, Public Relations, and Registrar. Thanks are also extended to the members of our Board of Trustees who enthusiastically supported this project, and to the staff of the Jewish Theological Seminary of America.

Other individuals whose contributions to this book I gratefully acknowledge include Adele Ursone of Universe Books, who was most gracious with her advice as we formulated the parameters of the publication, and Kay Douglas, the designer whose recommendations clarified many decisions regarding publication. Lynne Breslin and Shauna Mosseri deserve special recognition for their discerning and sensitive exhibition installation. Thanks to Stephen R. Frankel, editor, for his knowledgeable and skillful assistance, and to Dr. Sybil Milton who shared her time and expertise. The overwhelming generosity of private collectors and museums in the United States and throughout the world has made all of this possible. They are listed separately (following "Artists in the Exhibition"), and we wish to express our utmost gratitude to all of these lenders.

SUSAN TUMARKIN GOODMAN
CHIEF CURATOR, THE JEWISH MUSEUM

An exhibition like The Circle of Montparnasse—with scores of artists represented, a sizable period of time surveyed, and much historical research to be done—is an enormous undertaking. It requires the efforts of many people, in all kinds of capacities, some of whom are involved in the project from inception to realization (which in this case was several years). I am extremely grateful to those at the Jewish Museum who have helped make the exhibition and catalogue a reality: Susan Tumarkin Goodman, Chief Curator, whose idea the exhibition was and who invited me to organize it; Joan Rosenbaum, Director of the Museum; and Harley Spiller, Exhibitions Assistant, who has had the Sisyphean task of keeping track of and coordinating all the paperwork, and who has performed it with such good humor.

Four people outside the Museum have been especially important: early on, the poet and critic Edouard Roditi encouraged me to broaden my conception of the show to include a large number of artists, little-known and forgotten figures as well as the big guns, and to extend the focus of the period to end with World War II and the Holocaust. Both suggestions were heeded to the great benefit, I believe, of the exhibition. Billy Klüver and Julie Martin, whose paths I'd crossed earlier in another scholarly capacity, proved invaluable guides to the people, places, and literature of Montparnasse. They opened many doors for us, saved me from errors large and small, and then agreed to share a part of their knowledge in the form of an essay in this catalogue. Above all I am indebted to Romy Golan, guest assistant curator and co-author of the catalogue for "The Circle of Montparnasse," whose energy, dedication, and intelligence have helped to make the organization and research a voyage of discovery.

No exhibition is possible without the generosity of lenders. Aside from the acknowledgment of our debt to every one of them as they appear on our list of lenders, I want especially to thank a number of individuals who have loaned works to the exhibition or have one way or another helped us to secure loans (and as we were refused the loan of many important works for the show, the efforts of these individuals have been all the more appreciated): Oscar Ghez of the Petit Palais, Geneva; Germain Viatte and Nadine Pouillon of the Musée National d'Art Moderne, Centre Georges Pompidou, Paris; John Elderfield, Clive Phillpot, Bernice Rose, Cora Rosevear, and William Rubin of The Museum of Modern Art; William Lieberman and Lowery Sims of The Metropolitan Museum of Art; Sasha Newman of the Phillips Collection, Washington, D.C.; Allen Rosenbaum, of the Art Museum, Princeton University; Stephanie Barron of the Los Angeles County Museum of Art; Sophie Rosenfeld of the Musée d'Art Juif, Paris; Cécile Coutin and Laure Lemonnier of the Musée des Deux Guerres Mondiales, Paris; Mme Vidal of the Musée d'Art Moderne de la Ville de Paris; Robert Littman of the Tamayo Museum, Mexico City; Arthur Feldman of the Spertus Museum of Judaica, Chicago; Grace Cohen Grossman of the Hebrew Union College Skirball Museum, Los Angeles. Of the private collectors, I want particularly to express my gratitude to (in France) Camille Bondy and Jean Kisling, and (in the United States) Dr. Sabine Oishi, Kurt Olden, Esther Gentle Rattner, Mr. and Mrs. Joseph Randall Schapiro, Mrs. Eugen Spiro, and Richard Zeisler. Among the dealers, I would like to offer a special thanks to Roland Augustine, of the Galeri Bellman, New York; Jacob Baal-Teshuva, New York; Gilbert Brownstone, Paris; Bella Fishko, of the Forum Gallery, New York; Ursula Maria Johnson, of R. S. Johnson International Galleries, Chicago; Pierre Matisse, New York; Cheryl Niedorf, of the Galerie Vallois, Paris; Abel Rambert of the Galerie Rambert, Paris; Nicole Rousset-Altounian, Galerie NRA, Paris; Helen Serger of the Galerie La Boétie, New York; Micky Tiroche of the Tiroche Gallery, Tel Aviv; and Giulio Urbanati of the Galerie Le Point, Monte Carlo.

There are many other people to whom I am indebted, among them: Nelson Blitz, Jr., Georges Charensol, Nino Frank, Beth Gersh, Robert L. Herbert, Mrs. Neva Krohn, Sharon Lieberman, Daniel Marchéssau, Mr. and Mrs. Sigmund Menkès, Sibyl Milton, Yvette Moch, Linda Nochlin, Meg Perlman, Grace Ross, Stuart Silver, Jeanine Warnod, Marion Wolf, and my colleagues at the Fine Arts Department, Washington Square College, New York University, each of whom has offered advice and information to me in the course of my research. Among them I am especially grateful to my chairman, Lucy Freeman Sandler, who has made the facilities of my department available to me for work on the exhibition and catalogue; Pamela Sharpless, our Fine Arts librarian; Carol Herselle Krinsky, Edward Sullivan and Guy Walton, all of whom provided me with valuable information and guidance; and Robert Rosenblum, who has helped me in more ways than I can possibly enumerate. I'd also like to thank the staffs of the libraries of the YIVO and Leo Baeck Institute and Daniel Pearl of the Museum of Modern Art library. For his catalogue essay and general counsel I want to thank Arthur Cohen; Stephen R. Frankel for his superb

editing of the text; Adele Ursone of Universe Books for her knowledge, taste, and unfailing equilibrium; Kay Douglas for her beautiful design of this book; and Lynne Breslin and Shauna Mosseri, for their wonderfully imaginative and viable exhibition design. The American Council of Learned Societies provided me with a Grant-in-Aid that enabled me to undertake research in Paris for this catalogue, for which I am most grateful. Finally, I want to thank Zack Karantonis, who has listened to all of the problems, every step of the way, and who more than anyone I hope is pleased with the results.

KENNETH E. SILVER
GUEST CURATOR

INTRODUCTION

Thirty-five years ago, in the catalogue for the Soutine retrospective organized jointly by The Museum of Modern Art and The Cleveland Museum of Art, Monroe Wheeler wrote:

> More painting has been done in France in this century by immigrants from Eastern European ghettos than the Jewish nation has produced in all the centuries gone by. Whether by their own religious traditions, or by the repressions and injustices of others, Jews had previously been kept out of the arts almost entirely. Suddenly, there they were in the vanguard, uprooted but quickly digging in everywhere, mixing in everything, playing a great role in civilization. It may be that for Soutine and for other of his fellow artists in Paris, the important thing was not the sense of race repression but the opposite, the rapidity of liberation—what we now call vertical social mobility—and its consequences, psychological and otherwise. It made them bold, even insolent, concentrated upon their advancement, indefatigable; but it kept them under continuous strain, ever insecure and perhaps incredulous. Those days of their youth seemed too good to be true.[1]

Although one might make a few minor adjustments of fact—for instance, not all of the Jews from Eastern Europe in Paris were from ghettos, and indeed, most were not—Wheeler's observations remain the most astute and succinct description of the experience of Jewish artists during the first few decades of the century that has been offered.

This is our subject in *The Circle of Montparnasse:* *Jewish Artists in Paris, 1905–1945*, the unprecedented phenomenon wherein large numbers of Jews flocked to Paris with the express purpose of becoming artists. As Wheeler rightly points out, Jews had played little if any role in the development of the visual arts in the West, due both to external forces (that Western art has been mostly Christian art for nearly a millenium and a half) and to internal ones (traditional Jewish prohibitions against image-making, which Arthur Cohen discusses in his essay in this catalogue, "From Eastern Europe, to Paris and Beyond"). Then suddenly, at the beginning of the twentieth century, as if a mist had lifted, there were scores of Jewish artists to be seen on all the artistic horizons and nowhere more densely concentrated than in Paris.

That is not to say that these artists of Montparnasse (for that is the Left Bank neighborhood where most of them lived, worked, and socialized) made Jewish art. Very few did, although one of these—Marc Chagall, who has just passed away as I write these words—was the most famous Jewish artist in Paris, and may even be the most famous creator of Jewish art in history. Most of the circle of Montparnasse made not Jewish art, but Parisian art, which in the first decades of the century could mean everything from *belle peinture* to Cubism. (In fact there were Jews among the Dada and Surrealist artists, like Victor Brauner, Marcel Janco, and Man Ray, but they tended to comprise a circle of their own quite apart from the "mainstream" of Montparnasse.) As it turns out, the majority of Jewish artists, like the majority of all Parisian artists, tended to a greater or lesser extent toward an esthetic of the *juste-milieu*—a happy medium between extremes. Although there are instances of what passed then, and still passes now, for avant-garde artistic production, much of the work in this exhibition and catalogue manifests a rather agreeable updating of tradition and a modernism without the "sting."

But this does not mean, either, that being Jewish was unimportant or irrelevant to these artists. For sooner or later it became evident, in almost every case—including that of someone like Max Jacob, who converted to Catholicism—that one's Jewishness *did* matter. And I am not speaking here only of the Holocaust. Rather, from the very outset, being Jewish had a significance again both from the inside—in that there was a milieu of artists, critics, dealers, and patrons that was heavily Jewish—and from the outside, since the sudden appearance of so many Jews, all at once, on the Parisian scene was something with which the French felt they had to reckon (as discussed in Romy Golan's essay in this catalogue "The *Ecole Française* vs. the *Ecole de Paris*"). For many people, rightly or wrongly, Montparnasse and Jews were synonymous.[2] Of course by the mid-1930s and then the Nazi Occupation, an artist's Jewish identity counted in a way that no one could have imagined. Yet, that is to jump ahead to the end-point of the history, because for the most part the story we have to tell is really one of extraordinary opportunity and great good luck. Even given the emotional toll that, as Wheeler rightly observed, such rapid upward mobility took on the less stable of these immigrants, Paris meant liberation—especially for those who had come from places in which, as Jews, they were excluded from the normal rights of Christians, including the opportunity to receive an artistic education. Being in the French capital allowed them to live as free men and women, and to work as professional artists at the very center of Western culture. Is it any wonder that most of these Jews came to love their adopted city and nation, that they considered themselves French patriots—some even volunteered to serve under the *tricolore*—or that almost all became French citizens as soon as they had the chance?

To be sure, like all attempts to give a shape to history, *The Circle of Montparnasse* distorts certain issues in the process of clarifying others and bringing them into focus. For instance, while we have tried to give a representative cross-section of artistic practice within the self-imposed limits of the exhibition and catalogue—there are forty-three artists here shown—we have nonetheless thereby excluded scores of other Jewish artists of Montparnasse from this period. One could even make another presentation entirely of the same subject. At best, we can say that we have tried to discover the art and tell the story of *The Circle of Montparnasse* in a way that would be beautiful, interesting, and true to the extent that we have been able to understand it. Future investigators may well see it otherwise, in terms of different figures and different works of art. And there is another distortion as well: In presenting the Jewish artists of Montparnasse as if they were a group *sui generis*, we may wrongly give the impression that these painters

and sculptors constituted a world unto themselves. In reality, as Billy Klüver and Julie Martin explain in their essay here, "*Carrefour Vavin*," the Jews in Montparnasse were part of a vast population of artists—many of them foreigners, many of them French—that gave the neighborhood and Paris during the first three decades of the century its cosmopolitan character. Indeed, it is hoped that this exhibition and catalogue will contribute not only to a Jewish history of Montparnasse and Paris, but also to a general cultural history of this extraordinary time and place.

Finally, though, one lives with the limitations of any exhibition, hoping that the virtues of a point of view will make it all worthwhile. Our goal is to tell of the first generation of Jews to become professional visual artists in the West, and we hope that the Jewish Museum's visitors and the readers of this book will find it as compelling a history as did the organizers and authors of *The Circle of Montparnasse*.

K.E.S.

NOTES

1. Monroe Wheeler, *Soutine*, exhibition catalogue, The Museum of Modern Art, New York, 1950, pp. 35–36.
2. Jean-Paul Crespelle, as late as 1962, felt called upon to counteract the prevailing opinion that Montparnasse was mostly made up of Jews: "There is too great a tendency to believe that Montparnasse after World War I was exclusively colonized by Jews fleeing the pogroms and by political refugees from all over." *Montparnasse Vivant* (Paris, 1962), p. 241.

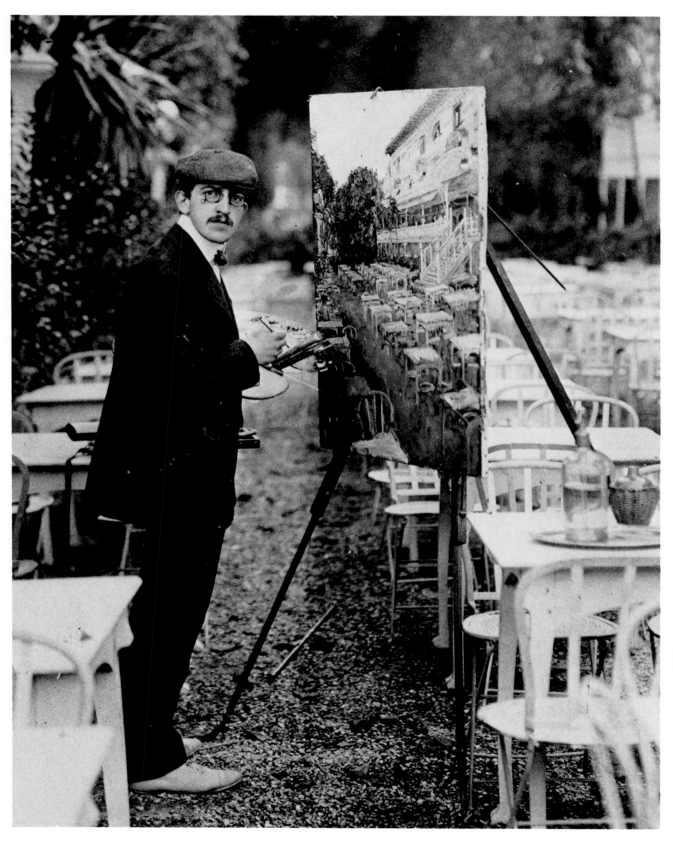

Figure 1 Walter Bondy, ca. 1907, painting *The "Pavillon Bleu" at St.-Cloud* (colorplate II).

JEWISH ARTISTS IN PARIS 1905-1945

BY KENNETH E. SILVER

Were it not for Jules Pascin—born Julius Mordecai Pincas in Vidin, Bulgaria, in 1885—the first major presence of Jewish artists in Paris might have passed unnoticed. But so well-known did Pascin become and so important an aspect of his public persona was his Jewish identity (even if he himself preferred not to emphasize it) that he functioned as a kind of magnetic force for many other Jewish artists in Paris at the beginning of the century. Not only was he a central figure in the social and cultural life of the cafés, clubs, hotels, and studios of Montparnasse, but it was as if his obvious talent were a kind of vindication for a group of people who had hitherto played such a marginal role in the visual arts. Of course, Pascin and the other Jewish artists were part of a much larger phenomenon: the great increase in the number of foreigners—including Belgian, Swiss, Scandinavian, German, Russian, and many other nationalities of artists—that flocked to Paris, and especially to the neighborhood of Montparnasse, in the late 19th and early 20th centuries.

In fact, it was first as a German artist that Pascin was known in Montparnasse, where he socialized with other German-speaking artists at the Café du Dôme, at the intersection of the Boulevard du Montparnasse and the Rue Delambre, attracting a group that came to be known informally as "Dômiers." Pascin was already famous in certain circles even before arriving in the French capital in 1905. In *The Autobiography of Alice B. Toklas*, Gertrude Stein recalled that "Among the Germans who used to come [to call at the Rue de Fleurus] in those early days was Pascin. He was at that time a thin, brilliant-looking creature, he already had a considerable reputation as a maker of neat little caricatures in *Simplicissimus*, the most lively of the German comic papers. The other Germans told strange stories of him. That he had been brought up in a house of prostitution of unknown and probably royal birth, etcetera."[1] Although Pascin was neither German nor sired in a whorehouse, he had lived in Munich before coming to Paris (he had also studied in Budapest, Vienna, and Berlin); and as a result, most of his Parisian friends were at first either Germans or Austrians, or other Eastern Europeans like himself who spoke German. He did in fact become famous for frequenting brothels as well as maintaining close relationships with prostitutes, pimps, and drug-dealers, but his origins were high rather than low (hence the implications of royal lineage): He was the son of an immensely wealthy Sephardic family of traders and bankers with close ties to the royal houses of Bulgaria and the old Ottoman Empire (his brother married the fashionable Princess Ghika). There was nonetheless a certain amount of exoticism that adhered to Pascin—his appearance was darkly foreign and, as André Salmon recounts, he was proud of having had a Turkish wet nurse.[2] This early memory may in part provide the context for one of the painter's loveliest pictures of his first Paris period, *The Turkish Family* of 1907 (colorplate I), in which a top-hatted man bearing a slight resemblance to the artist stands behind a large family of females of all ages, as a cherub flies overhead seeming to bless the gathering.

When on Christmas Eve 1905, at the age of twenty, Pascin descended at the Gare de l'Est from a smoking compartment of the Orient Express, he was greeted by a contingent of artists from the Dôme, including three Jewish friends from Munich: Walter Bondy, Rudolf Levy, and Bela Czobel.[3] Bondy, two years older than Pascin, was from a similarly privileged background. Otto Bondy, his father, was a Czech Jew who after Walter was born settled in Vienna, where he was a wire manufacturer; his mother was Julie Cassirer, sister of the neo-Kantian philosopher Ernst Cassirer.[4] There is a touching photograph of Bondy (fig. 1) standing before his easel *en plein air* in the garden of a popular restaurant and café in St.-Cloud, the so-called Pavillon Bleu,

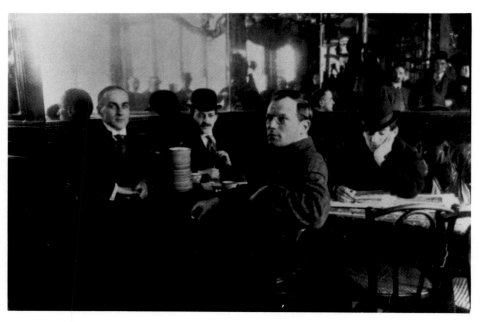

Figure 2 At the Café du Dôme, ca. 1910, are (right to left): Jules Pascin, Rudolf Levy, Walter Bondy, and Wilhelm Uhde.

hard at work on his most important early picture, of the pavilion and garden before him (colorplate II), really a late-Impressionist rendering (with a bluish, fin-de-siècle cast). Levy, ten years Pascin's senior, was from a well-to-do family of German merchants. The son of Julius and Theresa Levy, he was born in Pomerania, and the family moved to Danzig when Rudolf was an infant. Bondy and Levy had come together from Munich to Paris in 1903. In a photograph taken at the Dôme around 1910 (fig. 2), we see (from right to left): Pascin drawing; Levy facing back toward the camera from our side of the table; a mustachioed Bondy in the far corner; and Wilhelm Uhde, art dealer and collector, whose high-arching brow, tightly pursed lips and starched wing collar we recognize from Picasso's contemporaneous Cubist portrait of him. Pascin has also left a funny little drawing (fig. 3) of the kind that made him famous at *Simpliccisimus* in which Bondy is at work on a portrait of Levy, who is posed against a painted Alpine backdrop, much like the kind that portrait photographers used to use. At the right is a large painting of a nude with the French label *vendu* (sold). The last member of the trio from Munich was Czobel, born in Budapest, and who arrived in Paris in 1904. By the time that Pascin arrived the next year, Czobel was exhibiting with the Fauves at the Salon d'Automne. His *Man in a Straw Hat* (cat. no. 12), with its divisionist brushstroke and "mixed-technique" (which included the use of Matisse's device of letting exposed, unprimed

canvas stand for a light tone), was painted in 1906.

The habitués of the Café du Dôme were by no means completely isolated from the rest of Parisian artistic life, but they were distanced from native French culture not only because they for the most part spoke German but also because so many of them were of German nationality. We must not forget, as the French certainly had not, that the nation suffered a terrible humiliation in the Franco-Prussian War of 1870–1871; the result was a more or less perpetual animosity toward anything and anyone German.[5] While it is true that by the turn of the century German artists were once again coming to Paris in large numbers, neither they nor the Jews among them were ever greeted with much enthusiasm by the French. To make matters worse, especially for the Jews, but for foreigners in general and Germans in particular, the Dreyfus Affair that inflamed France during the 1890s—and which dragged on until the Jewish Colonel Dreyfus was cleared of all wrongdoing once and for all in 1906—was still very much on everyone's mind.[6] Add to this the official separation of Church and State in 1905 and one recognizes a French nation in the midst of epochal change, where non-indigenous factors—people, ideas, and things—were very much in evidence yet highly problematic.

Of course, most of the foreigners at the Dôme were not Jewish. These included the artists Wilhelm Lehmbruck, Hans Purrmann, Oskar and Greta Moll, Albert Weisgerber, Friedrich Ahlers-Hestermann, Rudolf

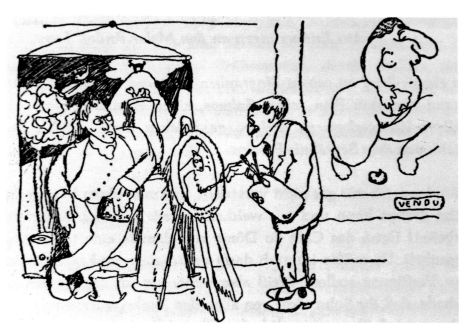

Figure 3 Undated drawing by Jules Pascin that depicts Walter Bondy painting a portrait of Rudolf Levy.

Grossmann; the dealer Wilhelm Uhde; and the writer Erich Klossowski—the father of Balthus—among many others. Still, there were a surprisingly large number of Jews at the Dôme and, although they never constituted an exclusive group, they appear to have stuck together a good deal. In another photograph taken at the Dôme (fig. 4), we see Hans Purrmann (at the right, toward the front), with mustache, goatee, and a balding head, and (to his right), at the tables at the back, next to the windows (right to left): Madame Bondy, in a large hat; Walter Bondy; Jules Pascin; the painter Hermine David (Pascin's wife-to-be); Rudolf Levy, in profile, again on our side of the table; and in the far corner another German Jewish painter, Walter Rosam, who always looks a bit troubled, both in photographs and even in a self-portrait of the period (cat. no. 99). Not present in the photograph, but also the author of a fine self-portrait (cat. no. 107) is the German Jewish artist Eugen Spiro, son of a cantor from Breslau.[7] His sister, Elisabeth Dorothea Spiro—who painted under the name of Baladine—married Erich Klossowski and was later the mother of Balthus and the lover of Rainer Maria Rilke. Among the other Jews at the Dôme were Galician-born dealer and critic Adolphe Basler,[8] the dealer (and presumably a relation of Bondy) Paul Cassirer, and another German dealer, Alfred Flechtheim.[9]

Sonia Delaunay, born Sonia Stern, the daughter of a poor Jewish laborer from the Ukraine, also moved on the edges of the Dôme group. Adopted at the age of five by her maternal uncle Henri Terk, a wealthy lawyer and art collector from St. Petersburg, Sonia Terk had, like so many others at the Dôme, the good fortune of an enlightened upbringing. She came to Paris in 1905, after first studying at the University of Karlsruhe for two years. By 1906 she had installed herself in a studio in Montparnasse, on the Rue Campagne-Première and, by 1908, in order to avoid being beckoned back to Russia by her family, she entered into a *mariage de convenance* with Uhde (at whose gallery on the Rue Notre-Dame-des-Champs she had her first one-person exhibition that same year). Sonia Terk's stunning, small portrait *Philomène* (colorplate III), painted the previous year, betrays at least three different artistic sources: a traditional, and quite learned, sculptural modeling of the planes of the face; a linear abbreviation that derives from Van Gogh and Gauguin (whose work was featured in a retrospective of over 200 works at the Salon d'Automne in 1906); and—perhaps most powerfully—the coloristic exuberance of Henri Matisse, whose *Woman with the Green Stripe* and *Woman with the Hat*, both of 1905, were probably known to her. Through Uhde, she came to know Picasso, Braque, and Derain, as well as Pascin, Levy, Purrmann, and Robert Delaunay. (At one of Sonia's first meetings with Robert, he had a violent argument with Rudolf Levy.) In 1910 she was amicably divorced from Uhde, married Delaunay, and launched toward the new esthetics of Cubism—or Orphism, as Apollinaire dubbed her new

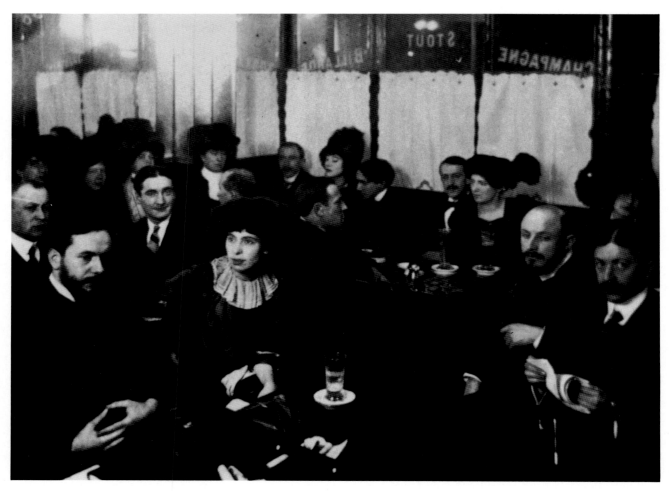

Figure 4 The Café du Dôme, ca. 1910. Sitting at the rear are (right to left): Mme. Bondy, Walter Bondy, Jules Pascin, Hermine David, and Walter Rosam. Rudolf Levy, sitting on our side of the table, is visible in profile.

husband's paintings.

Nonetheless, before 1910 the influence of Matisse was far and away the greatest of that of any living master on the art of the Dômiers. In spite of small discrepancies, depending on who tells the story, it is clear that some constellation of figures that included Michael and Sarah Stein (brother and sister-in-law of Gertrude), Hans Purrmann, the Swede Carl Palme, the American Patrick Henry Bruce, and Max Weber (an American Jew born in Bialystok) convinced Matisse to open his famous Academy in 1908, a school that was soon crowded to overflowing—which, however, did not prevent Matisse from giving up the venture and closing the school by 1911.[10] In a photograph of a small group of German and Scandinavian artists taken in Matisse's school (fig. 5), we now recognize a number of faces, including Rosam (seated at the lower left), Levy (in the derby at the center), and Hans Purrmann (standing in

the middle of the nine men). Also pictured, seated in profile at our left with his hand on his hip, is a Swede— in fact a Swedish Jew—named Isaac Grünewald, who would go on to become one of his country's most famous modern artists. The drawings by Grünewald and Levy of nude male models seen from the back (cat. nos. 22 and 46) were probably made in Matisse's school, as was Max Weber's intensely hued picture—with startling green highlights—of the huge plaster cast of Apollo (colorplate IV), seen from the back as well, of 1908. It was painted not long before Weber left Paris to return permanently to the United States.

As was often pointed out at the time, both by the students themselves as well as by observers, there was hardly any French spoken, except by the master himself, at the Matisse Academy; after all, almost all the students were foreigners—Americans, Germans, Scandanavians, Russians. Especially in the light of French

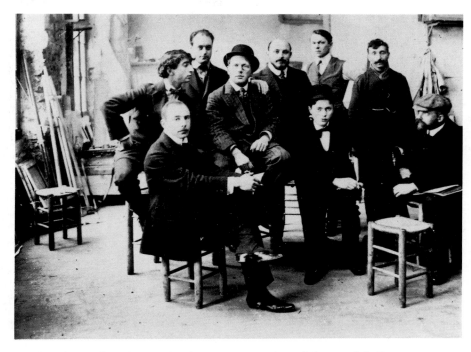

Figure 5 At the Matisse Academy, ca. 1910, are (left to right): Rosam (seated in front), Grünewald, Palme, Levy, Purrmann, Nölken (seated), unidentified man, and Straube (seated).

attitudes toward the Germans (and more generally considering post-Dreyfus xenophobia and anti-Semitism), this caused Matisse a good deal of very bad press. One critic, with an avowed antipathy for Matisse's esthetics, said that he was glad to see no Frenchmen among his students, but only "Russians, Poles, and Americans";[11] and another critic, writing in the influential magazine *L'Opinion* wrote, with an only slightly veiled anti-Semitism, that one found an international assortment of snobs in Matisse's school, who possess, whether it be "in New York, or in Moscow, in Berlin or in Bucharest," the same "mentality, the same instinct for going, in whatever they do, to extremes, in order to show off," but who, because they had acquired there the trademark of "French taste, French art [were able to] advantageously situate their merchandise"[12] in the art markets of the world. As early as 1907 one critic, in the conservative journal *l'Occident*, dismissed the artists and his followers by saying that Matisse was not taken seriously, "except by two or three Jews from San Francisco," by whom he meant the Stein family and their friends, "and by a few dealers."[13]

Of course it was true, and a sore spot for the anti-Semites in France—who tended to be on the Right, but not exclusively—that Jews were both active and visible in the French art world, even if few artists were Jewish before the 20th century. Many of the Right Bank deal-

ers (like the Bernheims and the Wildensteins) were Jewish, at least in origin, and so were many of the great collectors, including Isaac de Camondo, who bequeathed his important collection of Impressionist paintings to the Louvre in 1911 (thereby helping to fuel the twin prejudices against the modern and the Jewish), and his cousin Count Moïse de Camondo, who later bequeathed his house, containing what is considered to be the finest ensemble of 18th-century French furniture in the world (the museum called Nissim de Camondo), to the Musée des Arts Décoratifs.[14] The Left Bank dealers, who specialized in new, often avantgarde art, were likely to be Jewish as well: Berthe Weill, who gave Picasso two of his earliest exhibitions in Paris, in 1902 and 1904, and who would give Modigliani his first in 1917; Daniel-Henry Kahnweiler, the German Jewish dealer of the Cubists; Adolphe Basler, who dealt many of the artists from the Dôme; and, a bit later, the Rosenberg brothers, Léonce and Paul. Finally, several of the important critics were Jewish as well (that is, apart from Basler and Kahnweiler, both of whom also wrote criticism): Louis Vauxcelles (who had changed his name from Louis Meyer), Florent Fels, and Waldemar George.[15] Thus, even before foreign Jews came to Paris to be artists, French Jews had been playing important if auxiliary roles in the visual arts in France. Their presence on the Parisian scene certainly helped

to facilitate the entry of Jewish artists into the main-stream of Parisian culture.

The Germans and their other middle-European friends were not the only Jewish artists in Paris, nor were they the only Jews to frequent the Dôme. The Italian painter and sculptor Amedeo Modigliani, from Leghorn, of an old Sephardic family, came to Paris in 1906, living first in Montmartre, where he met the Bateau-Lavoir group that surrounded Picasso, including the poet Max Jacob, a French Jew from Quimper (Brittany). Modigliani's portrait drawing of Jacob of 1916 (cat. no. 73), a study for a painting of the same year now in Düsseldorf, depicts a dandified-looking character. The drawing is inscribed "to my brother, very tenderly, the night of March 7, the Crescent Moon"—occult references (astrological and cabalist) that fascinated both the painter and the poet. In fact this portrait, one of a remarkable gallery of such images drawn and painted at the cafés and studios of Montparnasse by Modigliani, was made slightly more than a year after Jacob's conversion to Catholicism. Agonized by his childhood feelings of separateness as a Jew in the provincial, devoutly Catholic atmosphere of Brittany, Jacob hoped also to atone for his homosexuality by his baptism (at which Picasso became his godfather), which took place in the Fathers of Zion convent in Montparnasse.

In about 1909 Modigliani moved from Montmartre to Montparnasse (which, literally translated, means from the Martyr's Mount to Mount Parnassus). His drawing of Adolphe Basler (fig. 6), a regular at the Dôme and other cafés in Montparnasse (fig. 7), could as well stand for the new neighborhood as the drawing of Jacob does for the old. Indeed, in 1912 Picasso also moved to Montparnasse, from the Boulevard de Clichy to 242 Boulevard Raspail, probably the most important sign that the artists' enclave on the Left Bank had definitively replaced the Right Bank hilltop village as the preeminent artistic neighborhood of Paris. Not even nostalgia would any longer bring serious artists to the *Butte*, as Montmartre had familiarly been called. In 1925 André Warnod wrote that "life in Montparnasse was always cleaner and more brutal than in Montmartre"[16] and by that he was referring not only to the physical aspects of the two *quartiers*—Montparnasse with its new buildings and broad avenues that contrasted so strikingly with the winding streets and picturesque seediness of Montmartre—but also to a change in time and attitude: The small, essentially private, bohemian world of 19th-century art had given way, or so it seemed, to the expansive but uncomfortably public and unrelenting world of 20th-century artistic production. "[It's] pretty too, my left bank," wrote André Salmon, "but much more built up than Montmartre. Five bourgeois floors rose up above the [Mont-

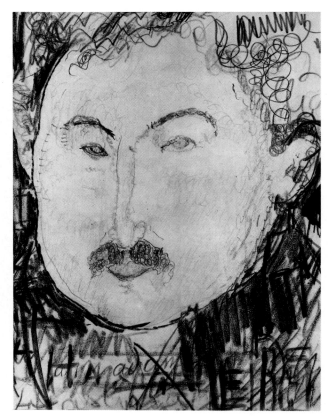

Figure 6 Amedeo Modigliani, *Portrait of Adolphe Basler*, ca. 1916 (cat. no. 71). The Brooklyn Museum, New York

parnasse restaurant] Closerie des Lilas . . . while, in order to reach the upper floors of the Bateau Lavoir [in Montmartre] you had to go downstairs,"[17] he explained, comparing the new, bourgeois apartment houses of the new Left Bank with the jerry-built, hillside accommodations of the Cubists.

By changing neighborhoods Modigliani also became an important link between the purposeful and conscious modernism of the Bateau-Lavoir and the more moderate if still modernist esthetics of Montparnasse. The beautiful self-portrait of 1919 (colorplate V), in which the artist turns away from his canvas toward us, proudly holding high his palette and brushes, tools of his *métier* (and wearing the velvet jacket for which he was famous, as well as a blue scarf or sweater tied around his neck), is at once a recapitulation of Cézanne and an ode to Botticelli. From the French Impressionist who died in 1906 Modigliani takes the thinly applied paint laid down in a repeated hatchwork; the warm/cool palette of earth and sky (or water) tones so beloved of the master from Aix; and even the characteristic and poignant tilt of the head, by which Cézanne evokes a

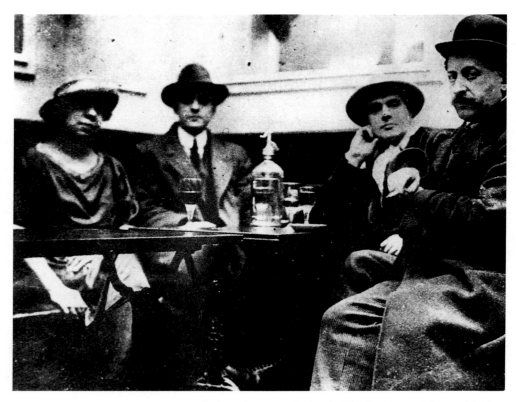

Figure 7 Shown here sitting with friends at a café (probably the Rotonde), ca. 1915, are Modigliani (leaning on table) and Basler (at far right).

sense of melancholy in the portraits of certain sitters. Yet it is in the tilt as well that we strongly sense Modigliani's predilection for the Italian Renaissance and especially for the art of Botticelli, for whom the tilted head is a sign of spiritual buoyancy (used most often for saints and the Virgin Mary). Italianate too, of course, are both the attenuated, linear style and the idealization of the form, which is at the crux of Modigliani's art. Although there is hardly a commentator who knew him that failed to remark on the artist's own startling physical beauty, he did not quite look like this; he was squatter and more masculine-looking than the delicate esthete who gazes out at us with vacant eyes in the painting.

Modigliani's Jewishness was a key element in his sense of identity, and even a matter of public record: The first picture he exhibited in Paris, at the Salon des Indépendants in 1908, was a portrait, titled simply *The Jewess (La Juive)*, and it is reported that at least once Modigliani got into a fight at a café with some young Royalists, who were making anti-Semitic remarks.[18] It appears, in fact, that Modigliani knew at least a rudimentary Hebrew: In a quick sketch of the sculptor Chana Orloff (fig. 31), made on an envelope while he

was sitting in a café in 1916, the artist wrote in Hebrew letters: "Chana, daughter of Raphael," presumably a reference to the idealizing esthetic inclination that she shared with Modigliani. There is also a lovely little page of sketches and jottings in French (fig. 8) that contains a woman's profile—perhaps the beginnings of a *maternité*—and two other faces, alongside lines of poetry and other inscriptions in which we find two small Stars of David. (Jacques Lipchitz recalls that when Max Jacob introduced him to Modigliani in 1913, at the Jardin de Luxembourg, the Italian was reciting Dante by heart—something he seems to have done fairly often.) One of the Stars of David appears between the lines "What is true is true equally in the Three Worlds/what is above [is] like that which is below." It would seem that Platonism and Judaism were perfectly complementary for Modigliani, perhaps just to the extent to which he felt both very much an Italian and very much a Jew. In this regard, it is worth pointing out that Christian imagery abounds in the art of Modigliani; he seems to have regarded religious differences much as he saw artistic distinctions, as being located on a continuum rather than contained in mutually exclusive compartments.

Modigliani's unique combination of qualities, as both a Jew and a "Latin" (the latter which signified, to the other Jewish immigrants, not only that he was a westerner but also that he was privy to the secrets of the great tradition of Western art), led to his being, rather like Pascin, an important role-model for the other immigrant Jewish artists. Moïse Kisling, for instance, a Polish Jew from Cracow, who had studied at the art academy there before arriving in Paris in 1910 with his close friend from home, Simon Mondzain (of whom Modigliani made a number of portraits), was soon also a friend of Modigliani. Certainly, even at the beginning, Kisling showed himself to be quite attached to the French tradition, as we see in his *Portrait of André Salmon* of 1912 (fig. 9) where, as in Modigliani, we feel the powerful influence of Cézanne—the very thin paint application, the obvious hatching strokes, the warm/cool palette. In fact, when Kisling moved to a studio in Montparnasse in the Rue Joseph-Bara, where Salmon lived across the street—we have a glimpse of the studio in a photograph taken sometime after 1916

Figure 8 Amedeo Modigliani, *Woman, Heads, and Jewish Symbols*, 1915 (cat. no. 69). Private collection, Italy

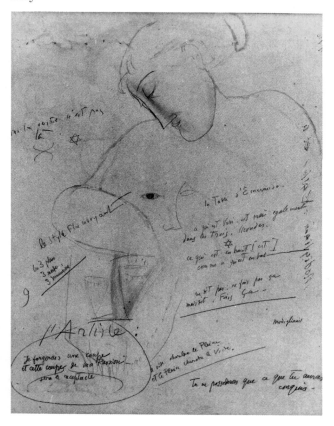

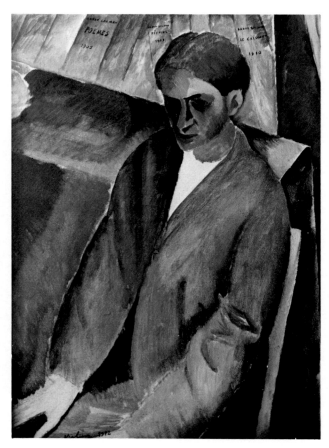

Figure 9 Moïse Kisling, *Portrait of André Salmon*, 1912 (cat. no. 38). Kisling Collection

(fig. 10)—Modigliani sometimes came to paint there. By this point their circle of friends was thoroughly intermingled, as demonstrated by Modigliani's portrait of Salmon (cat. no. 68) and Kisling's *Portrait of Adolphe Basler* of 1914 (fig. 11). Kisling inscribes it, at the upper right, *"à mon très, très cher Basler,"* which indeed the critic and dealer was to the painter, at least for a long while. Basler is said to have "discovered" Kisling and was the painter's critical advocate until the late 1920s, when he turned against him, calling him an academic endowed with no more than a "flattering brio."[19]

Esthetic issues aside, Kisling was a likely target for this kind of accusation, as much a result of jealousy as for any other reason, for he had rapidly become one of the most familiar, successful, sought-after, and well-liked artists of Montparnasse. Seats were reserved for "Kiki" (as he was called, but not to be confused with the Montparnasse model of the same name) at all the cafés and restaurants in the neighborhood, and his personal style was legendary. At one point he took to wearing blue mechanic's overalls (a style he seems to have

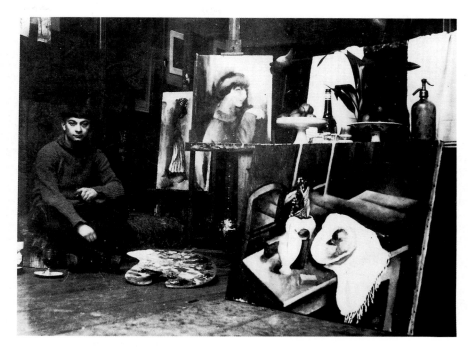

Figure 10 Moïse Kisling in his studio, Rue Joseph-Bara, ca. 1916.

learned from Picasso) and he cut his hair in a blunt-edged manner with very long bangs, a coiffure that Modigliani emphasized in a pencil portrait of 1916 (cat. no. 74). When Kisling married Renée Gros, the daughter of a French military officer, she had her hair cut in a style similar to his (called *coupe garçonne*, it was popular among fashionable women at that time). The two of them, dressed as they were in matching checked American cowboy shirts and unmatched socks, were soon among the most picturesque fixtures of Montparnasse.

The Kislings entertained a great deal in the Rue Joseph-Bara, and their apartment was one of the most famous inner sanctums in the neighborhood. Their wedding night is part of Montparnasse folklore: After much celebrating, Modigliani—who was a notoriously showy drunk—grabbed the bed linens off the waiting bridal bower, made a kind of toga for himself, and began reciting poetry. Renée, furious at the indiscretion, went for him and had to be physically restrained from doing Modigliani violence. It is also said that whenever a guest would leave a Kisling party at what Renée considered a too-early hour, she would, with a display of great strength, force him back into his seat. Moïse himself must have been more than a little pugilistic, as one of the more celebrated events in the annals of Montparnasse proves. Léopold Gottlieb,[20] son of a Talmudist from Austrian-occupied Poland, who had been in Paris since 1899—his *Return from Fishing* of 1925 (fig. 12)

is typical of his pale, classicized images—entered into a duel with Kisling in June 1914 over some issue now forgotten, at the Parc des Princes near the Porte de St.-Cloud, attended by their seconds and a group of spectators. The battle, which began with pistols and then went to swords when neither bullet hit its mark, continued until Kisling, his nose slashed, declared his wound "the fourth partition of Poland" (a remark that was particularly relevant to all of the Polish Jews present, whose families' nationalities had changed with the three late-18th-century partitions).[21]

It may have been Kisling's *savoir-faire* that helped bring him close to the always suave, multi-talented Jean Cocteau, whose portrait he painted in 1916 (color-plate VI). With the painter's dog Kouski resting at the poet's feet, Cocteau sits in Kisling's studio in a high-backed armchair, turned out in his usually elegant manner: He is wearing a *papillon* around his neck, and spats above which black-and-yellow patterned socks are visible. The whole exudes an air of preciousness, in part conveyed by the subtle colorations—note especially the juxtaposition of turquoise vase on mauve tabletop—but also owing to Kisling's almost miniaturist sensibility: Cocteau and all the objects in the room are delicately rendered as if in a dollhouse (a very pretty and sophisticated dollhouse, to be sure). Having Cocteau sit for him must have been a social coup for the still relatively little-known Kisling. But it was a triumph of sorts for the poet as well, who was just beginning his avant-

garde ascent in 1916 (he'd already conquered the artistic fringes of High Society before the war). About his situation in wartime Paris at the moment that he sat for Kisling's portrait Cocteau has written, "There were two fronts, the war front and then in Paris there was what might be called the Montparnasse front . . . I was on the way toward what seemed to me the intense life—toward Picasso, toward Modigliani, toward Satie . . ."[22] For an artist like Kisling, who began in Paris as a member of the "intense" confraternity of struggling artists, the friendship of a French, Right Bank socialite like Cocteau meant, needless to say, a step in the opposite direction—toward general Parisian culture and, ultimately, popular acceptance. In *Jean Cocteau in the Studio*, we catch a glimpse of the charmed life that Kisling was soon to know so well.

Cocteau's entry into the artistic life of Montparnasse more or less coincided with that of the foreign Jewish artists, and it may be for that reason that he seems to have given them and their heritage rather more thought than the average Frenchman. At one point, just after the Armistice that ended World War I, while musing in print about the life and death of cultures, he noted not only that Athens and Rome "still survive where their colonies have left traces, where their works astound" but also that "The temple of Jerusalem subsists in those places where the elements of a synagogue are found."[23] In the early 1920s, in a discussion of the relative importance of conception and execution in works of art, he noted that "the Jews were the real sculptors of Egypt,"[24] referring to the manual labor that they performed in building late-Egyptian monuments. This last statement may also have been provoked by the quantity of sculpture that he saw being made by the contemporary Jews around him. Modigliani, of course, was a sculptor as well as a painter, although in the end the sculptural output of his short career was quite limited. Of those Jewish artists in Paris who were exclusively sculptors, Jacques Lipchitz is certainly the best-known. A Lithuanian Jew, son of a building contractor, Lipchitz had studied in Bialystok and Vilna before coming to Paris in 1909, where he studied first as a free pupil in Injalbert's studio at the Ecole des Beaux-Arts and then at the Académie Julian and the Académie Colarossi in Montparnasse. It may well be that Lipchitz knew of the work of a Warsaw-born Jew who had come to Paris in 1904, Elie Nadelman, who had already had a hugely successful exhibition at the Galerie Druet just before Lipchitz arrived. Picasso had been to Nadelman's studio in 1908, taken there by Leo Stein. Lipchitz's *Horsewoman with Fan* of 1913 (cat. no. 48) is a modernist version of Nadelman's *Standing Nude* (colorplate VII) of ca. 1907–8, both figures assuming the pose of the *Venus pudica* type—a pose of

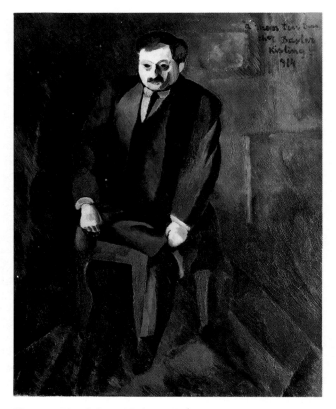

Figure 11 Moïse Kisling, *Portrait of Adolphe Basler*, 1914 (cat. no. 39). Petit Palais, Geneva

modesty in which the hands cover (or attempt to cover) the sexual organs. Nadelman's is essentially classicistic, with perhaps a simplifcation of forms that expresses a nascent primitivism; Lipchitz's circus bareback-rider with fan is a Cubistic adaptation of an ancient formula. By this point Lipchitz was working in a studio at no. 54, Rue de Montparnasse adjoining that of the Romanian sculptor Constantin Brancusi, and the geometric reduction of forms undoubtedly owes something to the association. He was also now friendly with Diego Rivera, the Mexican painter, who in turn introduced Lipchitz to Picasso, whose powerful influence can be seen in the remarkable *Head* (fig. 13) of 1915, in which essentially two solid shapes interpentrate at a 90-degree angle, forming the flat plane of the face and brow and the piercing vertical of the nose and the axis of the cranium. It is a stunning performance for an academically trained provincial artist after only five years in the West. Not surprisingly, Lipchitz was soon hailed as the leading Cubist sculptor and entered into a contract with the dealer Léonce Rosenberg in 1916. The degree of financial stability that it provided allowed the artist to commission Modigliani to paint a wedding portrait,

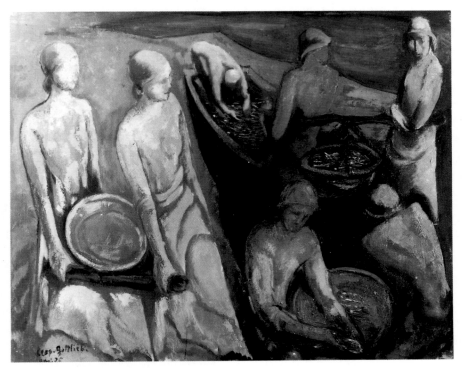

Figure 12 Léopold Gottlieb, *Return from Fishing*, 1925 (cat. no. 21). Petit Palais, Geneva

now in the Art Institute of Chicago (fig. 14), of him and his wife, the former Berthe Kitrosser, for which many pencil studies (cat. no. 78) were made.

For these largely East European immigrants, the preferred style was by no means Cubism, the pursuit of which usually presupposed a thorough grounding in artistic tradition along with, at the same time, a willingness to defy the norms of standard practice. To a certain extent this was putting the cart before the horse for a group that was still trying to master those norms and appreciate the classical canon. Yet, like Lipchitz and even pre-dating him, a number of these immigrants were both fast learners and desirous of working in what was surely the most self-consciously advanced esthetic of the pre-war period. Notable here is Louis Marcoussis (né Markus), from Warsaw, who arrived in Paris in 1903 after first studying painting in Cracow. He exhibited for the first time at the Salon d'Automne in 1905 and by 1910 was friendly with Picasso, Braque, and Apollinaire. Apollinaire, also Polish, had changed his name from Wilhelm de Kostrowitzky and suggested to the artist that he Gallicize his name as well (Marcoussis is the name of a small town in the Seine-et-Oise region). Marcoussis was soon a full-fledged Cubist painter (cat. no. 60) and showed with the Cubists in 1912 at the famous Section d'Or exhibition at the Gal-

erie de la Boétie in 1913. Having broken up with his lover Marcelle Humbert (who then became and remained Picasso's lover until her death in 1915), he married the painter Alice Halicka, daughter of a Jewish physician from Cracow, who had arrived in Paris only that year. She had spent the previous year at the art academy in Munich and was a student of Maurice Denis and Paul Sérusier at the Académie Ranson when she met Marcoussis. Another well-known Jewish immigrant who was drawn toward Cubism was Henri Hayden, from Warsaw (where he had studied at the fine arts academy). Hayden arrived in Paris in 1907, although it was not until 1914, when he moved to a studio in Montparnasse, that he entered the orbit of the Cubists by way of Max Jacob and Jacques Lipchitz. His view of a Parisian square (cat. no. 27) may be a picture of his new neighborhood, just as his *Characters from the Commedia dell'Arte* (fig. 15) marks the period of Hayden's first real contact with Cubism. In fact, the painting is yet another homage to the Cubist father-figure, Cézanne: Hayden's picture is a variation upon Cézanne's great *Mardi Gras* of 1880, which features similar, stiffly posed figures of Harlequin and Pulcinella. Nonetheless, it is a distinctly modern picture; both the masklike stylization of the faces and the flattened, contorted space were only possible after Picasso's work of

1907–8.

Two other painters ought to be mentioned in the context of pre-war modernist painting: Adolphe Féder and Georges Kars. The former—whose *Bather in the Studio* (colorplate VIII) is indebted both to Degas for its subject and to Cubism for the slight faceting of forms apparent in the modeling of the figure—had studied at the Matisse Academy and by 1912 was exhibiting at the Salon d'Automne. Works by both Féder and Kisling were illustrated in a review of the Salon in the October 2, 1912 issue of *L'Excelsior* (also reproduced were works by Matisse, Metzinger, Gleizes, La Fresnaye, and Kupka).[25] Kars, born near Prague of a wealthy German Jewish family, had been a friend of Rudolf Levy and Jules Pascin in Munich before coming to Paris in 1908, when he moved to Montmartre. Indeed, the influence of Picasso and Braque is strongly felt in Kars's *Bathers* of 1912 (colorplate IX). The blue tonality at once recalls both Cézanne and Blue Period Picasso, as does the iconography. The conceit of three nude Graces posed alongside a group of fully-dressed men has of course a venerable history in art, but makes one think most immediately of Manet's *Déjeuner sur l'herbe*, as well as Picasso's studies for the *Demoiselles d'Avignon*. Also,

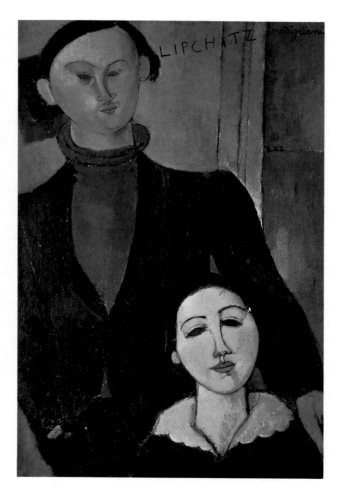

Figure 14 Amedeo Modigliani, *Portrait of Jacques Lipchitz and His Wife*, 1916–17. The Art Institute of Chicago (Helen Birch Bartlett Memorial Collection)

considering the similarity of the figure-types to those of Braque around 1908 (like his *Grand Nu*), it is tempting to speculate that Kars might have been a visitor to the Cubists' studios early on. Still another recent immigrant who was close to Jacob, Picasso, Brancusi, and Lipchitz was Ossip Zadkine, from Smolensk, Russia, the son of a Jewish university professor who had converted to the Orthodox faith upon marriage.[26] Although Zadkine did not embrace Cubism either as rapidly or as proficiently as Lipchitz (it was close to eight years after Zadkine's arrival in Paris in 1909 that he produced sculpture that can accurately be described as Cubist), when he did so it was with stunning success: His *Woman with a Fan*, a bronze of 1923 (fig. 16), is a particularly happy marriage of the monumental and the modernist.

Not long after he had arrived in Paris, Zadkine, like many other indigent artists, went to live at "La Ruche"

Figure 13 Jacques Lipchitz, *Cubist Head*, 1915 (cat. no. 49). Marlborough Gallery, New York

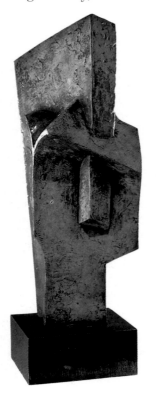

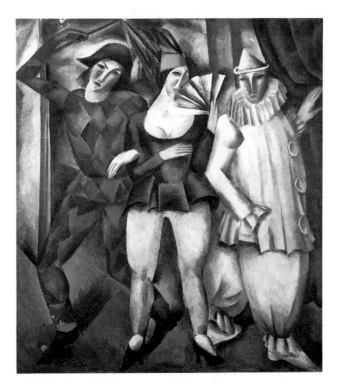

Figure 15 Henri Hayden, *Commedia dell'Arte Characters*, 1914 (cat. no. 26). Petit Palais, Geneva

(fig. 17), an artists' residence located on the southern edge of Montparnasse (actually in the fifteenth arrondissement), near the old Vaugirard slaughterhouses. *La ruche* means "the beehive," and it was intended by its creator, the academic sculptor Alfred Boucher, as a kind of ideal community of creative individuals working together, based on the ideas of France's 19th-century idealistic social reformer Charles Fourier, who called such communities *phalanstères* (phalansteries). Boucher was in fact the landlord of the artists who lived there, although he collected just enough rent from them to cover his expenses. He founded La Ruche in 1902, when it was inaugurated by—among others—the Minister of Beaux-Arts, accompanied by a small band playing *La Marseillaise*. Physically, the residence was a kind of collage made up of discarded pieces from the Universal Exposition of 1900: The octagonal, beehive-like main building whose three floors contained the majority of studios had been the Wine Pavilion; the caryatids flanking the main entrance were from the pavilion of British India; and the enormous, *art nouveau* wrought-iron front gate was from the Women's Pavilion. There were also several smaller structures, including additional studios, meeting places, and even a theater, while the area itself was still in a semirural state.[27]

Fernand Léger, the French Cubist painter from Normandy, was an early resident of La Ruche, as was Ardengo Soffici, the Italian Futurist poet. Nonetheless, the largest number of residents were from Eastern Europe (especially from Poland and Russia) and among these were many Jews; Michel Kikoïne, for example. Born in the town of Gomel, Russia, son of a banker in Minsk, he was the grandson of rabbis on both parents' sides. After first studying art in Vilna, he came to Paris around 1912 and lived at La Ruche, where he remained until 1927, at which point he had become prosperous enough to buy a studio in Montrouge. Kikoïne made a painting of La Ruche (fig. 18) sometime during his first winter there, for we see the premises under snow, although we can still recognize the characteristic sloping roof over the ground-floor sculptors' studios. Modigli-

Figure 16 Ossip Zadkine, *Woman with Fan*, 1923 (cat. no. 111). Musée National d'Art Moderne, Centre Georges Pompidou, Paris

ani drew a portrait of Kikoïne a few years later, probably while sitting in a café (fig. 19); it may have been made at Le Dantzig, the small café just beyond the gates of La Ruche, which opened onto the Passage Dantzig. Idealized in the usual Modigliani fashion (by elongating the figure) Kikoïne, with his pince-nez and intense expression, seems to fit the part of the young Russian emigré to perfection. Pinchus Krémègne, a friend of Kikoïne's from Vilna, Lithuania, who had also come to Paris around 1912, was like Kikoïne a resident at La Ruche, and he has left us a picture of his studio made in the early 1920s (fig. 20), in which we see a view out a window beyond his easel and a fragment of a kneeling Aphrodite. Isaac Dobrinsky, a Ukrainian Jew, after having spent six years in Kiev, arrived in Paris about the same time as Kikoïne and Krémègne and joined them at La Ruche (he lived there even longer than they, until 1934). At La Ruche he painted a picture of Boucher's phalanstery (cat no. 14) and made a portrait of his wife Wiera (colorplate X), in which her flesh tones are set off against a delicate palette of pearly blues and greens.

Figure 17 La Ruche, the artists' residence established by Alfred Boucher on the Impasse Dantzig, just southwest of Montparnasse.

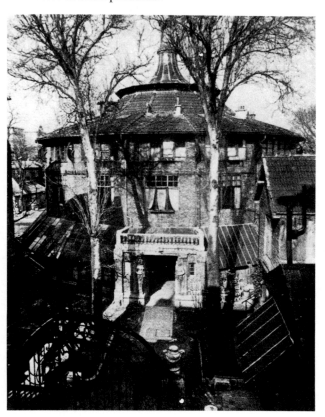

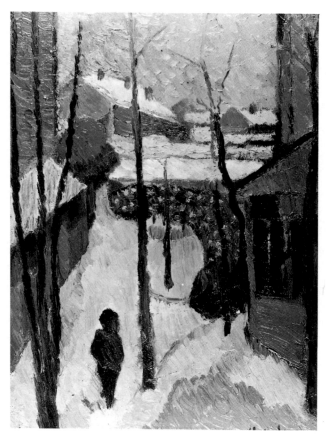

Figure 18 Michel Kikoïne, *La Ruche*, 1913–14 (cat. no. 36). Petit Palais, Geneva

Among the sculptors at La Ruche—and of course sculpture was dear to Boucher's heart—were the Russian Jew Möishe Kogan (cat. no. 43) and the Pole, from Lodz, Morice Lipsi (originally Lipszyc). Lipsi moved into a ground-floor studio at La Ruche shortly after he arrived in Paris in 1912 and was photographed there sometime in the 1920s (fig. 21). His work, perhaps in part influenced by his brief study at the Ecole des Beaux-Arts, but surely also by his brother, an ivory carver for whom Morice worked when he got to Paris, was frankly classicistic in the 1920s and 1930s, as in a quite lovely standing *Woman with Goat (The Shepherdess)* of 1925 (fig. 22), carved in cherry-wood. Among the Jewish artists who stayed longest at La Ruche were Jacques Chapiro (cat. no. 11), who did not arrive until 1925 but who went on to write a well-known book about the place, and Henri Epstein, who after first studying in Munich (he was a native of Lodz), came to Paris in 1912 (fig. 23).

In 1913 Blaise Cendrars, the poet and bard of the poverty-ridden "Villa Medici" that was La Ruche, com-

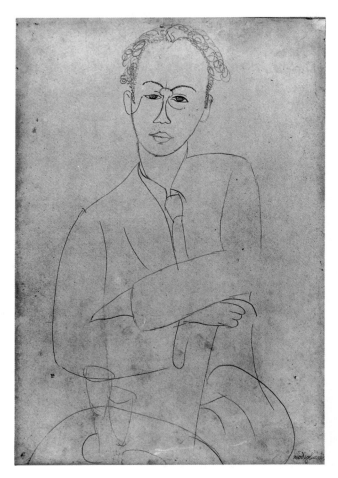

Figure 19 Amedeo Modigliani, *Portrait of Jacques Kikoïne*, ca. 1917 (cat. no. 77). E. Justman Collection, Paris

posed a poem in honor of its most famous resident, Marc Chagall. The first part, "Portrait," begins:

He is sleeping
He is awake
Suddenly, he paints
He takes a church and paints with a church
He takes a cow and paints with a cow
With a sardine
With heads, hands, knives
He paints with a bull's pizzle
He paints with all the foul passions of a little Jewish city
With all the heightened sexuality of provincial Russia
For France

and this part of the poem concludes:

Chagall is surprised he's still alive.

The second part of the poem, "Studio," then begins:

La Ruche
Stairs, doors, stairs
And his door opens like a newspaper
Covered with visiting cards
Then it closes.
Disorder, wild disorder
. . .[28]

Cendrars has tried to capture the rich and fantastic disorder that was both the reality of La Ruche and the landscape of Chagall's imagination. In the artist's own words, "When an insulted model sobbed in the Russian studios, when songs to the guitar echoed in the Italian studios, when the Jews carried on their heated discussions—I remained in my studio alone with my petrol lamp."[29] He tended to keep himself at a distance from the other painters, Jewish and otherwise, and associate more freely with the poets and critics, to which his

Figure 20 Pinchus Krémègne, *View of the Studio at La Ruche*, 1920 (cat. no. 44). Tiroche Gallery, Tel Aviv, Israel

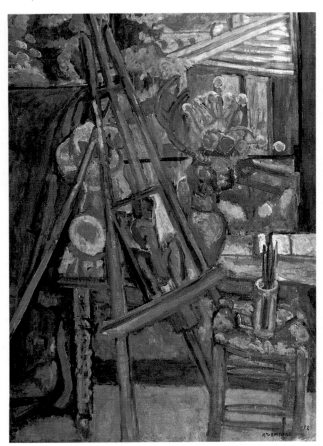

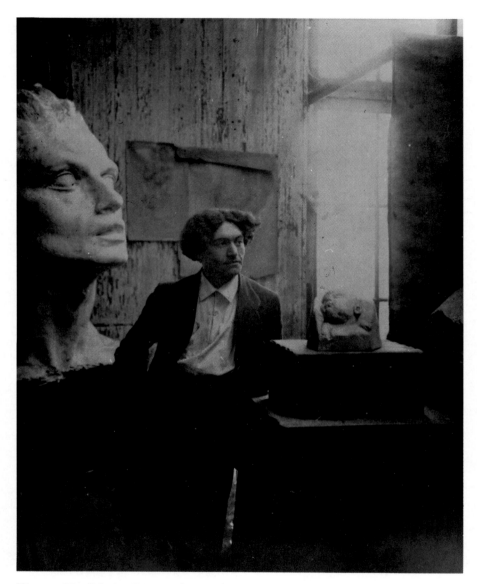

Figure 21 Morice Lipsi in his studio at La Ruche, ca. 1925–30.

important early picture *The Poet with the Birds* of 1911 attests (cat. no. 5).

Chagall was born, as nearly everyone knows, in Vitebsk, Russia, and began studying art there before going to St. Petersburg, where he was a student of Léon Bakst (cat. no. 76), the most famous scene and costume designer of Diaghilev's Ballets Russes (Bakst had changed his name from Rosenberg). If, more than any other Jewish artist in Montparnasse, Chagall remained thematically and pictorially loyal to his Russian Jewish roots, to the life of his forbears, it is largely owing to the nationalistic and folkloric movements in Russian culture of the late 19th and early 20th centuries, of which

Bakst was an important representative (see Arthur Cohen's discussion of this issue in his essay in this catalogue, "From Eastern Europe to Paris and Beyond"). When Chagall arrived in Paris in 1910, not only was he already equipped to make an artistic configuration out of his cultural heritage, but he was encouraged to do so by the current vogue for things Russian and folkloric in Paris around 1910—the Ballets Russes and his teacher Bakst had preceded him to the City of Light by a few years, where they were all the rage in fashionable circles. It was in this context that Chagall began to limn his highly estheticized re-creations of Russia, in works like *The Samovar* (cat. no. 3) and *Russia (or, Maternity)*

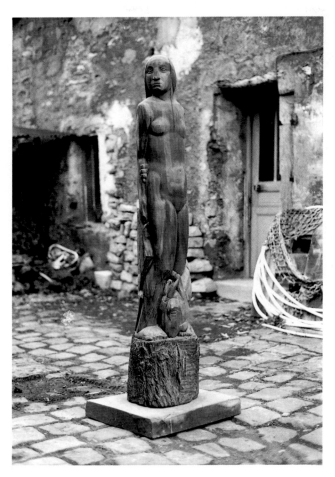

Figure 22 Morice Lipsi, *Woman with Goat* (*The Shepherdess*), 1925 (cat. no. 57). Morice Lipsi Collection

(cat. no. 6). In fact, Chagall went backstage at one of the Ballets Russes productions to see his former teacher, and although he felt at the time that he was perhaps an embarrassment to the Russian-assimilated member of the international set, not long afterward Bakst came to visit Chagall in his dingy quarters at La Ruche.

In other words Chagall, far more than many other foreign artists at La Ruche—which, for the Jews at least, bore a certain resemblance in its artistic cloistering to the ghettoes of Poland and Russia—was possessed of a usable past. Moreover, although he lived like the others at La Ruche, he was not actually indigent: During his early years in Paris, Chagall had a stipend of 125 francs per month from a Russian patron, Maxim Vinaver. This combination of psychic and financial stability may account, in turn, for the ease with which Chagall became a Parisian and, in time, a Frenchman. The Eiffel Tower, for instance, makes its appearance as

the symbol of Paris in many of his works of the period, including *The Passy Bridge and the Eiffel Tower* (cat. no. 4) and *Paris through the Window* of 1913, now in the Guggenheim Museum, for which there is a grisaille-and-color study (colorplate XI) made either before or after the Guggenheim oil. Chagall's picture of Paris, portrayed as both a physical reality through the window and a mythic array organized "through a temperament," is surely the greatest picture of Paris produced in this century. Which is not to say that in the strictest sense it is an original painting: To the contrary, Chagall's *Paris* relies heavily on contemporaneous and earlier Cubist works, such as Robert Delaunay's *City of Paris* (ca. 1910–12) and his various Eiffel Tower and "Window" pictures, as well as Roger de la Fresnaye's *Conquest of the Air* (1913); yet, in the end, it is a far more profound and imaginative work than any of its sources. The critic Waldemar George put it quite well in 1928: "He takes advantage of Cubism," he said of Chagall, "but while most of the painters consider it a morphology, Chagall makes of it a poetics."[30]

Chagall's first decision, to work in an almost perfectly square format, would seem to present nearly insurmountable problems in the fashioning of an image whose subject is not only the undeniably vertical Eiffel Tower but also the imaginative ascent of the artist in response to the city and its most important symbol. This may be in part why Chagall chose not to use the vertical format, so as not to allow the tower to dominate the visual field. Nonetheless, the light/dark patterning that courses through the picture in diagonal swipes may even have been inspired by the diagonal strutwork of the tower's construction, and it is a scaffolding which Chagall here uses as well to reach the sky. Beginning with the first rising diagonal from the bottom center to the Janus-headed man at the lower right (which, with the second rising diagonal from the man's chin, through the cat's neck, up to the top of the first windowpane, forms a tower-shaped wedge, on its side), Chagall superimposes a grid—perhaps the mapping of his psyche—that is equal to the vertical and horizontal grid created by the window at the left and reinforced by the window ledge and the cityspace beyond. Of course, it is a kind of law of Chagall's metaphysical science that the mere shifting of position, be it by 45 physical degrees or an equally minor adjustment in imaginative perspective, accounts for unexpected temporal juxtapositions of phenomena. This floating world of Paris as seen by the Russian Jew contains objects that are both explainable and mysterious: The tender bouquet at the lower left that sits upon a chair—these bits of nature, cut and arranged in a little bowl for visual delight, may have had a sweet and melancholy association for the deracinated artist. The human-faced cat—animal trapped in a

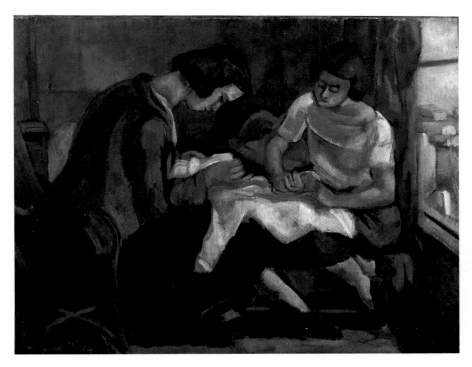

Figure 23 Henri Epstein, *Two Girls Sewing*, n.d. (cat. no. 16). Tiroche Gallery, Tel Aviv, Israel

world of men, man trapped by his animal nature, and endowed with a sphinxlike gift of prophesy. The Janus-headed man at the lower right—the artist in his double aspect as imitator of appearances and inventor of phantoms, as well as being (as Däubler suggested in 1916) Chagall himself, with one face fixed upon Paris and the West, the other looking back to Russia.[31] The little horizontal man and woman that float above this head—the man resembling an elder from the *shtetl*, the woman perhaps his mother. The upside-down train visible through the window—powerfully evocative of Chagall's own immense journey to the West, but more specifically perhaps a reference to the illustrated epic poem *Prose of the Transsiberian* (by Cendrars in collaboration with Chagall's friend and fellow Russian Sonia Delaunay), in which a railroad journey becomes a vehicle for psychic disorientation. And finally, apart from the traditional symbols of window as knowledge and the Eiffel Tower as Paris, there is the little man who floats down from what appears to be the top of the tower on a triangular-shaped parachute, and who perhaps best conveys the sense of buoyancy, risk-taking, and Icarus-like *chutzpah* that Chagall himself was feeling in Paris in 1913.

The second most famous Jewish resident of La Ruche, apart from Modigliani (who was there irregularly), is another Russian immigrant, Chaim Soutine.

Soutine's attitude toward his past was the opposite of Chagall's—he wanted only to forget the deprivation and cruelty of his hometown of Smilovitchi, located twelve miles from Minsk. He was born there in 1893, one of eleven children, the son of an impoverished mender of clothes. The young Soutine expected to become a shoemaker; instead, by the age of sixteen, he was already producing art and—so an anecdote goes—he asked the local rabbi to pose for a portrait, not really understanding the traditional Jewish prejudices against representation (again, see Cohen's essay in this catalogue for a discussion of the Second Commandment and its relationship to Jewish art). This led, in short order, to a brutal beating of Chaim by the rabbi's son, for which his mother then insisted upon, and received, an indemnity of twenty-five rubles. With this money, Soutine left for Minsk to attend a painting school with his friend Michel Kikoïne, a relatively well-do-do friend from Smilovitchi, and from there the two proceeded to the school of fine arts at Vilna, where they met Pinchus Krémègne. In 1913 Soutine came to Paris, first staying at La Ruche and then at the Cité Falguière, another artists' residence (to which we will return shortly). Although Soutine destroyed much of his early work in 1923, having decided that it was an embarrassment, there survies a fascinating *Self-Portrait* from about 1918 (cat. no. 100) in which the artist, posed before his

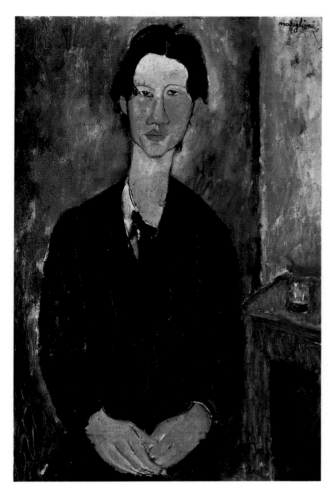

Figure 24 Amedeo Modigliani, *Portrait of Chaim Soutine*, 1917. National Gallery of Art, Washington, D.C., Chester Dale Collection

easel, stares out at us with all the intensity of someone looking at himself in the mirror. Set against a yellow-green ground, the artist's head and all the rest is rendered in a very loose, painterly stroke, a forecast of the kind of frenzied brushwork for which he was soon to become famous. How different this self-portrait, in which the artist is dwarfed beside his easel, from Modigliani's elegant self-affirmation: Modigliani's eyes are vacant and focused on something grand and beautiful beyond our ken, while Soutine, having given himself a pair of grostequely large lips, seems to challenge us to behold him in all his uncouth reality.

Ironically, it was none other than Modigliani—the elegant, articulate, Italian Jew—who became the friend, defender, and patron saint of this *misérable* from Smilovitchi (Lipchitz introduced them in 1915). Modigliani made many portraits of Soutine, including a painting now in the Chester Dale Collection at the National Gallery of Art (fig. 24) in which, despite the obviously enormous nose, big lips, and mismatched, almost oriental-looking eyes, Modigliani manages also to convey a kind of poetic beauty in his sitter, that special brand of idealization for which he is justly famous. Particularly in this portrait of Soutine we feel the truth of James Thrall Soby's observations that "the vigor of his [Modigliani's] style burns away over-localized fact," and that, at the same time, "one senses in his finest pictures a unique and forceful impact from the sitter, an atmosphere of special circumstance, not to recur."[32] Unfortunately Soutine never reciprocated by painting Modigliani's portrait; it would have been interesting to see how he saw his friend and self-appointed protector. We do, though, have a portrait of Kisling by Soutine (colorplate XII), in which the sitter with his hands displayed prominently on a table at the lower right is cast into the role of Dr. Gachet, as painted by Van Gogh— an artist whom Soutine claimed to despise, but whose art obviously influenced his work. Even here we feel the legacy of Van Gogh's pigment-heavy brush, as Soutine lays down clear and separate strokes, one atop another.

An even more remarkable portrait by Soutine is that of the sculptor Oscar Miestchaninoff of 1923 (fig. 25), which owes some of its power to Soutine's use of Jean Fouquet's 15th-century *Portrait of Charles VII*, a painting that he called the "greatest picture in the Louvre,"[33] and which was popular with critics and artists in the early 1920s. Surely one of the most compelling aspects of Fouquet's picture for Soutine must have been the expression of fatigue and sadness on the French king's face, conveying an emotional depth that the artist may well have associated with *shtetl* Jews like himself. Charles also has a bulbous nose and prominent lips, both of which Soutine has made exceedingly red in the portrait, in contrast to the intense royal blue of the sculptor's smock. He has also borrowed the frontal pose and clasped hands from Fouquet, as well as the suggestion of a curtain in the upper left, and even the undulating line of the thighs and lap at the bottom of the picture. Modigliani also made numerous portraits of Miestchaninoff, including an especially beautiful drawing (fig. 26) in which the sitter again is endowed with an aristocratic air, in this case conveyed by the elegant Charles X chair in which he sits, by the noble head held high, and, most importantly, by the large, presumably velvet tassel that hangs down just behind his forehead, which can only be for beckoning servants.[34] In fact, Miestchaninoff's humble origins—he was the son of a Jewish shopkeeper from Vitebsk—would seem to render Soutine's regal references and Modigliani's aristocratic ones ironic, but this was not the case. Somehow or other, after attending art school in Odessa, arriving

in Paris in 1906, where he attended both the Ecole des Arts Décoratifs and the Ecole des Beaux-Arts, and embarking on a career as a sculptor, Miestchaninoff managed to become quite rich, to the extent that he was considered rather a *grand seigneur* in Parisian artistic circles, especially among the Jews of Montparnasse. He was an art collector and perhaps a dealer, as well as a sculptor, his most famous work being the *Man in the Top Hat* of 1922 (fig. 27), now in the collection of the Musée National d'Art Moderne, Paris, that was celebrated in its day for its daring juxtaposition of formal hat and gloves and nude male torso (the model for which is supposed to have been Isaac Pailès, another Jewish artist from Montparnasse).[35]

There is an early photograph of Soutine (fig. 28) that may have been taken in Miestchaninoff's studio at the Cité Falguière—the artists' residence and studios located not far from La Ruche—where Modigliani also had a sculpture studio intermittently between 1909 and 1919. (The Cité got its name from Jean-Alexandre-Joseph Falguière, one of France's most famous sculptors in the late 19th century.)

Yet another sculptor at the Cité Falguière was Léon

Figure 25 Chaim Soutine, *Portrait of Oscar Miestchaninoff*, 1923 (cat. no. 102). Musée National d'Art Moderne, Centre Georges Pompidou, Paris

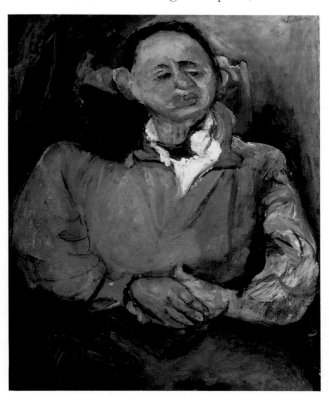

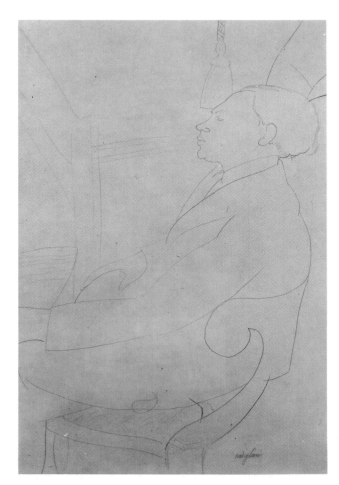

Figure 26 Amedeo Modigliani, *Portrait of Oscar Miestchaninoff*, 1918 (cat. no. 79). The Museum of Modern Art, New York, Gift of Mrs. Donald B. Strauss

Indenbaum (cat. no. 30), another Jew from Vilna and a friend of Miestchaninoff; he settled at the Cité when he arrived in Paris in 1911 but soon moved into La Ruche (where he stayed until 1927). Modigliani also painted Indenbaum, in a sensitive portrait (fig. 30) which bears his name writ large across the top (with the exception of the second "n"), and which makes him—rather like Miestchaninoff—a man whose name we know thanks to Modigliani but whose work has all but disappeared from view.[36] Modigliani also drew a portrait of the sculptor who was certainly the best known of this group, Chana Orloff (fig. 31), although she too is now a mostly forgotten figure. Orloff was born in a small Ukrainian village in 1888; her family emigrated to Palestine in 1905. Five years later she came by herself to Paris, where she was a student at the Ecole des Arts Décoratifs and an excellent wood carver from the start. Her *Equestrian* of 1916 (fig. 32) is one of these works

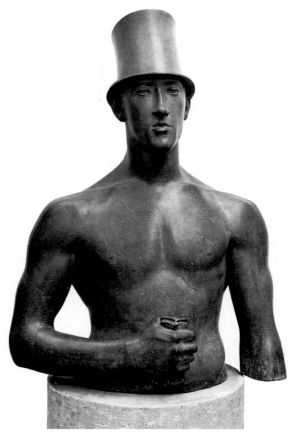

Figure 27 Oscar Miestchaninoff, *Man in a Top Hat*, 1922. Musée National d'Art Moderne, Centre Georges Pompidou, Paris

carving through of the Boulevard Raspail north of the Boulevard de Montparnasse—the café is located on the northwest corner of the intersection of those two thoroughfares—but did not become a major café or a haunt for artists until 1910, when the owner, Victor Libion, considerably expanded the establishment (as Billy Klüver and Julie Martin explain in their essay in this catalogue). Libion, a true friend of artists and a good businessman, did everything he could to attract artists to his café and to keep them coming, ordering foreign-language newspaper for his artistic "tower of Babel"—many of the immigrants could barely read or even speak French when they arrived—and allowing clients to dawdle as long as they chose over even the order of a single *expresso*.

Of course, the Jewish artists with whom we are concerned were only a part, if an important and thoroughly integrated part, of the artistic and literary population that frequented the Rotonde: Chagall, Soutine, Lipchitz, Modigliani, Orloff, Kikoïne, Krémègne, Indenbaum, Miestchaninoff, Kisling, Zadkine, and Pascin (who shuttled back and forth between the Dôme and the Rotonde) were part of a throng that also included Picasso, Léger, Derain, Diego Rivera, Apollinaire, Jacob, Salmon, De Chirico, and Vlaminck, among many others, including Trotsky and some say Lenin as well. Marevna, a Russian, half-Jewish painter, who arrived

Figure 28 Chaim Soutine at the Cité Falguière (?), Paris, n.d.

in wood that in its simplification of forms reminds us a bit of Lipchitz's *Equestrian* of three years earlier, which Orloff may have known. Be that as it may, Orloff's facility and unerring sense of design are evident here and are a prediction of the great success that would come to her in the ensuing years.

Life for the artists of Montparnasse was by no means only a question of work in the dingy studios of La Ruche and the Cité Falguière or the various other places they found to paint and sculpt. This being Paris—and especially considering how poor most of their living quarters were, at least in the early years—the café became an important center for socializing, making professional contacts, and eating meals. And just as the Germans had their café, the Dôme, so the "second-wave" of Jewish artists in Paris, who were for the most part Poles and Russians, had theirs: the Café de la Rotonde. In 1911 President Poincaré officiated at the inaugural ceremonies for the completion of the Boulevard Raspail. The Rotonde had opened after the

RITTER LIBRARY
BALDWIN-WALLACE COLLEGE

in Paris in 1912, and who by 1921 had concluded a
passionate love-affair with Diego Rivera and given
birth to their daughter, has left a quick, on-the-spot
sketch (fig. 33) of the Rotonde. There is also a photo-
graph, probably taken during World War I (fig. 34), of
the crowded, sunny terrace of the café, where we can
recognize among those present Léon Bakst (seated at
the extreme right) and, standing in the back (partly
blocking the sign that announces *choucroute garnie à
toute heure*) Leopold Zborowski, the bearded man in
the tall hat—who was first Modigliani's and then later
Soutine's dealer—and Adolphe Basler, who we first en-
countered as part of the circle at the Dôme. Zadkine,
who made wonderful watercolors when he wasn't busy
sculpting, painted a funny café scene in hieratic scale
(fig. 35), in which a giant guitarist serenades a captive
audience.

Libion's Café de la Rotonde, although it was by far
the most important café for Montparnasse artists by the

Figure 29 Exterior of Soutine's studio at the Cité
Falguière, Paris, 1981.

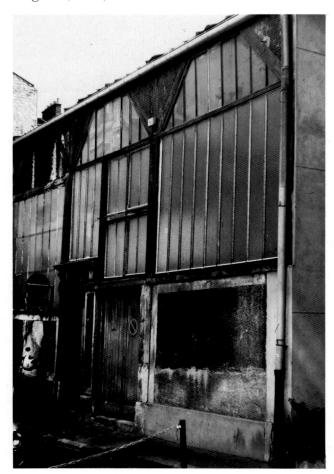

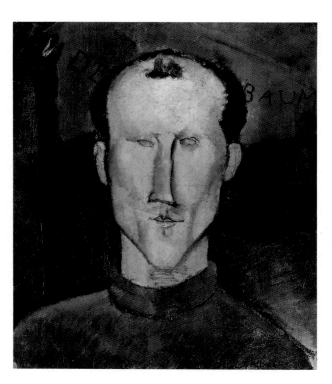

Figure 30 Amedeo Modigliani, *Portrait of Léon
Indenbaum*, 1916 (cat. no. 72). The Henry and Rose
Pearlman Foundation

middle of World War I, also became highly suspect by
the Parisian police during the war as a result of its vast
mixture of foreigners. By 1917, the year that the new
Bolshevik government in Russia withdrew from the Al-
lied cause in order to sign the peace treaty of Brest-
Litovsk with Germany, Libion was being continually
harassed by the police on various imagined charges of
espionage and sedition. The war, needless to say, did
more than simply cause trouble at the Rotonde. All of
a sudden the Germans, including the German and
Austrian Jews, were enemies; as Salmon put it, "the
war had taken away our seven Germans from the
Dôme,"[37] by whom he meant Pascin, Levy, Bondy, and
their friends. Pascin took the *Lusitania* to New York in
October 1914 (and by 1920 had become an American
citizen); Bondy was already in Berlin; Spiro went back
to Germany, where he worked for the army mapping
unit; Levy became a soldier, fought in France, and was
awarded the Iron Cross; Rosam also enlisted in the
Germany army but unfortunately never returned from
the war (he died of wounds in a Russian military hos-
pital in 1916). Kahnweiler, the dealer, sat out the war
in Switzerland; the French authorities had confiscated
his entire stock of art, which they later sold off at auc-
tion in the 1920s (Uhde shared a similar fate).[38] In fact,

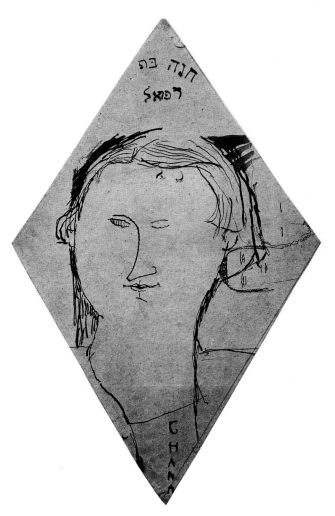

Figure 31 Amedeo Modigliani, *Portrait of Chana Orloff*, 1916 (cat. no. 75). E. Justman Collection, Paris

it was not just the Germans who were suddenly absent from Montparnasse after August 1914. Marc Chagall, who was back in Russia in the summer of 1914, decided to remain there for the duration (after the Revolution he was named Commissar of Fine Arts for the city of Vitebsk). And Mané-Katz, a Ukrainian Jew and son of a synagogue beadle, who had just arrived in Paris the previous year, went back to Russia in late 1914 after having been refused induction into the French Foreign Legion owing to his small stature. Like Chagall, he would return, triumphantly, to Paris in the early 1920s, but not before he was made a professor of fine arts back home.

Several of the foreign Jewish artists volunteered for military service in the Great War, for reasons that ranged from a love for France to a desire to fulfill a

military obligation that would otherwise be required back home—and even, perhaps, the knowledge that serving in the French army would later insure them French citizenship. Zadkine, for instance, went into the army as a second-class stretcher-bearer and worked in various capacities in the medical corps until he was gassed at the front in December 1917 and invalided out of the army. Louis Marcoussis also volunteered, although he was apparently under no military obligation; he may have been inspired by the enlistment of his close friend Apollinaire. On the basis of gouache studies preserved at the Musée des Deux-Guerres in Paris, we know that Marcoussis, owing to his skills as an artist, aided the military in their camouflage efforts (back in Paris, however, his wife Alice Halicka had a rough time of it; as an immigrant from the Austrian-dominated part of Poland, she was harrassed by the authorities: "Female spies were in fashion," she wrote, referring to Mata Hari).[39] Moïse Kisling also volunteered, and we have a photograph of him (fig. 36) with his regiment at the very beginning of the war, in October 1914; Kisling is standing in the center with a ciga-

Figure 32 Chana Orloff, *Equestrian*, 1916 (cat. no. 84). E. Justman Collection, Paris

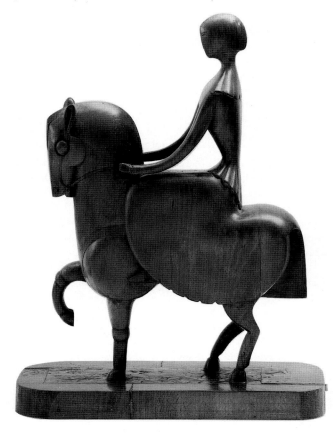

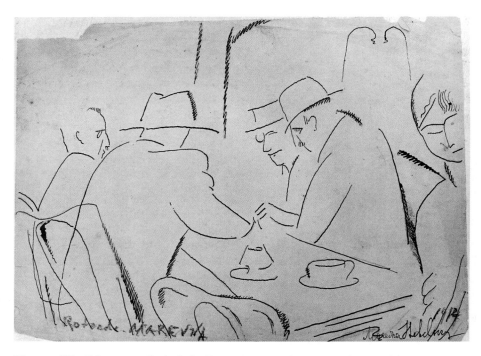

Figure 33 Marevna, *Café de la Rotonde*, 1914 (cat. no. 61). Marika Rivera
Phillips (daughter of Marevna and Diego Rivera) Collection

rette in his hand. After being wounded, he was
honorably discharged in 1915 and was made a French
citizen. His old friend Simon Mondzain was still in the
army, though, in the Light Infantry Division of the
Foreign Legion, where he made drawings of his fellow
soldiers (cat. no. 81) and also became very despondent.
In an exchange of letters with Kisling, Mondzain was
encouraged to keep his spirits up and "above all, not
give in to black thoughts." But "the only thing that
bothers me," Kisling wrote to Mondzain, who was still
in uniform on Bastille Day 1918, "is that you will not
receive the Order of Merit . . . I will squirm with jeal-
ousy that the Markuses [Marcoussis and his wife] will
be decorated and not you, my poor little Hy-
mie." Obviously there was a bit of animosity on Kis-
ling's part toward Marcoussis and Halicka, of whom he
goes on to inquire in the next sentence, "By the way,
what's become of these Markus Jews?"[40] which may be
a reference to what was perhaps the couple's desire "to
pass" as gentiles. In 1920 Mondzain drew what is surely
among the most lugubrious images of the post-war pe-
riod, *Pro Patria*, his homage to the fallen French sol-
diers (colorplate XIII), which he exhibited at the Salon
des Indépendants that year. While a corpse of a soldier
wearing the medallion of Mondzain's own Thirteenth
Regiment lies in a coffin in the foreground, he is at-
tended in a crypt by two mourning women at the right
and at the left by a naked figure of Marianne, symbol

of France, wearing only her Phrygian bonnet and of-
fering a potted rosebush (the rose being the French
national flower). Alongside her is a grave marker
that reads "Pro Patria" and bears the dates
"1914–15–16–17–18." Marevna also made a picture
inspired by the war, an ironic one, in which a soldier
and his girlfriend sit drinking in a café, while wearing
gas-masks on their heads (cat. no. 62).

Interestingly, although wartime France was an un-
comfortable period for resident foreigners, especially
noncombatants, it was also the time when the circle of
Jewish artists in Montparnasse began to make their
presence felt on the Parisian scene. In part, this was a
result of the disarray into which French life in general
and Parisian culture in particular—and the so-called
avant-garde most particularly—were thrown by the war
that was declared in August 1914. The wartime lack of
cohesion and direction in the art world worked to the
advantage of those who had been either outside or on
the fringes of it before the war, creating fresh possibili-
ties and new alliances. Moreover, for the Russians and
Poles particularly, many of whom had come to Paris
around 1912, enough time had elapsed by the mid-war
years that they began to have a foothold in the network
of friendships and financial arrangements that allow
an artist to become successful. For instance, the career
of Kisling, now a certifiably patriotic veteran, began to
blossom after his return from the front. Aside from the

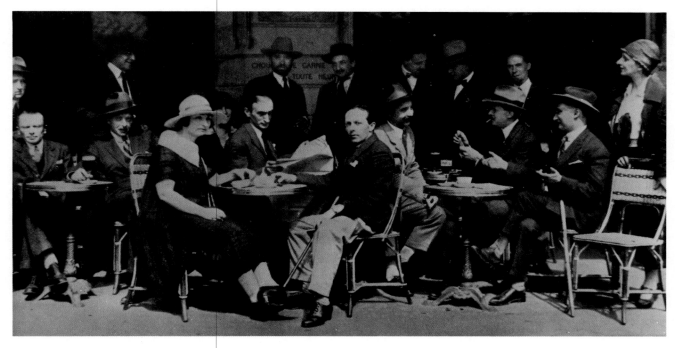

Figure 34 The terrace of the Café de la Rotonde, ca. 1916, Carrefour Vavin, Paris.

unexpected—and perhaps apocryphal—windfall of having been left a legacy of 25,000 francs by an American friend, a sculptor shot down in an air fight, Kisling was also featured in a group exhibition organized by the artists' association Lyre et Palette on the Rue Huyghens. At the very same moment, Zborowski organized Modigliani's first one-person exhibition, from December 3 to 30, 1917, at Berthe Weill's gallery on Rue Taitbout in the ninth arrondissement, which resulted in a minor scandal, although perhaps one that in the long-run may have helped Modigliani's reputation. On the basis of a painting that was hung in the gallery's window, a quite lascivious nude, the police demanded that it and four other pictures be removed from the show. The next year Lyre et Palette sponsored an exhibition that united Kisling, Modigliani, and Zadkine. As we've already said, in the very midst of the war, in 1916, Lipchitz entered into a contract with the dealer Léonce Rosenberg, and Chana Orloff was featured both in an exhibition at the prestigious Galerie Bernheim-Jeune in 1916 and in a show that she organized in her own studio in 1917, with the title *Sic Ambulant*. Things were beginning to happen for the foreigners.

Be that as it may, the post-war era began with two formidable shocks for the Parisian avant-garde: First, two days before the Armistice, Guillaume Apollinaire died (of head wounds sustained in combat); and then, especially painful for the Jewish artists of Montparnasse, came Modigliani's death (of a tubercular condi-tion exacerbated by alcohol and drugs) on January 24, 1920, followed the next day by the suicide of his mistress Jeanne Hébuterne. On January 27, Modigliani was buried, with a short Jewish ceremony, at Père-Lachaise Cemetery, where, according to one source, the mourners included Jacob, Kisling, Salmon, Soutine, and Lipchitz, as well as Picasso, Léger, Derain, Vlaminck, Foujita, Brancusi, and Zborowski. Lipchitz recalled that at that moment, "everyone felt deeply that Montparnasse had lost something precious, something very essential," and it may have been for that reason that Kisling, and Conrad Moricand, a friend, attempted to make a death mask of the artist. Unfortunately, they botched the job and had to bring in Lipchitz to help, by both putting the bits and pieces of plaster together and also restoring the missing parts. He eventually made twelve plaster molds that were distributed among friends (cat. no. 52).[41]

By October, Montparnasse was offered a certain degree of solace in the return to Paris, after his peregrinations in America, of Pascin, who promptly took up where he'd left off in 1914. For many—and more so than ever in the 1920s—Pascin was the very symbol of Montparnasse (despite the fact that he was now living on the Boulevard de Clichy, on the Right Bank). Warnod called him "the latest incarnation of the Wandering Jew", and felt that "if we had to designate a single painter capable of representing all the lively forces that animate Montparnasse,"—this was in 1925—"there

would be no hesitation. We would name Pascin."[42] At the lower left-hand corner of a photograph (fig. 37), a man who may be Pascin sits with a girl on his lap at one of the costume parties (this one at the Maison Watteau, on the Rue Jules-Chaplain) for which Montparnasse was so notorious. (Renée Kisling is also standing near the center, in a checked cap, a cigarette dangling from her lips, and leaning against a man in white, with Moïse just barely visible behind; Zadkine is seated on the floor, in the front row, with a scarf around his neck; the critic Florent Fels sits just behind him, with exposed shoulder and arms, wearing what seems to be a Chinese hat, and thick eye makeup over which he has put his eyeglasses!) This may well have been one of the balls arranged by the Union of Russian Artists, an organization in Montparnasse established for the mutual aid of Russian emigrés.[43] It is also probably for a party like this that Pascin made his large picture *Socrates and His Disciples Mocked by the Courtesans*, done in oil, gouache, and crayon on paper, mounted on canvas (fig.

Figure 36 Moïse Kisling (standing front center, holding cigarette) with his regiment in the French Army at the beginning of World War I, October 1914. The photograph is inscribed "to Mademoiselle Frida Herzberg."

Figure 35 Ossip Zadkine, *The Guitar Player* (*On the Café Terrace*), 1920 (cat. no. 110). Musée d'Art Moderne de la Ville de Paris

38), a kind of tongue-in-cheek send-up of "history" painting (a combination of David's *Death of Socrates* and Rubens *Three Graces*) in which the Three Graces in the center—here prostitutes—dancingly tease the high-minded, naked, and gay assembly of philosopher and followers at the left. Not that all of the abundant sexuality of Pascin's art is funny. We sense, for instance, in his *Model in the Studio* of 1926 (cat. no. 97) what Leo Steinberg has called "the artist's poetry of decadence," wherein "the disrobing of those weary bodies reads as a dismantling of the will."[44]

Again it was Warnod, the most generous of French critics and decent-minded of observers, who sensed that by the mid-1920s Montparnasse had truly become an international city within the already cosmopolitan context of Paris. The term "The School of Paris"—used specifically *not* to designate French painting made by Frenchmen (as it is now loosely used) but rather art made in Paris by foreigners (see Romy Golan's essay in this catalogue, "The *École Française* vs. the *École de Paris*")—is already invoked by Warnod in 1925, and in a well-known book of that year he begins by defending

ERRATA

p. 27, fig. 19 caption; and p. 124, catalog #77; should read:
Portrait of Michel Kikoïne

p. 41, figs. 39 and 40; p. 124, catalog #87; and p. 125, catalog #96;
should read: *Accordionist*

p. 81, line 1: *Française*

p. 83, line 9; should read: *the Spenglerian title . . .*

p. 108, Morice Lipsi entry, line 9; should read: *Chevilly Larue*

p. 117, Eugène Zak entry, lines 8 and 9; should read: *From 1914 to 1916,
Zak stayed in the south of France, in Nice and in Vence.*

p. 122, catalog #33; and colorplate IX; replaced with:
George Kars
The Bathers, 1912
oil on canvas
31¾ x 39½ in. (80.7 x 100.3 cm.)
Tiroche Gallery, Tel Aviv

p. 122, catalog #35: not in exhibition

p. 123, catalog #48: not illustrated

p. 123, catalog #49: not in exhibition

Much generous support for the exhibition was made known after this catalogue
went to press. Sara Lieberman is gratefully acknowledged for taking on the co-
chairmanship of the Minnesota Committee. A major grant was made by the New
York State Council on the Arts.

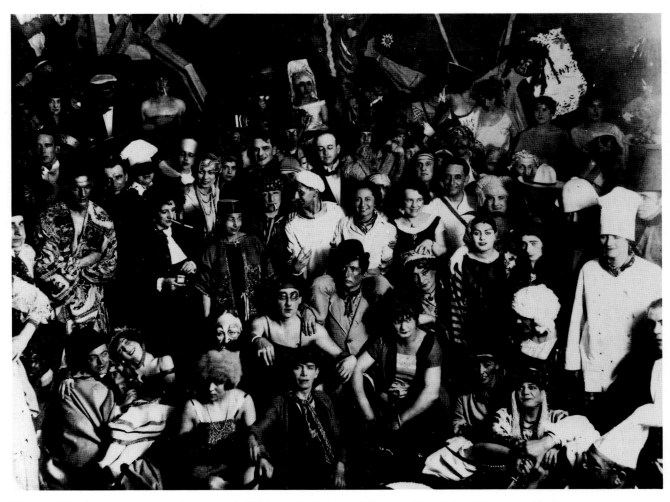

Figure 37 A costume party in the mid-1920s at the Maison Watteau, Rue Jules-Chaplain, Paris.

the foreign "invasion" and exalting Paris for hosting the visitors:

> The School of Paris exists [for] many reasons, which have nothing to do with the Fine Arts, [and] mean that Montparnasse is peopled with men and women of all nationalities . . . Can one consider undesirable the artist for whom Paris is the promised land, the blessed land of painters and sculptors? . . . Ought we reproach them who carry nothing other in their baggage than the will to enrich their art with what they will find here? . . . Besides, it is difficult to say what the foreigners take from us and what we take from them.[45]

Indeed, these foreign Jews created many of the most characteristic Parisian works of the inter-war years, like

Pascin's portrait of the writer Pierre Mac Orlan (fig. 39) who, with the ever-present cigarette dangling from his Gallic lips, plays his accordion, the music of which is to this very day considered the working-man's music *par excellence*. In fact, accordeonists abound in the art of Montparnasse in the 1920s: Lipsi portrayed them several times (cat. no. 58) and one of Orloff's most famous works is a large, seated *Accordeonist* (fig. 40) of 1924 which in a very real sense (and not unlike Pascin) matches a popular subject with a popular style. Where Pascin carries Impressionism—especially the art of Renoir and Cézanne—forward into the 20th century by adopting with great panache the movement's lightness of touch but leaving behind its divisionism (really creating a palatable "academic" Impressionism), Orloff makes a popular art out of Cubism, as any number of others were at that time trying to do (if much less well). In the *Accordeonist*, for instance, she has taken a struc-

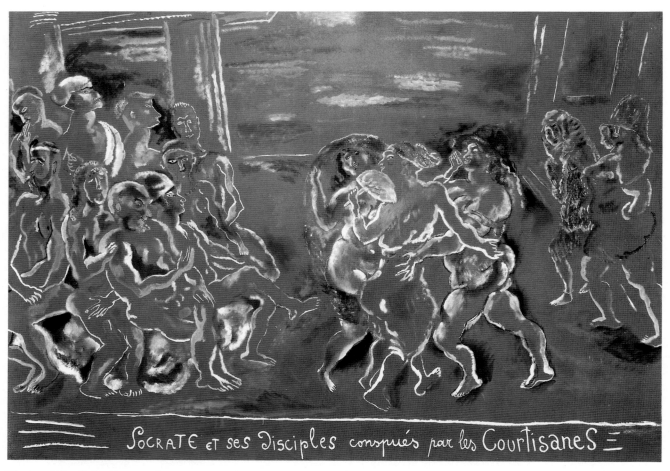

Figure 38 Jules Pascin, *Socrates and His Disciples Mocked by the Courtesans,* ca. 1921 (cat. no. 95). The Museum of Modern Art, New York, Given anonymously in memory of the artist.

tural toughness from the Cubists—the powerful planar conception of form—and left to others, like Lipchitz, the movement's more intellectually challenging aspects. Orloff's enormously appealing sculpture is to Cubism what Art Deco architecture was to Le Corbusier's work, a popular recasting of a difficult art. It is perhaps not surprising that Orloff had great success, as did Zadkine and other foreign artists, at the famous Art Deco fair (the *Exposition Internationale des Arts décoratifs et industriels modernes*) of 1925.[46]

Orloff's *Accordeonist* is, like Pascin's, also a portrait, in this case of the Norwegian artist Per Krohg (son of Edvard Munch's friend Christian Krohg), who might well have been forgotten had not his wife Lucy (née Vidil) become Pascin's lover. Pascin, of course, was married himself, to Hermine David, whose face we know so well from the painter's numerous portraits of her (cat. no. 94), in which her eyes are always averted from us. Although these portraits of a woman with

downcast eyes tend to convey a sense of melancholy and excessive modesty—which may well have been part of Pascin's artistic intention—the truth is that Hermine David was apparently quite lively, despite having to share her husband with Lucy Krohg, and that her averted gaze was due to a severely damaged eye (her right); one can see the impairment in many photos. Perhaps all of this would not be worth mentioning except that these two couples were at the very center of so much that happened in Montparnasse. For instance, the Krohgs, who had a certain reputation back in Sweden as a professional dance team, had fallen in love while dancing at the Bal Ballier.[47] This seems like a Montparnasse story *par excellence,* reminding us of Orloff's *Dancers* of 1923–24 (colorplate XIV), one of her most successful works, which, in turn, makes us think of Léger's essay of 1925, "Popular Dance Halls." Here the Cubist painter says that "Dance, like all other national qualities, is exclusively the domain of the

of his last, for by 1922 Hayden had returned to very traditional, illusionistic rendering—*The Three Musicians* of 1920 (colorplate XV). A large work, nearly six feet square, it features a banjo player, clarinetist, and guitarist and is often cited as an inspiration for Picasso's two *Three Musicians* paintings of the following year.[49] In fact, although Picasso himself had moved to the high-rent area of the Right Bank in 1918, Montparnasse more than ever was learning to accommodate the throngs: In 1924 the Dôme and the Rotonde were renovated and enlarged; also that year the Select opened on the same side of the Boulevard de Montparnasse as the Rotonde and just a few steps west of it (the Select is still preserved with its Art Deco interior intact); and most conspicuously, a mammoth eatery called the Coupole (fig. 42)—still Paris's biggest restaurant—opened fifty meters from the Dôme (see Klüver and Martin's

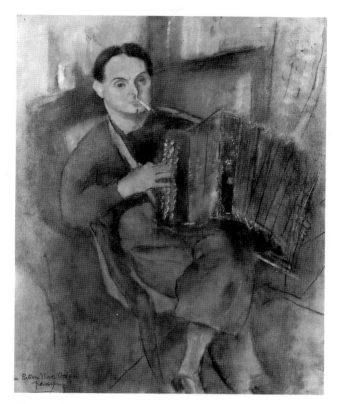

Figure 39 Jules Pascin, *Portrait of Pierre Mac Orlan* (*The Accordeonist*), 1924 (cat. no. 96). Perls Galleries, New York

Figure 40 Chana Orloff, *The Accordeonist* (*Portrait of Per Krohg*), 1924 (cast 1929) (cat. no. 87). Galerie Vallois, Paris

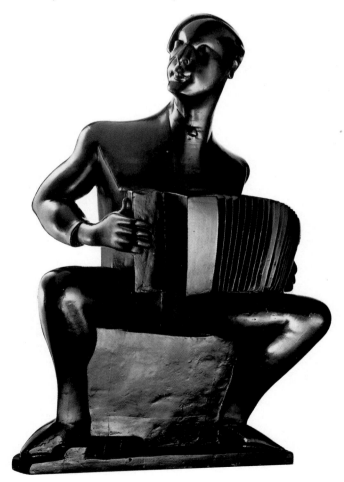

masses,"[48] and goes on to extol the virtues of the *bals populaires*, where one might see a couple like Orloff's—a sailor and his sweetheart. An altogether different conception is that conveyed in *The Dancer* of 1921 (fig. 41) by Eugène Zak, a Jewish painter from Mogino, Russia, who had settled in Paris in1904. Here the dancer is not a man of the people out for a Saturday night on the Rue de Lappe, but a pixyish stage performer prancing about in a role that eludes us. Zak, unfortunately, died of a heart attack at the age of forty, in 1926, but his wife went on to become, with her Galerie Zak, one of the best-known art dealers on the Left Bank.

It should not surprise us that Montparnasse in the 1920s—a decade that Americans call "Roaring" and the French refer to as *les années folles* (the crazy years)—begat so much art about music and dancing, for these were the popular forms of entertainment for an era and for a neighborhood that was rapidly becoming a major tourist attraction of Paris. Henri Hayden has left us, for example, two of these Jazz Age images: a watercolor of the *Cabaret Boum-Boum* (cat. no. 28), in which we see a black (probably American) trio at the upper left; and his most famous Cubist painting—one

essay). Fraux and Lafon, former managers of the Dôme, hired the architect Le Bouc and the interior designer Solvay, to create the enormous space with a huge central cupola, from which the restaurant took its name (and which was obviously meant to create a symmetry with the "Dome" and the "Rotunda"). On opening night, December 20, 1927, before the restaurant closed its doors at 5:00 A.M., the invited guests—seemingly all of the artistic community of Montparnasse—had consumed, according to one source, 10,000 canapés, 3,000 hard-boiled eggs, 1,000 pairs of *saucisses chaudes*, and 800 cakes (the champagne ran out early).[50] Just as it remains to this day, the Coupole was from the very start a crossroads and common ground for the unknown and the famous, the lower middle-class and the *haute bourgeoisie*, the artistic and the philistine, all of whom gazed upon murals and columns decorated by a huge team of Montparnasse artists that included Isaac Grünewald and Georges Kars. Of course, the new cafés and restaurants near the Carrefour Vavin did not replace the old haunts (the French

Figure 42 La Coupole, Boulevard de Montparnasse, Paris, 1984. (Photograph by Kenneth E. Silver)

Figure 41 Eugène Zak, *Dancer*, 1921–22 (cat. no. 113). Petit Palais, Geneva

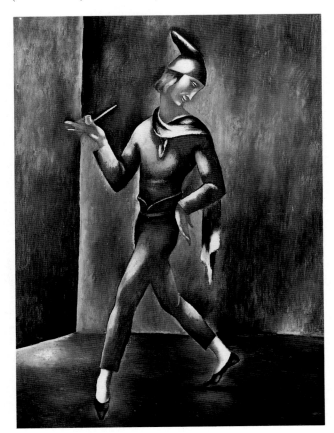

are notoriously loyal *fréquenteurs*); the Closerie des Lilas, for instance, further down the Boulevard de Montparnasse, near the Jardin de l'Observatoire, was as popular as ever. There is a photograph taken at a luncheon in honor of the painter Georges Rouault around 1925 (fig. 43), that in its gathering of personalities indicates how major a role Jews had come to play in the cultural life of Montparnasse, and how thoroughly integrated these artists and critics were in that Parisian milieu. From the bottom row, seated, we can identify: Juliette Roche Gleizes (wife of painter Albert Gleizes), Madame Florent Fels (in a Sonia Delaunay dress), Madame Marcel Gromaire, Georges Rouault, and Bela Chagall (the Chagalls returned to Paris from Russia in 1923); second row: Jean Crotti, Louis Marcoussis, Alice Halicka, Léopold Lévy (see Romy Golan's essay in this catalogue for Léopold Lévy and Simon Lévy), and Waldemar George; top row: Georges Duthuit, Simon Lévy, André Favory (a Cubist painter), Jacques Lipchitz, André Salmon, André Lhote, Madame Lhote, Florent Fels, and Marc Chagall.

As is already apparent, portraiture was an important genre—in some sense the typical genre—of the art made in Montparnasse between the wars. In part this was for the same reasons that portraiture always seems to survive the vicissitudes of artistic taste: Vanity springs eternal and will accommodate itself to even the least flattering of styles if that's what it takes to get one's portrait painted. (Besides, in the 1920s, certain con-

Figure 43 A banquet held in honor of Georges Rouault at the Closerie des Lilas, Boulevard du Montparnasse, Paris, probably 1925. Among those who attended were (left to right): (BOTTOM ROW): 1. Juliette Roche Gleizes 2. Mme. Fels in a Sonia Delaunay dress 3. Mme. Gromaire 4. Georges Rouault 5. Bella Chagall (MIDDLE ROW): 6. Jean Crotti 7. Louis Marcoussis 8. Alice Halicka 9. Léopold Lévy 10. Per Krohg 11. Le Corbusier(?) 12. Waldemar George (TOP ROW): 13. Georges Duthuit 14. Simon Lévy 15. André Favory 16. Jacques Lipchitz 17. André Salmon 18. André Lhote 19. Florent Fels 20. Marc Chagall

tracts between painters and galleries contained a clause that excluded portraits from the galleries' financial claims—in effect the artist was a free lance where portraits were concerned.) Moreover, in a period that can rightly be called the century's first "post-modern" moment—after the innovative heyday of the pre-war period—portraiture seemed an appropriate subject (conservative but not ostentatiously *retardataire*) for the "return to tradition" so widely heralded in Paris in the 1920s. Lipchitz's *Portrait of Gertrude Stein* of 1920 (cat. no. 51) is a striking case in point, almost shockingly naturalistic is it in comparison to the Cubist *Head* of 1915 (fig. 13). Kisling's portrait of *Kiki in a Red Dress* (fig. 70), a picture of one of the legends of Montparnasse (she was an artist's model and singer, and Man Ray was one of her lovers), represents no such striking transformation in Kisling's art, but rather a mannered version of his own "solid painting" of his earlier years. (This latter style eventually became the inspiration for countless paintings of big-eyed waifs of Montmartre street-art fame, which in turn became an "interna-

tional style" that still thrives.) The painter Abraham Rattner, an American Jew who arrived in Paris from Philadelphia in 1921, made a quite touching portrait of his wife *Bettina Bedwell* in 1925 (fig. 44), when she was a fashion journalist; while another young Jew, a recent arrival from Poland, Sigmund Menkès, painted a portrait of a couple who look obviously Russian (cat. no. 65), in the slightly inflated-figure mode for which he was quite well-known in the 1920s.

By the end of the 1920s, portraiture had become a kind of epidemic in Paris, with a very funny story to mark its decline. In the spring of 1929, the "Abramovicz brothers," motion-picture impresarios, arrived in Paris with their latest star from Germany, Maria Lani, a stage and film actress. They were not looking for work for the great Lani (she was presumably already overbooked in Berlin and Hollywood); they were looking for artists to paint and sculpt her portrait because the star was a great connoisseur of art (and was beautiful, as well). Without much difficulty, despite the fact that no one had ever heard of Maria Lani, the Abramoviczes and the star convinced fifty-one well-known Parisian artists to make her portrait without charge. The Galerie

Figure 44 Abraham Rattner, *Portrait of Bettina Bedwell*, 1925 (cat. no. 98). Esther Gentle Rattner Collection

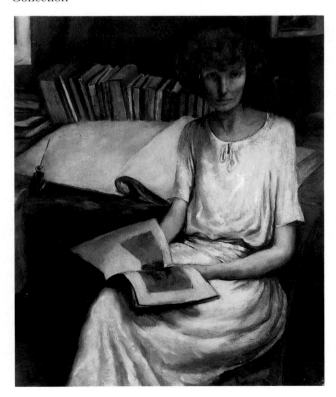

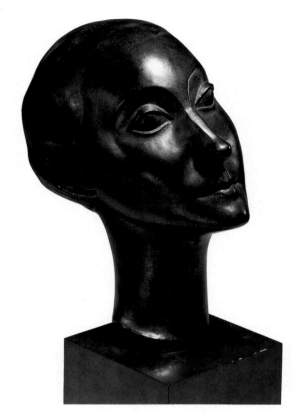

Figure 45 Chana Orloff, *Portrait of Maria Lani*, 1929 (cat. no. 90). Mount Holyoke College Art Museum, Gift of Mrs. Randall Chadwick

Bernheim-Jeune organized an exhibition of all the works, which took place in November 1930, accompanied by a deluxe catalogue, fully illustrated, edited by Jean Cocteau, Mac Ramo, and Waldemar George. Along with portraits of Maria Lani by artists like Bonnard, Braque, De Chirico, Cocteau, Hermine David, Delaunay, Derain, Dufy, Foujita, Per Krohg, Léger, Lhote, Matisse, Ozenfant, Picabia, and Van Dongen, were portraits by Chagall (he painted Maria Lani with a Nefertiti hairdo that contains the Eiffel Tower!), Kisling, Marcoussis, Max Jacob, Orloff (fig. 45), Pascin, Soutine (fig. 46), and Zadkine. But this was not the end of the story. It was soon discovered that the reason no one had previously heard of Lani was not because Paris was so out of touch with events in Germany, but because she was nothing but a stenographer from Prague, and the Abramovicz brothers were actually the stenographer's brother and her husband. By the time that the discovery was made, however, the threesome had fled to America with all the fifty-one-plus portraits (some artists had made several pictures of Lani). The French are right—those were "crazy years."[51]

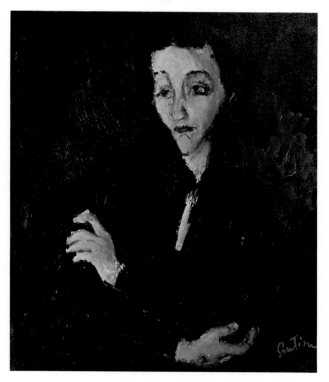

Figure 46 Chaim Soutine, *Portrait of Maria Lani*, 1929 (cat. no. 104). The Museum of Modern Art, New York, Mrs. Sam A. Lewisohn Bequest, 1954

They were also years in which a tremendous amount of money changed hands in the Parisian art world, truly a "boom" in the market in which not only the dealers but also the artists got rich. And not just the famous ones: Max Jacob, who was not even *supposed* to be an artist nonetheless had contracts in the late 1920s and early 1930s with two important galleries, Percier and Georges Petit, to sell his gouaches (fig. 47). Warnod noted in 1925 that "In Montparnasse, one sees people bothered by questions that, in Montmartre, didn't even exist. I'm talking about the love of money and of a taste for bargaining and making deals. On the terraces of the cafés one hears as much discussion of the price of pictures as of artistic value. One traffics, does business, talks profits, brokerage, commissions. It's [now] a part of artistic bohemia."[52] Halicka put it this way about the 1920s: "What painter didn't have or wasn't on the point of buying a car? New streets sprang up in which the artists lived in town houses in the style of Le Corbusier and Mallet-Stevens. The painters carried themselves like nouveaux-riches, talked lots about country property, makes of cars, jewels they'd given to their wives, etc."[53] And she ought to have known: She and Marcoussis were for a long time patronized by Helena Rub-

instein, the cosmetics mogul, who bought a lot of art in Paris between the wars.

Actually, Halicka's remarks were not random observations but quite specific references to artists of whose prosperity she appears to have been resentful, for whatever reason. In 1924 Lipchitz and Miestchaninoff did in fact commission Le Corbusier to build twin (attached) studio-houses (fig. 48) in the Parisian suburb of Boulogne (photographs of which were featured in Johnson and Hitchcock's "International Style" exhibition and catalogue of 1932 at the Museum of Modern Art), just as in 1926 Orloff commissioned a much less expensive but still quite elegant studio-house from Auguste Perret (fig. 49) on the street called Villa Seurat in Montparnasse—one of the many new streets that Halicka says had "sprung up" to accommodate the newly rich artists, like the Rue Mallet-Stevens in the sixteenth arrondissement. There is a photograph (fig. 50), taken at Orloff's house, in which the sculptor (on the right), sitting awkwardly in a fancy dress, seems to be trying to entertain her friends Olga Sacharoff and an even more awkward-looking Chaim Soutine who, for a brief time, was a neighbor of Orloff's in the Villa Seurat (we can also see a watercolor by Pascin and an oil painting by Georges Kars on the wall behind).

Indeed, the story of Soutine's sudden fame and fortune (or at any rate, a brand-new financial stability) is the stuff of which a young artist's dreams are made. Given his poverty-stricken origins and his famous neglect of his toilette, it was all the more remarkable that

Figure 47 Max Jacob, *At the Opera*, ca. 1930 (cat. no. 32). Musée National d'Art Moderne, Centre Georges Pompidou, Paris

Soutine of all people should become the "chosen" of the Parisian art world. And it all happened quite easily: Dr. Albert C. Barnes, wealthy American inventor (of the patent medicine Argyrol) and art collector-founder of the Barnes Foundation in Merion, Pennsylvania, came to Paris in the winter of 1922–23, where he saw a painting by Soutine at the shop of his Parisian art consultant, Paul Guillaume. He then proceeded to buy all the Soutines he could get his hands on, thereby also creating a market for the work of the artist, the demand for which continued more or less steadily. (Barnes also commissioned five reliefs from Jacques Lipchitz, in 1922, for installation on the exterior of the Foundation.) From this point on Soutine was basically solvent and launched toward respectability. Meistchaninoff gave him a book on grooming, *L'Homme du Monde*,[54] and we note that Soutine almost always looks well turned out in the later photographs; he was able to indulge himself in fairly constant travel in the south of France and other regions (as well as to Amsterdam, where he would go to see the Rembrandts); and beginning in 1927 he was taken care of and partly supported by the wealthy French couple Marcellin and Madeleine Castaing, summering at their house near Chartres in the early 1930s.

It is worth pointing out the context in which Soutine's art was received by the public and sold by the dealers. Guillaume—Barnes's man-in-Paris and the major dealer and collector of Soutine there—collected a broad

Figure 49 Auguste Perret (architect), house built for Chana Orloff in the Villa Seurat (a newly created street in Montparnasse), Paris, 1926.

Figure 48 Le Corbusier and Pierre Jeanneret (architects), twin studio-houses built for Lipchitz and Miestchaninoff, Boulogne-sur-Seine, France, 1924.

range of late-19th- and early-20th-century art made in Paris, in addition to Soutine, including a good deal of Cézanne and Renoir, as well as Matisse, Picasso, and others. The two largest holdings were in Modigliani and Derain, the latter being considered at that time the leading exemplar of the pure French tradition. What is interesting is how Soutine appears in this group (which can currently be seen in the installation of the Jean Walter and Paul Guillaume Collection at the Musée de l'Orangerie, in Paris), a sampling that gives us a fairly accurate idea of what was thought to constitute "French

Figure 50 Chana Orloff (right) entertaining Olga Sacharoff and Chaim Soutine at her house, in the Villa Seurat, Paris (n.d.) © S.P.A.D.E.M., Paris/V.A.G.A., New York, 1985

art" in the broadest sense during the boom years of the late 1920s.[55] Aside from the Frenchmen Renoir, Derain, et al., there are the foreigners. In the case of Modigliani and Picasso, it is obvious that it is their "classicizing" bent that qualified them for Guillaume's taste and for his conception of great French art (Guillaume collected only Picasso's classical works, from around 1905 or from the 1920s; there is but one marginally Cubist still-life from 1917). But what is Soutine, the Expressionist, doing here? More or less the same thing that Utrillo, Henri Rousseau, and Marie Laurencin are—he is one of the "primitives" in this context, a maker of painterly *images d'Epinal*, the old folk-prints so beloved of the French. Furthermore, although everyone knew that Soutine was Jewish, he never painted a single specifically Jewish picture in his entire career. As a result, within the framework of Guillaume's classicizing French taste, Soutine's art looks eminently French, like the work of a provincial peasant painter, and the subjects confirm this: landscapes, still-lifes, servants (maids, butlers, pastry-chefs), and even little First Communion girls and choir boys (fig. 70).[56] In effect, the *shtetl* boy from Smilovitchi had transformed him-

self into a kind of still-rough-around-the-edges local hero with a foreign accent, his art a manifestation of the civilizing power of French culture and the nourishing capacity of *la terre de France*.

Which is not to say that the art of Soutine was uniformly admired. Pascin thought that painters of Soutine's quality were a dime-a-dozen: "There's a genius like that in every ghetto,"[57] he told Salmon. Basler, also Jewish, considered it nothing but "gloomy impasto, muddy material, greasy sweepings," and referred to it as *Schmiermalerei*—smeary painting—that represented Soutine's translation of the most uncouth aspects of ghetto life.[58]

It should be said in Basler's defense, though, that he did not dismiss Jewish painting that proclaimed itself as such, and in the 1920s in Montparnasse there were several artists known for their Jewish subjects.[59] Chagall was the most famous of these, and the lovely gouache of 1925, *Jew with Torah* (fig. 51), was the kind of memory picture for which the artist was justly renowned. Halicka owed her reputation chiefly to the pictures she painted of ghetto life (fig. 52), which were inspired by a post-war voyage home to Poland. But

perhaps more than anyone else it is Mané-Katz, the son of a synagogue beadle from the Ukraine, who represents the Jewish artist of Montparnasse in the fullest sense. At any rate, his painting *Homage to Paris* of 1930 (colorplate XVI), a picture that at first glance seems to conjoin two utterly incongruous elements—in the foregound, a Hasidic Jew with long *peyes* (sidelocks), wearing *tallit* (prayer shawl) and *tefillin* (phylacteries), and with prayer book held high, and behind him, the Place de la Concorde and the Eiffel Tower—becomes with some familiarity a very moving image: for in its *schmiermalerei* style, it enunciated as clearly what it meant to be a successful Jewish artist in Paris in 1930 as Chagall's *Paris Through the Window* evoked what it felt like to be a newcomer there in 1913, the very year that Mané-Katz himself had arrived. Now, nearly two decades later—three years after the artist's having been made a French citizen and just over a year after his first visit to Palestine—his Jewishness is proclaimed in a forthright way and on a monumental scale, in order to bless *la ville de Paris* and all it means,

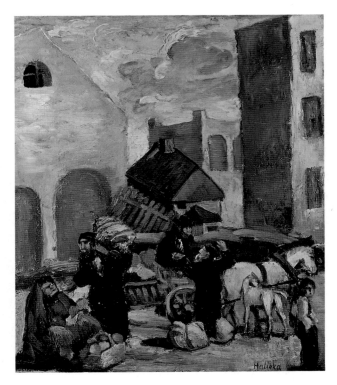

Figure 52 Alice Halicka, *The Jewish Quarter, Cracow*, ca. 1920–26 (cat. no. 23). Petit Palais, Geneva

Figure 51 Marc Chagall, *Jew with Torah*, 1925 (cat. no. 9). The Tel Aviv Museum, Gift of the artist, 1931

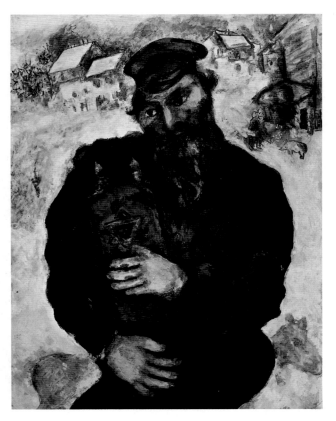

from art and culture (the sculpted fountain of the Concorde in the front) to modernity (the tower on the horizon). And something even larger is receiving the benediction as well. The critic J. M. Aimot explained in 1933 that "a full and complete understanding of the *Homage to Paris* is only possible with a perfect comprehension of this state of mind so common among young Jews enthralled by the French Revolution," what he refers to as "the France of Michelet and Victor Hugo." Aimot goes on to point out that the protagonist of the painting holds in his hand "the Book whose cult is permitted here," and this, of course, is the key, that for Jews like Mané-Katz, Paris was still the great symbol of religious and political freedom, the nation of "Liberty, Equality, Fraternity."[60] Besides, for Mané-Katz, Paris had also turned out to be the Land of Opportunity: He made a healthy income from the sale of his pictures, enough so that he could become the proud occupant of the studio that had belonged to the celebrated academic painter William-Adolphe Bouguereau.

Still, these kinds of Jewish pictures were rare; most Jewish artists in Paris, consciously or not, avoided specific reference to Jewish things. (For that matter, with very few exceptions the Parisian avant-garde had long

Figure 53 Léon Zack, *Mother and Child*, 1935 (cat. no. 109). Musée National d'Art Moderne, Centre Georges Pompidou, Paris

though it is true that few Jewish artists made Jewish paintings or sculpture in Paris, nevertheless by the end of the 1920s self-consciousness about Jewish identity— in the positive sense—was at its peak. For instance, between about 1928 and 1930 a series of inexpensive, portable, but well-produced monographs appeared on the Jewish artists of Montparnasse, titled simply "Les Artistes Juifs," published by Le Triangle. Each book featured on its cover either a photograph or a portrait of the artist, and contained a short interpretative essay (by the likes of Florent Fels and Waldemar George) and a group of reproductions of the artist's work. Many of the artists we have been discussing, both better-known and less-known, had a volume in the series devoted to them.

On the other hand, the new decade began for the Jewish artists much as the last had, with a tragic death.

Figure 54 Jacques Lipchitz, *Mother and Child*, 1915 (cat. no. 50). Marlborough Fine Art, London

before forsaken religious subjects, like mythological and historical subjects, as hopelessly old-fashioned.) What we do find, though, is a kind of halfway-house iconography, located at a middle point between the secular and the religious and between the Christian and the Jewish as well: specifically, the subject of mother-and-child (what the French call *maternité*). As a subject that touches everyone, the theme of mother-and-child is a perennial one in the history of art; especially for the artist, compelled by esthetic creation, the fact of biological fecundity has always stood as a mirror and a challenge to his, or her, capacity for esthetic creation. But especially for the Jewish artists of the early part of this century, this theme at once established their place in the chain of the history of art—the Christian version being, of course, a key image in all art since the Middle Ages—and at the same time represented no literal trespass onto that cultural terrain. As a result, we find artists of the most varying sensibilities treating the theme: from Eugène Zak (cat. no. 114); to Léon Zack, a Russian Jew who had only moved to Paris in 1923 (fig. 53); from Orloff (cat. no. 85) to Modigliani (cat. no. 70); and not least of all, Lipchitz (fig. 54), who made a study for a Cubist sculpture *Maternité* in 1915. Al-

This time it was Pascin—he of the Dôme, of all the money, and the parties, and the wives and girlfriends, and the champagne, and the countless paintings of it all. If reports are to be believed, it was almost as devastating as Modigliani's death had been ten years before, mediated perhaps a bit by the fact that Pascin was forty-five rather than thirty-six. But the death was really much worse, and no one expected it. On June 2, 1930, shortly before a major exhibition of his work was to open at the Galerie Petit, Pascin slit his wrists and with the blood wrote "Adieu, Lucy" (his lover Lucy Krohg) on the back of the door. Then, the old Roman way of death not having proved fast or effective, he hanged himself. Three days later Lucy broke down the door of the studio and finding him there, laid him out beneath one of his own paintings, *The Raising of Lazarus*. He was buried at St.-Ouen cemetery after a short service at which Scholem Asch and André Salmon spoke the euologies.[61]

It was a bad beginning for what proved to be, as we all know, the darkest moment in the history of the Jews. But in Paris, that came gradually. First came the impact of the American stock-market crash, not felt in Paris until about 1931 but which effectively ended the heyday of the art market. To be sure, the art scene by no means came to a halt—most of the artists who had reputations by this time either continued to thrive or at least managed to get by. Yet the city was no longer a magnet. Artistic emigration to France's capital dwindled; exhibitions were fewer, purchases less frequent. Since most of the Jewish artists of Montparnasse were by this time French citizens, they simply went about their lives as Parisian artists, the only difference being the sense that the expansiveness of the 1920s had come to an end. A few, such as Marcoussis and Halicka, went where there was a prospect of work and money; in 1935, these two went to New York, where Helena Rubinstein had arranged for the couple to design theater sets and costumes for a few years. When in 1929 Basler published his collection of essays *Le Cafard après la fête (Down in the Dumps after the Party)*, it was truly prescient.

For the Jewish artists of Montparnasse, as for all European Jews, events in Germany soon overshadowed everything else. Hitler came to power in January 1933, at which point the systematic persecution of the Jews began. This in turn led to a mass exodus of Jews— those who could manage to get out of the country— mostly to neighboring nations, and especially to France, which most Jews still saw as Mané-Katz pictured it in 1930, a place of freedom and asylum. For those German-speaking Jews from the old days at the Café du Dôme, of course, the departure from Germany and Austria was also a homecoming: in 1933 Rudolf

Figure 55 Léon Blum, 1939. Blum was premier of France in 1936–37.

Levy came back briefly to France before settling in Italy (where he had close friends) and Eugen Spiro returned to Paris. At the first signs of dangerous anti-Semitism, in 1931, Walter Bondy went to Switzerland before also settling again in France, but in the south at Sanary (on the coast near Toulon), where the Kislings had a house and where many German refugees, like the best-selling Jewish author Lion Feuchtwanger, were now living.[62]

Soon, however, the problems of the displaced German Jews began to impinge on the lives of the French Jews, whether native or naturalized; with the enormous influx of foreigners—in addition to the German refugees, there was the emigration of Spaniards fleeing the civil war and Franco after mid-1936—French indignation was increasing. But French anti-Semitism, long a central motif in French political and cultural life, did not flare up all at once. As Michael Marrus and Robert O. Paxton have shown, there was "a long habituation through the decade of the 1930s to the idea of the

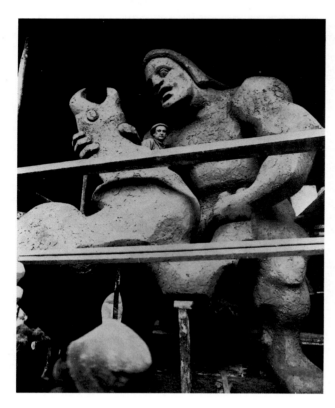

Figure 56 Jacques Lipchitz perched upon the final clay model (46 feet high) of *Prometheus Strangling the Vulture*, before its installation over a portal of the Grand Palais, for the Paris World's Fair, 1937.

foreigner—and especially the Jew—as the enemy of the state."[63] Beginning in the early 1930s, the government started to find all sorts of administrative tactics to limit the arrival of foreigners, monitor the activities of those who got in, and restrict their access to certain kinds of employment. In early 1935 three thousand foreigners were expelled, after an authorization the previous fall that mandated the expulsion of those whose papers were not in order. The Laval Law was also passed in 1935, whereby, for instance, all foreign needle-and-garment workers—10,000 of whom were East European Jews—had to obtain "artisan's cards" from the local craftsmen's associations, many of which were anti-Semitic and all of which had a vested interest in limiting access to jobs. Less concretely, but with perhaps even greater long-term impact, was a shift in French opinion of Jews. "It is striking," write Marrus and Paxton, "how widely fragments of the anti-Semitic position permeated moderate political vocabulary after the mid-1930s. Anti-Jewish expressions acquired new kinds of legitimacy. The old taboos against anti-Jewish

language, widespread since the vindication of Dreyfus, were clearly softening."[64]

In the midst of this, though, something surprising happened: In June 1936 the French not only elected their first Socialist premier, but also their first Jewish one, Léon Blum (fig. 55). Elected on the platform of the Popular Front, a coalition of various political parties of the French Left, Blum was in practice a kind of Roosevelt New Dealer (and was, in fact, a great admirer of the American President and his policies).[65] Responsible for a number of lasting reforms in French social legislation—including the forty-hour week, collective bargaining, and substantial paid vacations for all employees—Blum was not only an outspoken champion of the working class but in the eyes of many Jews a hero as well. Lipchitz, who seems never to have previously been much involved in French politics, now collaborated with Marcel Gromaire in designing a float (dedicated to Emile Zola, author of the Dreyfusard rallying call *J'Accuse*) for a Popular Front parade in 1936.[66] A much greater public demonstration of his art—and far more notoriety—was in store for Lipchitz the next year. Blum's government invited him to create a monumental sculpture to decorate the Palace of Discovery and Inventions, housed in the Grand Palais, at the 1937 Paris World's Fair (fig. 56). The plaster group was enormous, 30 feet high and located 40 feet above the ground, and represented a subject of Lipchitz's choosing, *Prometheus Strangling the Vulture*, the meaning of which functioned on several levels. On the most obvious level, it represented (as Lipchitz explained) Science, in the guise of Prometheus, struggling to bring enlightenment against the forces of ignorance, embodied by the vulture (the Greek myth contained no reference to Prometheus "strangling" the vulture; Lipchitz devised this motif himself). Of course, Lipchitz also drew on the Prometheus myth because, having been asked by Zeus to create man from clay, the Greek god was a kind of archetypal sculptor. Indeed, Lipchitz's group was very "sculptural" in the Baroque sense—agitated, gestural, and non-abstract. But there was yet a third meaning to the sculpture fashioned for the fair at which the Nazi government had a pavilion: It also represented the struggle, as the artist said, of "democracy" against the forces that would see it destroyed. Lipchitz even put a Phrygian bonnet on the head of Prometheus, so that it became a kind of colossal fantasy of France strangling the Third Reich. This meaning was not lost on the French Right, which, after the sculpture was awarded a gold medal at the fair—and then when the fair closed was given a place of honor on the Champs Elysées (with thoughts of having it permanently cast)— declared it seditious and provocative, contrary to the spirit of appeasement with the Nazis. By this point

Figure 57 Alice Halicka, *La Place de la Concorde*, 1938 (cat. no. 25). Musée National d'Art Moderne, Centre Georges Pompidou, Paris

León Blum's government had fallen (it had lasted but a year, aside from a brief return to power for less than two months in 1938), and the forces of Reaction were already gaining power. A petition was brought against the artist and his sculpture, and such a protest was launched that, in the spring of 1938, while Lipchitz watched, it was cut up into pieces and hauled away.[67] Yet, *Prometheus Strangling the Vulture* had been such an important work and personal symbol of success for Lipchitz that it provided a rich source of imagery for subsequent production. His gouache study (cat. no. 55) for a *Rape of Europa* of 1941, in which the myth now unequivocally proclaims its relevance to contemporary events, derives most directly from the group of 1937. Indeed, the theme of armed struggle had been part of Lipchitz's oeuvre since as early as 1932, when he made a sculpture of *Jacob Wrestling with the Angel*, a mild and more strictly art-related forecast of the ferocious images of combat to come.

For the Jews in France, Blum's government therefore turned out to be only a hiatus in the ongoing perpetration of French anti-Semitism in the 1930s. If anything, anti-Jewish feeling on the Right became even stronger after the Popular Front, with the Jews being blamed for the failures of the Blum government, and Blum in turn used as the symbol for everything the Right hated about Jews. Yet, even in the face of this, in comparison to Germany it seemed that the Jews had it good in France. The Marcoussis family, for instance, could have remained in America but chose not to, returning

to Paris in 1938, at which point Halicka showed a picture, *La Place de la Concorde* (fig. 25) at her exhibition that year at the Galerie Pascaud. She wanted, she subsequently wrote, "to paint the statues of the Concorde in their marvelous classical sense of order, in contrast to the disheveled romanticism of the great American city [New York]."[68] Of course, Halicka would not have considered placing a Hasidic Jew, as Mané-Katz had done, in front of the Place de la Concorde (although she herself, as we know, had painted the Jews of Poland in the early 1920s), for now she was an assimilated French Jew just as she had previously been an assimilated Polish Jew; her religious origins and her French nationality seem never to have been united in her personality. In her reminisences, *Hier*, published in 1946, she never once mentions that either she or her husband were Jewish, even though she recounts all of her ghastly experiences during World War II. This is not to imply that her feelings for France and her joy at being back in Paris after the American sojourn were inauthentic. If she painted a very glamorous, almost touristic picture of the Place de la Concorde, it was with the same sense of awe and accelerated heartbeat that most Frenchmen and most foreigners have greeted that great *carrefour* for a century-and-a-half.

Still, however great her love for France, it did Halicka no good in the end. She found herself, like so many other French Jews, a vagabond in her own country after the German Occupation of June 1940 and the establishment of the collaborationist Vichy government the

Figure 58 . Marevna, *Bouquet at the Colombe d'Or, St.-Paul-de-Vence*, 1942 (cat. no. 64). Petit Palais, Geneva

following month. She and Marcoussis fled Paris with their daughter in May 1940, at first staying at Cusset, just outside of Vichy, in fact. After increasing difficulties and much fear of denunciation, it was discovered that Marcoussis had lung cancer, to which he succumbed in October 1941. By December things had gotten so bad that the widowed Halicka and her daughter, who had been dismissed from her post at a radio station, left for Marseilles, the port in France's so-called Free Zone where the largest number of refugees had gathered. They stayed there till November 1942, until things got so dangerous that they went to Vienne, a town near Lyons, to hide. By the following spring, in 1943, Halicka went into even deeper hiding at Chamonix, near Switzerland, and when that too became dangerous she left again, this time for the village of Sallanches 20 miles away where, luckily, she remained in hiding until the Liberation. Which is to say that one could, with a lot of luck, survive in France: Sonia Delaunay stayed at first in the Auvergne with Robert, then in Mougins, and

briefly in Montpellier (where Robert died of cancer), and then for the duration at Grasse. Kikoïne hid undetected in the French provinces, as did Dobrinsky, Lipsi (before leaving for Switzerland), and Marevna as well. One of the ironies of the war is that a number of Jews suddenly found themselves rustics or semipermanent vacationers and began to create art out of the bucolic experience: Kikoïne painted a series of lovely gouaches while in hiding. Soutine, who had always been a landscapist, created yet another landscape series *sub rosa:* For instance, when in 1939 he was forbidden by the authorities to leave the town of Civry, he made a vivid image of ecstatic innocence, *Children Before a Storm* (cat. no. 106). And in 1942 Marevna, in the Free Zone, painted a neo-Impressionist bouquet on a ledge of the famous inn Colombe d'Or, with a view of St.-Paul-de-Vence in the background (fig. 58).

Many artists were not so lucky as these. One estimate is that approximately eighty Jewish artists from Montparnasse died in the Holocaust, most having first been sent to deportation camps in France (near Paris, two of the major camps were Drancy and Compiègne; in the south, Les Milles and Gurs, to name but a few).[69] In some cases we know nothing of an artist's work aside from what was done in the camps, like Abraham Berline, originally from the Ukraine, who was at both Compiègne (cat. no. 1) and Drancy before being deported to a death camp in Germany, where he died. Jacques Gotko, originally from Odessa but raised in Paris, was an exhibiting member of the Salon d'Automne and Salon des Indépendants in the 1920s. He too was at both Compiègne and Drancy, where he made a small watercolor, dated May 21, 1942, that shows two filled wine glasses being clinked together, in a setting of barbed wire, with the Drancy observation tower in the background. In the upper right are the words *"quand même . . . "* which translate as something close to "even though . . . " Many of his friends have also signed their names of this visual toast to life *in extremis*, and Berline's is among them. The next winter Gotko made a greeting card—sent to whom? for whom?—inscribed "New Year's Day, 1943" (fig. 59), and down below, amid a landscape of barbed wire and cooking facilities, he writes, "Kitchen 4, Drancy." Again, his friends sign, but this time Berline's name is not here. Gotko himself was deported and perished the next year. But there is another signature here, "I[sis] Kischka," who had also been previously at Compiègne, where he made a picture of a local roadside tavern as observed through barbed wire (cat. no. 37). I'm glad to be able to say that Kischka survived the camps and went on to have a flourishing career in Paris. But this was exceptional among those who were sent to Drancy: Henri Epstein was rounded up by the Gestapo at La Ruche, and was sent to Drancy and from there to his

death; Moishe Kogan was also found by the Germans in Paris and subsequently was exterminated. Adolphe Féder, who when he first arrived in Paris had been a student at the Matisse Academy, was also sent to Drancy before being sent east to die. While in the deportation camp, Féder made a charcoal and pastel self-portrait (fig. 60) in which he appears elegant and self-assured in pose, although his face looks worried and of course he wears the yellow star with the word "JUIF"—Jew—inscribed thereon. There is an awful photograph from 1943 of Max Jacob (fig. 61), who is also wearing the yellow star, but unlike Féder, the poet who had converted to Catholicism in 1915 and lived most of the rest of his life at an abbey at St.-Benoît-sur-Loire looks pitiful in his self-effacing restraint. Beginning in 1942, Jacob's Jewish origins (which, it should be pointed out, he never hid or denied) were made forcefully real to him: A yellow star was affixed to his family's store at Quimper; in 1943 his brother was deported to Auschwitz, where he was exterminated; and his sister and brother-in-law were deported and killed the next year. He himself was arrested on February 24, 1944, and despite the efforts of friends like Jean Coc-

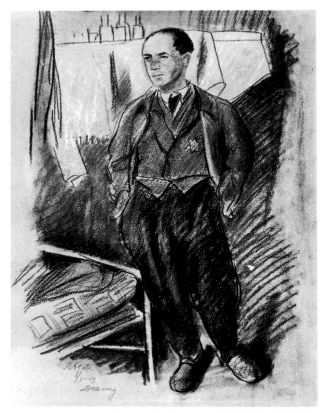

Figure 60 Adolphe Féder, *Self-Portrait with Yellow Star, at Drancy*, 1943 (cat. no. 18). Kibbutz Lohamei Haghetaot, Israel

Figure 59 Jacques Gotko, *New Year's Day*, 1943 (cat. no. 20). Musée des Deux Guerres Mondiales, Paris

teau to obtain his release, he was sent to Drancy shortly thereafter. Due to the freezing cold at the camp, Jacob came down with pneumonia and on March 5, after having asked for last rites—for which he asked forgiveness of his fellow Jewish prisoners—he died.

Rudolf Levy, who had not taken careful precautions to protect himself, was living at a *pensione* in Florence when the Gestapo came for him in 1943; he was then sent to an Italian deportation camp, at Carpi, and then to Auschwitz (although it is said that he died before ever arriving there). Levy's last self-portrait (fig. 62) shows a man bewildered; it is especially poignant to see this look on the face of a man who, from his youthful photographs seemed so filled with confidence, even arrogance. He was probably unaware that his old friend Walter Bondy, who had also been one of the "gilded youth" of the *fin-de-siècle*, had died a "natural" suicide: Bondy, a diabetic, when told that he would soon be taken away by the authorities, simply chose not to take his normal injection of insulin. Surely there are numerous other examples of deaths that, although "natural," were at least indirectly related to the regime. Soutine's

died anyway; maybe not. Two days later he was buried in Montparnasse Cemetery. His death certificate reads: *"Connu comme JUIF".*—Known to be a Jew.

Finally, there were the truly fortunate, those who escaped.[70] For that one needed, if it was after 1940, money or influential friends, preferably both. It helped to be famous. Chana Orloff, for instance, was able through important connections to escape to Switzerland—something that was extremely difficult to do—in 1942 with her son and Georges Kars in tow, and they remained there until the Liberation (although Kars, upon learning at that point that his family had been entirely wiped out by the Nazis, commited suicide). Orloff made a drawing of him on his deathbed (cat. no. 91). Almost all of the others who escaped France came to the United States, including Zadkine, Mané-Katz, and Miestchaninoff. Both Lipchitz and Chagall were reluctant to leave France, until it became quite apparent that they had little choice. By that point, in 1941, it was no longer easy, although luckily for them they were both on the list that had been provided to Varian Fry, of the Emergency Rescue Committee, a private organization that had been established to save leading European artists and intellectuals, whom, after all, it was

Figure 62 Rudolf Levy, *Last Self-Portrait,* 1943 (cat. no. 47). Pfalzgalerie, Kaiserslautern, West Germany

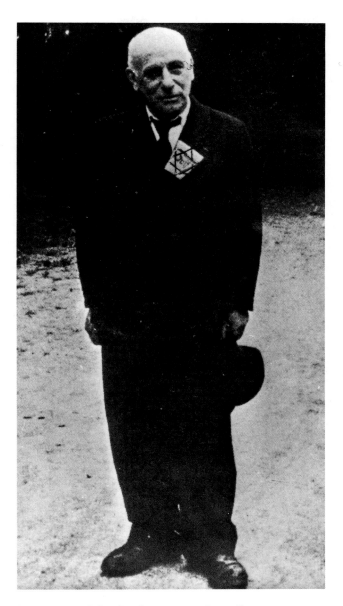

Figure 61 Max Jacob, wearing the yellow star identifying him as a Jew, in St.-Benoit-sur-Loire, ca. 1943.

death, for instance: While it is certainly true that the painter had long suffered from stomach ulcers, it is also true that the fear and trembling that he experienced while hiding at Champigny, near Tours (under the protection of some influential locals), must have aggravated the condition. By August 1943 this resulted in perforated ulcers, which required surgery. But after taking a circuitous route to Paris to avoid discovery by the Germans, Soutine arrived so late that, despite the operation, he died on August 9. Perhaps he would have

Figure 63 Jacques Lipchitz, *Arrival*, 1941 (cat. no. 54). The Institute for
Advanced Study, Princeton, Gift of Joseph H. Hazen

only possible to save because of their celebrity.[71] Lipchitz, who had been living in Toulouse, made a sculpture just before leaving France, titled *Flight* (cat. no. 53), in which a man and a woman, in an activated intermingling of their bodies, are in the process of running, as the man's arms are held high. After he had gotten safely to New York, Lipchitz made a companion piece, *Arrival* (fig. 63), in which the man and woman are still running, but now the woman holds aloft a baby, like a kind of trophy. Lipchitz said that the works in the series that followed were like "ecstatic prayers of thanks, notes of jubilation."[72] Chagall nearly didn't make it: He was caught in a police roundup in the south of France, where he had been living, but Fry heard about it (he was stationed in Marseilles), called the police almost immediately, and told them that he was going to inform the Vichy correspondent for the *New York Times* that they had arrested the famous artist if they didn't release him immediately. They did, and on May 7, 1941, Marc and Bella Chagall crossed the border into Spain; they arrived in New York, by way of steamship from Lisbon, on June 23. The well-known

New York art dealer Pierre Matisse (son of Henri) helped the Chagalls get a room at the St. Moritz Hotel on Central Park South. In fact, the novelist Feuchtwanger, another of Varian Fry's "endangered artists," found himself in circumstances almost identical to Chagall's. He recounts in his book *The Devil in France: My Encounter with Him in the Summer of 1940*, published in November 1941: "As I look out of the window of my hotel in New York over Central Park, with its lines of skyscrapers to the right and left, as I look out over the great, throbbing city bustling with the pursuits of peace, I ask myself again and again: Can this be real? Am I really here?"[73]

Moïse Kisling arrived in New York in 1941, after having first served in the French army during the *drôle de guerre* (the so-called Phony War of 1939–40 before the Germans invaded France). While waiting out the war in the United States, he took a map of Europe and, as the Allied victories occurred, painted them in, using various colors (fig. 64). One can read, in addition to patriotic slogans and the locations of all the other battles, the names, at the extreme right, of those places in

Figure 64 Moïse Kisling, *Map of Allied Victories*, 1943–45 (cat. no. 42). Kisling Collection

Eastern Europe—Cracovie, Varsovie, Smolensk, Vitebsk, Minsk—that he and his friends had left . . . not so very long ago.

NOTES

1. Gertrude Stein, *The Autobiography of Alice B. Toklas* (New York, 1961), p. 95. For monographic literature on Pascin and all the artists mentioned in this essay, please see the Artists' Biographies in the Appendix of this catalogue; each biography includes a selected bibliography.

2. André Salmon, *Souvenirs sans fin*, vol. 3 (Paris, 1961), p. 229.

3. For the "Dômiers," see *Pariser Begegnungen 1904–1914* (exhibition catalogue), Wilhelm-Lehmbruck-Museum der Stadt Duisberg (Duisberg, Germany, 1965), as well as Barbara and Erhard Göpel, *Hans Purrmann, Schriften* (Wiesbaden, 1961).

4. I am especially grateful to Camille Bondy for her assistance in researching the work of her first husband, Walter Bondy, and for opening her photographic archive to me. I am also grateful to the historian Jeanpierre Guindon for sharing with me, during my visit to his home in Sanary in June 1984, his knowledge of Bondy and the other refugees in the south of France in the 1930s.

5. As far as the extreme Right was concerned, France had literally sold her soul to the German devil after 1870–1871. This created a difficult situation for the many Frenchmen with an appreciation for the numerous achievements of German culture; it made, for instance, the French passion for the music of Richard Wagner especially pain-

ful. French attitudes toward Germany and German culture is a complex issue in the period 1870–1914. Among other sources see: Henry Contamine, *La Revanche 1871–1914* (Paris, 1957); Léon Daudet, *Hors du joug allemand* (Paris, 1915); Kenneth E. Silver, "*Esprit de Corps:* The Great War and French Art 1914–1925" (Ph.D. dissertation, Yale University, 1981); and Eugen Weber, *Action Française: Royalism and Reaction in Twentieth-Century France* (Stanford, 1962).

6. For the Dreyfus Affair see Alfred Dreyfus, *Five Years in My Life* (New York, 1901); Georges Clemenceau, *La Honte* (Paris, 1903); and Louis Snyder, *The Dreyfus Affair Case: A Documentary History* (New Brunswick, N.J., 1973).

7. I am grateful to Mrs. Eugen Spiro for information about her husband, which she communicated to me in conversation in November 1984; and to Dr. Sabine Oishi for information about her grandfather, Walter Rosam.

8. Adolphe Basler (1876–1951) was the author of several important books on art, including *Le Cafard apres la fête* (Paris, 1929) and *The Modernists, from Matisse to Segonzac* (London, 1931). For information about Basler, see *Pariser Begegnungen 1904–1914*, n.p.; see also an appreciation at the time of his death by Florent Fels, "Adolphe Basler," *Art-Documents*, Paris (June 1951), p. 2.

9. Alfred Flechtheim (1878–1937) was one of Germany's best-known dealers of modern art, with galleries in Düsseldorf and Berlin. Pascin painted a portrait of Flechtheim dressed in toreador costume (ca. 1924), now in the Musée National d'Art Moderne, Paris. For information on Flechtheim see *Pariser Begegnungen 1904–1914*, n.p.

10. For the Matisse Academy, see Alfred H. Barr, Jr., *Matisse: His Art and His Public* (New York, 1951), pp. 116–18;

11. J. F. Schnerb, "Exposition Henri Matisse," *La Chronique des arts et de la curiosité*, 19 February 1910, p. 59. Cited in Marit War-

enskiold, *The Concept of Expressionism: Origin and Metamorphosis* (Oslo, 1984), p. 184, n. 36.

12. Gabriel Mourey, "Lettres à un campagnard: Exposition Henri Matisse," *L'Opinion* February 26, 1910, p. 281. Cited in Warenskiold, pp. 184–5. n. 36.

13. Louis Rouart, "Salon d'Automne," *L'Occident*, November, 1907, p. 236. Cited in Ellen Oppler, *Fauvism Reexamined* (New York, 1976), p. 225.

14. For a taste (unpleasant though it is) of this tendency to associate things Jewish, German, and modernist, see Tony Tollet, *De l'influence de la corporation judéo-allemande des marchandes de tableaux de Paris sur l'art français* (Lyons, 1915).

15. For Berthe Weill, see her autobiography, *Pan! dans l'Oeil . . .* (Paris, 1933); for Kahnweiler, see his book *My Galleries and Painters* (London, 1971); for the Rosenbergs, see Pierre Cabanne, *L'Epopée du Cubisme* (Paris, 1963); for Vauxcelles, see the archives "Fonds Vauxcelles" at the Bibliothèque Jacques Doucet, Institut d'art et archéologie, Paris. As for André Salmon (whose surname name is almost always a Jewish one in France), his ethnic and religious origins are unclear. Although he was born a Catholic, he may have been of mixed Jewish and Christian ancestry. Sidney Alexander writes, "When Salmon was questioned about his early years—whose *landsmann* was he? Litvak? Galitsianer?—'By our discretion we guarantee bread to those whom Stephane Mallarmé called *les scoliastes futurs*,' " which provides no answer, of course. Yet, for reasons that he does not explain, Alexander concludes: "But at least one knew that Salmon was a Russian Jew, like so many of those living at La Ruche." Alexander, *Marc Chagall: A Biography* (New York, 1978), p. 135. See also *L'Art Vivant d'André Salmon* (exhibition catalogue), Galerie Brigitte Schéhadé (Paris, n.d.).

16. André Warnod, *Les Berceaux de la Jeune Peinture* (Paris, 1925), p. 169.

17. Salmon, *Souvenirs*, vol. 1, p. 176.

18. Jacques Lipchitz, *Amedeo Modigliani* (New York, 1952), p. 12.

19. Basler, *Le Cafard*, p. 36.

20. Gottlieb lived, like Kisling, at 3, Rue Joseph-Bara, and was a close friend of Diego Rivera (who lived nearby at 26, Rue du Départ). Gottlieb painted a portrait of Rivera in 1912 that is now in the Museo Casa Diego Rivera, Guanajuato, Mexico. See *Diego Rivera: The Cubist Years*, exhibition catalogue, the Phoenix Art Museum, 1984, pp. 36–37. See also Apollinaire's account of the duel, published on 13 June 1914, in Leory Breunig, ed., *Apollinaire on Art* (New York, 1972) pp. 405–6. The duel was also reported in *L'Intransigeant* (Paris) on 12 June.

21. Salmon is an excellent source for discussions of Kisling. Much of the information here has been drawn from the three volumes of the *Souvenirs*; however, the facts have always been cross-referenced, as Salmon is notoriously inaccurate as to dates.

22. Jean Cocteau, quoted in Francis Steegmuller, *Cocteau: A Biography* (Boston, 1970), p. 149.

23. Jean Cocteau, "Carte Blanche," originally in *Paris-Midi*, July 7, 1919, and reprinted in *Le Rappel à l'Ordre* (Paris, 1948), p. 124.

24. "Ainsi les juifs furent-ils les veritables sculpteurs de l'Egypte." Jean Cocteau, "Le Secret Professionel," (ca. 1921–22), reprinted in *Le Rappel*, p. 223.

25. The page (apparently no. 5) from *L'Excelsior* is reproduced in *Kupka: A Retrospective* (exhibition catalogue), Guggenheim Museum, New York, 1975, p. 310.

26. Marevna writes that Zadkine said to her, "I want to revive Jewish art." Marevna, *Life with the Painters of La Ruche* (London, 1972), p. 36.

27. The basic books on La Ruche are Jeanine Warnod, *La Ruche and Montparnasse* (Paris and Geneva, 1978) and Jacques Chapiro, *La Ruche* (Paris, 1960), although the latter is really a memoir without a great deal of information.

28. Blaise Cendrars, "Portrait" and "Atelier" from "Nineteen Elastic Poems," in Walter Albert, ed., *Selected Writings of Blaise Cendrars* (New York, 1966), pp. 148–54.

29. Marc Chagall as quoted in Walter Erben, *Marc Chagall* (New York, 1966), p. 49.

30. Waldemar George, *Marc Chagall* (Paris, 1928), p. 8.

31. For the historiography of *Paris through the Window*, see Angelica Zander Rudenstine, *The Guggenheim Museum Collection: Paintings 1880–1945*, vol. I, (New York, 1976), pp. 63–67.

32. James Thrall Soby, *Modigliani: Paintings, Drawings, Sculpture* (exhibition catalogue), The Museum of Modern Art, New York, 1951, p. 10.

33. Both Meyer Schapiro and Jacques Lipchitz reported this quotation to Maurice Tuchman. See *Chaim Soutine 1893–1943* (exhibition catalogue), Arts Council of Great Britain, London, 1981, p. 58 (and note 24, p. 70).

34. Diego Rivera also painted a portrait of Oscar Miestchaninoff (subtitled "The Sculptor") that now belongs to the state of Veracruz, Mexico. See *Diego Rivera: The Cubist Years*, Phoenix Art Museum, cat. no. 11.

35. Marevna, on the other hand, described Miestchaninoff as "a short, broad man, with a round, red face, rather conceited, who paid court to me . . . Unfortunately, I liked neither Miestchaninoff nor his sculpture." *Life with the Painters of La Ruche*, p. 77.

36. Rivera painted Indenbaum as well; see *Diego Rivera: The Cubist Years*, p. 36.

37. Salmon, *Souvenirs*, vol. 2, p. 327.

38. For the Uhde and Kahnweiler sales as well as a general survey, unique of its kind, of the Parisian art market, see Malcolm Gee, *Dealers, Critics, and Collectors of Modern Painting: Aspects of the Parisian Art Market Between 1910 and 1930* (New York, 1981).

39. The Musée des Deux Guerres Mondiales, Hotel Nationale des Invalides, Paris, has examples of the wartime work of Zadkine and Marcoussis.

40. *Mondzain*, (exhibition catalogue), Musée Granet, Aix-en-Provence, France, 1983, pp. 98–101.

41. Lipchitz, *Modigliani*, pp. 18–20.

42. Warnod, *Les Berceaux*, p. 235.

43. Marevna, in *Life with the Painters of La Ruche*, discusses the parties and balls arranged by the Russian organization.

44. Leo Steinberg, "Pascin," *Arts* (December 1955), reprinted in *Other Criteria: Confrontations with Twentieth-Century Art* (London, 1972), p. 271.

45. Warnod, *Les Berceaux*, p. 7.

46. It is probable that Orloff's work appeared at a number of different places at the Exposition; one that I came across just recently in reproduction is Pierre Chareau's "Habitation Coloniale" (the dining room), in which one can make out two of Orloff's sculptures, as well as what appears to be a third. See Léon Deshairs, *Exposition des Arts Décoratifs, Paris, 1925, Interieurs en Couleurs* (Paris, 1926), pl. 36.

47. I am grateful to Billy Klüver and Julie Martin for telling me about the Krohgs' dance career.

48. Fernand Léger, "Popular Dance Halls," *Bulletin de l'Effort Moderne* (Paris, 1925), reprinted in *Functions of Painting* (New York, 1973), p. 74.

49. For the relationship between Picasso's and Hayden's pictures, see Theodore Reff, "Picasso's *Three Musicians*: Maskers, Artists, and Friends," *Art in America* 68, no. 10 (December 1980): 124–42.

50. These statistics are from Jean-Paul Crespelle (who supplies no source for his figures), *Montparnasse Vivant* (Paris, 1962), p. 32.

51. For the "Maria Lani story" see the catalogue *Maria Lani* (Jean Cocteau, Mac Ramo, Waldemar George, eds.), published by the Editions des Quatre Chemins (Paris, 1929); see also Jean-Paul Crespelle, *La Folle Epoque* (Paris, 1968), pp. 280–82, and R. H. Wilenski, *Modern French Painters*, vol. 2 (New York, 1960), p. 220.

52. Warnod, *Les Berceaux*, p. 165.

53. Halicka, *Hier*, p. 101.

54. Marevna mentions this in *Life with the Painters of La Ruche*, p. 160.

55. For the Paul Guillaume Collection, see Waldemar George, *Collection Paul Guillaume* (Paris, 1933), and Michel Hoog, *Catalogue de la Collection Jean Walter et Paul Guillaume*, (exhibition catalogue), Musée de l'Orangerie (Paris, 1984).

56. See Maurice Tuchman's excellent discussion of Soutine's Christian subjects, as well as Chimen Abransky's more literal inter-

pretation of Soutine's Jewishness (or, as he sees it, lack thereof) in *Chaim Soutine*, Arts Council of Great Britain, 1982.

57. Salmon, *Souvenirs*, vol. 3, p. 261.

58. Basler, *The Modernists*, p. 56.

59. See Romy Golan's essay, "The *Ecole Francaise* vs. the *Ecole de Paris*," in this catalogue for a discussion of Basler's "Y a-t-il une peinture juive," of 1929. In fact, despite the spleen that Basler vents in his essay against all manner of artists and critics, it is one of the most intelligent pieces of writing to deal with the issue of the status of "Jewish art" in the 20th century.

60. J. M. Aimot, *Mané-Katz* (Paris [or Brussels?], 1933), pp. 72–73.

61. Gaston Diehl, *Pascin* (New York, n.d.), p. 78.

62. See the excellent catalogue, *Emigrés français en Allemagne/ Emigrés allemands en France 1685–1945*, Goethe Institute and the Minister of Exterior Relations (Paris, 1983), eds. Jacques Grandjonc et Klaus Voigt, for a discussion of German immigration to France, 1933–45.

63. Michael R. Marrus and Robert O. Paxton, *Vichy France and the Jews* (New York, ca. 1981), p. 54.

64. Marrus and Paxton, *Vichy France and the Jews*, p. 49. My discussion of the Jews in France during the 1930s is almost entirely dependent on Marrus and Paxton's excellent study.

65. My discussion of Blum is drawn from Joel Colton, *Léon Blum: Humanist in Politics* (New York, 1966).

66. A drawing for the float is reproduced in Cynthia Jaffee McCabe, *Artistic Collaboration in the Twentieth Century* (Hirshhorn Museum, Washington, D.C., 1984), p. 116 (fig. 34).

67. For the best discussion to date of this sculpture and the controversy surrounding it, see *Controversial Public Art, from Rodin to di Suvero, (exhibition catalogue)*, Milwaukee Art Museum (October 21, 1983–January 15, 1984), pp. 28–30.

68. Halicka, *Hier*, p. 248.

69. Basic references on the subject of the Holocaust and Parisian artists include *Spiritual Resistance 1940–1945: Art from the Concentration Camps* (a selection of drawings and paintings from the collection of Kibbutz Lochamei HaGhettoat, Israel), Union of American Hebrew Congregations (exhibition catalogue), New York, 1978; Oscar Ghez, *Memorial in Honor of Jewish Artists Victims of Nazism*, exhibition catalogue (University of Haifa, Israel, 1978); *Oeuvres d'artistes juifs morts en déportation*, exhibition catalogue (Musée d'Art Juif and Galerie Zak, Paris, 1955); Avram Kampf, *Jewish Experience in the Art of the Twentieth Century* (Massachusetts, 1984); Janet Blatter and Sybil Milton, *Art of the Holocaust* (New York, 1981).

70. For the escape of Jewish artists to America, see Cynthia Jaffee McCabe, *The Golden Door: Artist-Immigrants of America, 1876–1976*, exhibition catalogue (The Hirshhorn Museum, Washington, D.C., 1976) and Jarrel C. Jackman and Carla M. Borden, eds., *The Muses Flee Hitler: Cultural Transfer and Adaptation, 1930–1945* (Washington, D.C., 1983).

71. See Varian Fry's account of the Emergency Rescue Committee in *Surrender on Demand* (New York, 1945).

72. Jacques Lipchitz, *My Life in Sculpture* (New York, 1972), p. 143.

73. Lion Feuchtwanger, *The Devil in France (My Encounter with Him in the Summer of 1940)* (New York, 1941), p. 5.

Figure 65 Sonia Delaunay at the age of eight in the home of her maternal uncle (and adopted father), Henri Terk, in St. Petersburg, 1893.

FROM EASTERN EUROPE TO PARIS AND BEYOND

BY ARTHUR A. COHEN

With the exception of Marc Chagall's fanciful memoir of his youth in the small city of Vitebsk, we have little or insufficient information about the childhood, youth, or education of the Jewish artists of Eastern Europe who became the Jewish painters and sculptors of Montparnasse. We have the odd (but extraordinarily revealing) story of deprivation and parental cruelty in the childhood of Chaim Soutine in the Lithuanian village of Smilovitchi;[1] we know that Sonia Delaunay's parents sent her away to be brought up by a wealthy uncle in St. Petersburg, Henri Terk, so that she might escape the poverty of their home in the Ukraine (fig. 65); we know about the religious family of Mané-Katz and the fact that Abraham Mintchine (1898–1931) was an apprentice goldsmith in Kiev. But such information offers us only a series of unconnected details without any clear and defined sense of how this remarkable group of artists arose out of Eastern Europe. Moreover, the state of East European Jewish studies does not help matters since, until recently, there has been virtually no interest in clarifying how it came about that Jews of the East first picked up colored pencils and drew, rather than taking up pen and writing texts.[2] In other words, it is difficult to address the problem of how this remarkable group of artists came together in Montparnasse, formed an association of Jewish artists, dealt with the charges of being Jewish nihilists or mere eclectics preying on the body of advanced French art, achieved notoriety and success (or alternately continued to be obscure and unknown), and all the while, despite the absence of Jewish subject matter (for the most part and for most of the artists involved), were nonetheless seen by others and by themselves as Jewish artists.

In such a context, the old problem cannot help but reassert itself: What is the nature and dimension of Jewish art? Indeed, does it exist at all?

It is so familiar an assertion that Judaism is a tradition expressly forbidding the production of visual icons that it will perhaps surprise some to learn that nowhere is the prohibition of the representative imaging of God explicitly expressed in either the Hebrew Bible or its rabbinic exegesis.[3] What is clearly forbidden is the fabrication of idols ("graven images") and the imaging of elements of the universe that might serve as idols. Were not this formulation sufficient, Exodus 20:4–5 continues by warning that these objects (if the prohibition has been ignored and the object fashioned) must not be worshipped. Indeed it may be claimed that the object is at most essentially neutral, although threatening, until it is worshipped. Worship releases the potency of the object, converting it from a work of art intended to reflect beauty or sublimity in nature into an idol whose beauty is at most a means of seduction. As a work of art, the painted or graven image has a grounded charge; however, as an object physicalizing the spiritual, the object becomes an idol. The Biblical injunction is thus not anti-iconic as such, but against idolatry. It is easy to understand, despite these qualifications, how the prohibition against idol-making should yield, by the late 2d century of the common era—"the period from which Jewish art is first extant in representative amounts"[4]—to the unexpressed but well-diffused taboo against all iconic representation.

If the preferred medium for idolatrous manifestation is representation in either sculpture or painting of the image of God, its prohibition will have become so commonplace as not to require an overt rabbinic indictment against art as such in order to enforce its exclusion. And yet, even here, we remain mystified by an assumption that achieved such universality without dogmatic formulation. The discussion in the rabbinic collection *Mekhilta de Rabbi Ishmael* on the passage in question[5] makes clear that what is prohibited in Exodus 20:4–5 is the "graven image," the idol—and not simply the idol that is fashioned by art, but anything that man might call an idol, whether a tree that grows up from a seedling planted as an idol or a "figured stone" (*even*

mashchit in Leviticus 26:1) or an object molded in precious metal or in any natural stuff from which "molten gods" (Leviticus 19:4) could be contrived. The idol is forbidden in all its modalities—from that which is imagined to represent the highest divinity to the use of any creature upon the earth as "form of any figure" (Deuteronomy 4:16), as well as any angel or cherub that might be imagined and hence construed for worship. The intent is clear: Anything lesser that might be worshipped in the stead of that which is the greatest may not be fabricated, lest it be worshipped. Since man cannot imagine the most high, any image formulated by the imagination as an image of God is by definition defective and false. Insofar as it undertakes to present itself as substitute and replacement for the divine and encourages man by its attractiveness or its mysteriousness to worship God through it or, worse still, to become a God worshipped in itself, the violation of this strict commandment is brought about. What is at stake then in the anti-iconic Second Commandment is the fear of idolatry, the prohibition of the worship of idols, and the extenuating implication that anything made by man to represent the beautiful and the sublime risks the making of an idol.

The prohibition of the making of an image of God is, however, never asserted as such. No real need. God is the speaker of Exodus 20 in his own person. Having already affirmed himself to be unique and absolute, before whom no other gods shall stand, God hardly needs to prohibit his worshippers from making an image of him. For once, the Biblical text is sparing, refusing the clear opportunity of imputing to God a redundancy. It is rather taken for granted that God cannot be imaged (since he cannot be adequately imagined). Or, logically formulated, it can be insisted that the prohibition of the making of an image of God is not mentioned since any human fashioning of an image of God is (by the nature of man's created estate and the complementary gift of revelation) incomplete, inadequate, and hence always an idol (that is, a partitive supplantment of the totality that cannot be expressed by human means). The plastic arts appear to be prohibited lest the anthropomorphic representation of God be undertaken. Since man is prohibited from imaging the divine, the whole fiat of revelation is retained for God's generosity toward creation. Representational art is forbidden in order that divine revelation will be unchallenged.

In a famous and frequently cited passage from Chagall's Yiddish essay "What is a Jewish artist?", Chagall reports on a conversation overheard in Paris, through the thin walls of his studio in La Ruche, in which emigrant voices debate the question of whether Mark Antokolsky, Jozef Israels, and Max Liebermann—well-known Jewish artists of the 19th century—are Jewish

artists. Chagall finds the question ludicrous. For him the issue is not debatable. A national art is not possible or meaningful in a world now dominated by individual talent. What is distinctive and unique among the anonymous artists of the ancient world—he argues—who made Japanese, Egyptian, Persian, Greek art, has all but disappeared. Chagall allows for something mysterious in the Jews out of all relation to their numbers in the world: "When it [Judaism] wished, it brought forth Christ and Christianity. When it wanted, it produced Marx and socialism. Can it be, then, that it would not show the world some sort of art?"[6] Having first denied the prospect of Jewish art, Chagall concludes with a weak affirmation of its possibility.

As in all things speculative and ideological, Chagall's reflections are thin and rhetorical, but he nonetheless adumbrates several of the essential issues being debated by East European Jewish writers, intellectuals, and artists during the first decades of the 20th century, a debate echoed but not seriously recapitulated in the West. The debate, it should be noted at the outset, was principally conducted among the Jews of Eastern Europe since their own situation was in the vanguard of the secular search for political emancipation and cultural independence in the period just prior to World War I. Although in the West the issue of Jewish art had been raised primarily as an aspect of the continuing wish of the Jewish minority to maintain some form of independent identity, the reality of Jewish art—unconnected in the assimilated capitals of Western Europe with an indigenous folk tradition—was vigorously opposed by those who regarded the possibility of Jewish art only in the context of Zionist fulfillment. It is no surprise that Martin Buber in one of his less than persuasive essays should answer the question "Is a Jewish art possible today?" with a resounding "No," going on to argue in his address at the Fifth Zionist Congress in Basel (December 1901) that "a national art needs a soil from which to spring and a sky toward which to rise . . . a national style needs a homogeneous society from which it grows and for which it exists."[7]

The argument over Jewish art took a very different course among West European Jewish intellectuals than it took among the Jews of the East. For the former, ethnic and national art no longer seemed possible in the emancipated climate of Germany and France, whereas the question of national art remained of considerable importance not only to the latter but to enthusiasts of Slavic culture as well during the last decades of the 19th century. It was easier for Buber to displace the question of Jewish art to the time of Zionist fulfillment, leaving behind the many hundreds of practicing European Jewish artists to do the work of bourgeois evocation in which paintings of artists such as Moritz Oppenheim, Isidore Kaufman, Lesser Ury, Jozef Is-

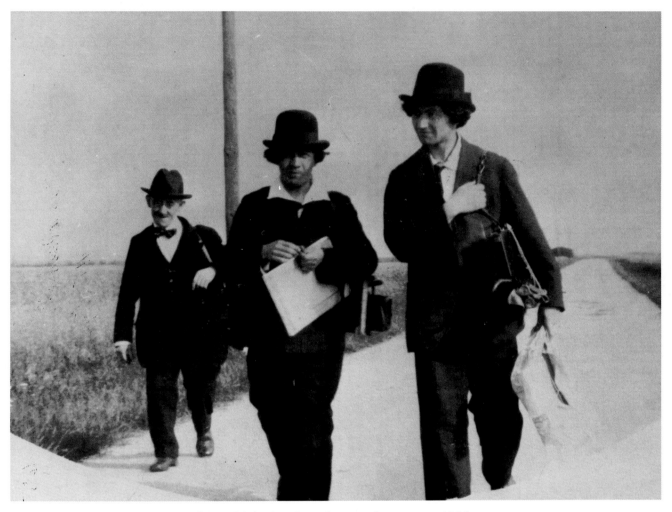

Figure 66 Morice Lipsi (far right) and friends, whereabouts unknown, ca. 1925.

raels, Max Liebermann, and many others became signs of Jewish self-acceptance in an otherwise wholly assimilated bourgeois environment.[8]

The situation in the East was radically different. It should be recalled that in the period just prior to World War I there was a population of roughly five million Jews, still bonded to traditional values, Yiddish-speaking "to the extent that ninety seven percent . . . spoke Yiddish at the time of the Russian revolution",[9] living in hundreds of small towns and villages in a wide swath that stretched north to south from Lithuania to the Black Sea, largely self-administered (although constantly interfered with and dislocated since the interventions of Czar Nicholas I after his accession to the throne in 1825[10]), and forming a significant majority in many Eastern provinces. For all this cohesiveness and raw power, the Jews still lacked an awareness of the strength of their political and cultural forces and re-

mained for the most part passive and ineffectual. The pogroms that afflicted East European Jewry at the end of the 19th and the beginning of the 20th centuries generated an upsurge of energy and creative protest among the advanced sectors of Jewry, providing an impetus to radical and Bundist politics, to Zionism, and to programs of cultural autonomy. Among the issues that came to the fore was that of Jewish art, since it served the Jewish artist to supply a cultural rationale for persevering as Jews; just as poetry and fiction served a broader intelligentsia, so visual artifacts were to serve the needs of the People.

Yet, it was no longer possible for Jewish artists—cut off as they were from the piety that produced the holy and abstract images that decorated the great stone synagogues of Gothic Germany or the wooden synagogues of Poland and Russia—to create afresh a new folk art. These artists were neither peasants, open and ready for

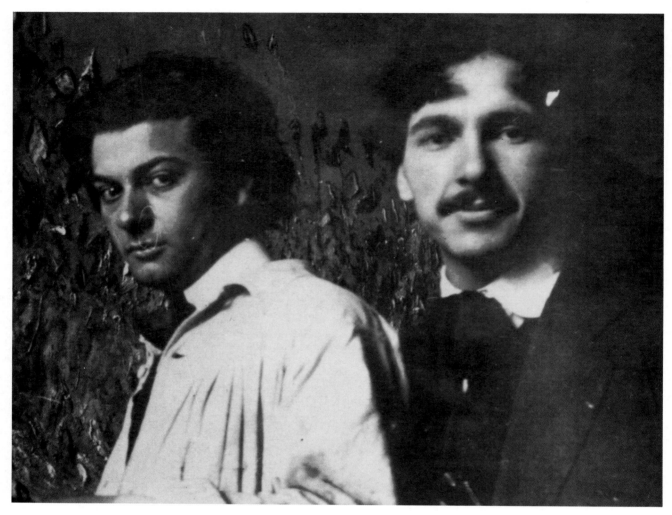

Figure 67 Moïse Kisling and Simon Mondzain at the fine arts academy in Cracow, before 1910.

training in colonies like those of Mamontov's Abramtsevo and Princess Tenisheva's Talashkino, nor urbane craftsmen influenced by William Morris, the Deutscher Werkbund, or the Darmstadt colony of Matildehöhe. For the most part the new Jewish artists were painters from secular and assimilated urban Jewish families or children of *shtetl* backgrounds who shared in common one defect of existence that did not afflict comparably motivated Russian and Polish national artists: They were Jews and hence prohibited from attending certain advanced schools for training, unable to gain admission for even temporary settlement in certain cities of Great Russia, and excluded by harassment and police surveillance from even the modest degree of freedom enjoyed by the non-Jewish citizenry.

This is the context for the migration *en masse* of the East European Jewish artists toward Paris (fig. 66). De-

nied freedom of movement and access to higher education in the arts at home, for them Paris—as it had been for so many of the world's oppressed since the French Revolution—became a refuge and eventually a new home. Without attempting a comprehensive description of the environment of Eastern Europe from which the Jewish artists of Montparnasse derive, we can identify certain characteristics of their world. For example, if they emigrated from the large cosmopolitan cities of the East—Warsaw, Cracow, Budapest, Lodz, Odessa—it was more than likely that they came from secure, perhaps even rich, middle-class families, enjoyed formal education in the local school system, had mastered at least one and perhaps several non-Jewish languages, and, even if religiously instructed, were not significantly compelled by traditional religious values and hence were spared a painful degree of guilt and

melancholy during their re-settlement in Paris.

Even before World War I, the process of acculturation and assimilation documented by Ezra Mendelsohn[11] had begun: Jews of the middle class tended to be urban; open to the political polarization introduced by the nationalist parties of Poland, Lithuania, Hungary, and other countries or territories of Eastern Europe; familiar, if not intimate, with Gentiles; conversant in European tongues; and educated in non-Jewish environments. However, this was not the case with Jews from small, unexceptional towns and villages—the *shtetlach* of fact and fantasy—which were endemically poor, implicitly segregated, paranoid before Gentile sensibility, fearful of pogrom, and religiously orthodox and conservative.

For example, consider the odd situation of a community like Vitebsk (which became part of White Russia after Poland's partition) from which came Chagall, Oscar Miestchaninoff, and the Yiddish playwright S. Y. An-Ski. Although regarded by the careless as a *shtetl*, Vitebsk was rather more than that for it was a community numbering 67,719 inhabitants in 1895 of which 34,420 were Jews,[12] and a rail junction of some importance and hence the seat of significant light manufacturing. Although its streets were unpaved, its atmosphere insalubrious, and (near the end of the century) only some 650 of its eight thousand houses were of stone,[13] it was still a thriving provincial metropolis in which, despite its lack of sophistication, it was possible for Marc Chagall (and Benjamin Kopman[14]) to have their first experience of painting instruction in the school run by Yehuda Pen, a Jewish academic draftsman of no particular talent. Moreover (and of some importance) is the fact that in nearly every biography we have of the artists of Montparnasse, at least one parent is noted to have supported their child's wish to study art. Often, the father wanted a more economically promising and bourgeois career for his child—as in the case of Jacques Lipchitz's father, a successful building contractor in Druskieniki, who wished his son to be an architect while his mother was willing to allow him to follow the career he wanted, that of a sculptor.[15]

Chagall's narcissistic delight in his origins and history is unique among the Jewish painters of Montparnasse. Only he composed an autobiography (originally intended to be illustrated by a suite of drypoint etchings, which were in fact published by Paul Cassirer in 1923 independently of any text). Chagall's narrative is characterized by romantic enthusiasm for his childhood in Vitebsk[16] and the laying of groundwork for the distinctively Chagallian mythology of alogical associative elements and connections that dominate his imagination. No one else undertook to make of his own childhood an affair consisting of equal parts of affection

and calamity. Many among the Jewish artists exhibit that pathetic temperament that some critics have tried to read into their work as distinctively Jewish, but invariably such a characterization breaks apart since it is virtually indescribable, invariably inconsistent, and nowhere documented by the artist's own confessional admission of his intentionally sorrowful brushstroke. There is, therefore, hardly any linkage between remembered episodes of their East European origins and their mature work, except in the narrative and anecdotal paintings of Chagall, Mané-Katz, and Max Weber.

The artists of Montparnasse who came from Eastern Europe had certain sociological and cultural experiences that can be identified as characteristic. In most cases they had their first training in painting or the decorative arts either in their own city of birth, if it was a large and cosmopolitan center (for example, Hayden in Warsaw, Menkès in Lvov, Krémègne in Vilna), or in a traditionally strict academic environment away from home, whether in the West or in the East (in Munich for a considerable number of artists, including Czobel, Epstein, Halicka, Kars, and Pascin; Cracow in the case of Kisling and Mondzain (fig. 67); Hayden, Warsaw for Zak; Minsk for Soutine and Kikoïne; or, St. Petersburg or Moscow for Sonia Delaunay, Chagall, and Marevna if they were fortunate enough to have residence permits or temporary authorization). Moreover, with few exceptions, none of the artists went straight away to Paris. Paris was an almost mythical place to which artists of the East had been traveling for many decades, but for the most part, after a stay of a number of years, they returned to their homelands. It was a new phenomenon for artists during the early decades of the new century to go to Paris and never to return. At the outset, however, Paris was simply a rumored place. "During my years at Vilna," Lipchitz recalled, "I must have learned about Paris as the center for the study of art, and I developed a passionate desire to go there."[17] In the case of Chagall, it was in the studio of Léon Bakst, an assimilated Russian Jew, where he studied in 1905 that he first heard the names of the new Parisian artists and conceived his passion for Paris, finally assisted in his ambition by the support of Max Moisevich Vinaver, a member of the Duma and editor of Jewish cultural periodicals.[18] Paris was by then seen as the city from which artists would not return. Sonia Delaunay reported that her uncle was reluctant to allow her to study in Paris after she completed her preliminary education in Karlsruhe since he feared—correctly—that she would not return to St. Petersburg to assume her bourgeois responsibilities.[19]

Paris was the city where artistic experimentation was being conducted in an atmosphere free of state bureau-

cracy and government control of bursaries and exami-
nations that marred the Russian atmosphere. In Paris,
if an aspiring artist loathed the Ecole des Beaux-Arts,
there were a considerable number of options, with aca-
demies of drawing and painting maintained by rigorous
academics, minor as well as major artists, including the
schools of such innovative masters as Henri Matisse. If
one had no wish to continue formal training, the society
of artists who were making modern art, critics and en-
thusiasts, collectors and poets was open and unre-
stricted, and the variety of museums, galleries, and
exhibitions was seemingly unlimited. Paris was clearly
the city to which to come if one had made up one's
mind to seek a life in art.

The price of this migration, though, was an undeni-
able loss of Jewish self-consciousness. The debate about
the Jewishness of Jewish art as it had been elaborated
in Eastern Europe, for instance, was for better or worse
nullified in Paris, where the lack of any official anti-
Semitism—and even, relatively speaking, the absence
of any effectual social prejudice (until the late 1930s)—
meant an exhilaratingly open field for Jewish artists
and, indeed, for artists of whatever ethnic origins. With
the notable exceptions of Chagall and Mané-Katz (and
a few lesser-known figures), the Jewish artists in Mont-
parnasse wanted first and foremost to be "Parisian"
artists—that is, to be equal to the world-standard for
artists. Which is not to say that these painters and
sculptors lost their Jewish identity. A few did attempt
to deny or ignore their origins, but for the most part the
Jewish artists of Montparnasse simply lived as artists
and as Jews, without a necessary relationship between
those two identities (although the rapport between the
two identities was by no means immutable). This very
freedom to choose when, where, and in what way to
combine—or not to combine—origins and art is the
measure of how far this first generation of Jewish artists
in the West had traveled from Eastern Europe.

NOTES

1. Soutine "was the tenth of eleven children of a miserably poor
Jewish tailor who wanted him to become a shoemaker. But he was a
born painter. . . . At the age of seven, he so desired a colored pencil
that he stole some utensils from his mother's kitchen in order to buy
one, and was punished by two days' incarceration in the family cel-
lar. . . . He then had the temerity to ask the rabbi to pose for his
portrait. The rabbi's son, feeling that his father had been insulted,
met him at the door and beat him so brutally that it took him a week
to recover." Soutine's mother's support for him was so significant that
the settlement of twenty-five rubles, paid over by the rabbi in settle-
ment of her threatened suit for the beating, was used by her to finance
her son's early art education in Minsk. Monroe Wheeler, *Soutine*
(New York: The Museum of Modern Art, 1950), pp. 32–33.
2. The recent remarkable book by Avram Kampf, *Jewish Experi-
ence in the Art of the Twentieth Century* (South Hadley, Mass., 1984)
is the first systematic attempt to trace the history of the formation of

the Jewish esthetic avant-garde. It is not simply a gathering of Jewish
names which renders the earlier work edited by Cecil Roth, *Jewish
Art: An Illustrated History* (New York, 1961) an uncritical hodge-
podge. Kampf, building on the researches of many scholars (not least
among them Rachel Wischnitzer or the contributions of a *Journal of
Jewish Art*) has focused many of the critical questions about the ori-
gins of the Jewish allegiance to esthetic modernism and my own
discussion in this essay is profoundly indebted to his pioneering work.
3. Ellen S. Saltman, "The 'Forbidden Image' in Jewish Art,"
Journal of Jewish Art, Center for Jewish Art of The Hebrew Univer-
sity, Jerusalem, vol. 8 (1981), p. 42, note 2: ". . . there is nothing in
the Bible that specifically forbids the representation of God in any
form, anthropomorphic or otherwise, and nothing in the rabbinic
literature that condemns it."
4. Ibid.
5. Jacob Z. Lauterbach, ed., *Mekilta de-Rabbi Ishmael* (Philadel-
phia, 1949), pp. 241–44.
6. Marc Chagall, "Eygns," in Gregory Aronson, ed., *Vitebsk
amol*, (New York, 1956), pp. 441–44, translated from the Yiddish by
Lucy Dawidowicz and published in her remarkable anthology *The
Golden Tradition* (New York, 1967), pp. 331–32.
7. Kampf, *Jewish Experience in the Art of the Twentieth Century*,
p. 203, fn. 4. Kampf's discussion here was first published as an essay,
"In Quest of the Jewish Style in the Era of the Russian Revolution,"
Journal of Jewish Art, vol. 5 (Chicago, 1978), pp. 48–75. Although
Buber denied the existence of a Jewish art in his essay on Lesser Ury
in *Ost und West*, vol. 2 (Berlin, February 1902)—from which Kampf
quotes—he allows for the existence of Jewish artists: "Lesser Ury ist
ein Jude. Er ist auch in Wahrheit ein jüdischer Künstler." *Lesser Ury:
Juedische Kuenstler* (Berlin, 1903), p. 71.
8. Kampf, *Jewish Experience*, p. 203, fn. 2, in which Alfred Nos-
sig cites the English Jewish painter Frank L. Emmanuel who com-
piled a list of more than four hundred Jewish artists working in
Europe. "Ausstellung Jüdisdher Künstler," *Ost und West*, vol. 12
(Berlin, December 1907).
9. Kampf, *Jewish Experience*, p. 15.
10. Michael Stanislavski, *Tsar Nicholas I and the Jews: The Trans-
formation of Jewish Society in Russia, 1825–1855* (Philadelphia,
1983), passim.
11. Ezra Mendelsohn, *The Jews of East Central Europe Between
the World Wars* (Bloomington, Ind., 1983), p. 2.
12. This information stems from the generous scholarship of Pro-
fessor Lucjan Dobroscycki of the YIVO Institute for Jewish Research,
who prepared a memorandum for me on the composition of many of
the cities and *shtetlach* from which the Jewish artists of Eastern
Europe came. Also, Dina Abramowicz, librarian at YIVO, was ex-
tremely helpful in organizing for me research sources which I con-
sulted during the preparation of this essay.
13. Franz Meyer, *Marc Chagall* (New York, 1961), p. 21. Meyer
credits his information on Vitebsk to W. P. Simenov, *Russia*, vol. 9
(St. Petersburg, 1905).
14. J. Tofel, *B. Kopman* (Paris, n.d.), biographical note preceding
essay, p. 6.
15. Jacques Lipchitz, with H. H. Arnason, *My Life in Sculpture*
(New York, 1972), p. 3.
16. Marc Chagall, *My Life* (New York, 1960), passim.
17. Lipchitz, *My Life in Sculpture*.
18. Meyer, *Chagall*, pp. 57, 93.
19. Arthur A. Cohen, *Sonia Delaunay* (New York, 1975), pp.
40, 44.

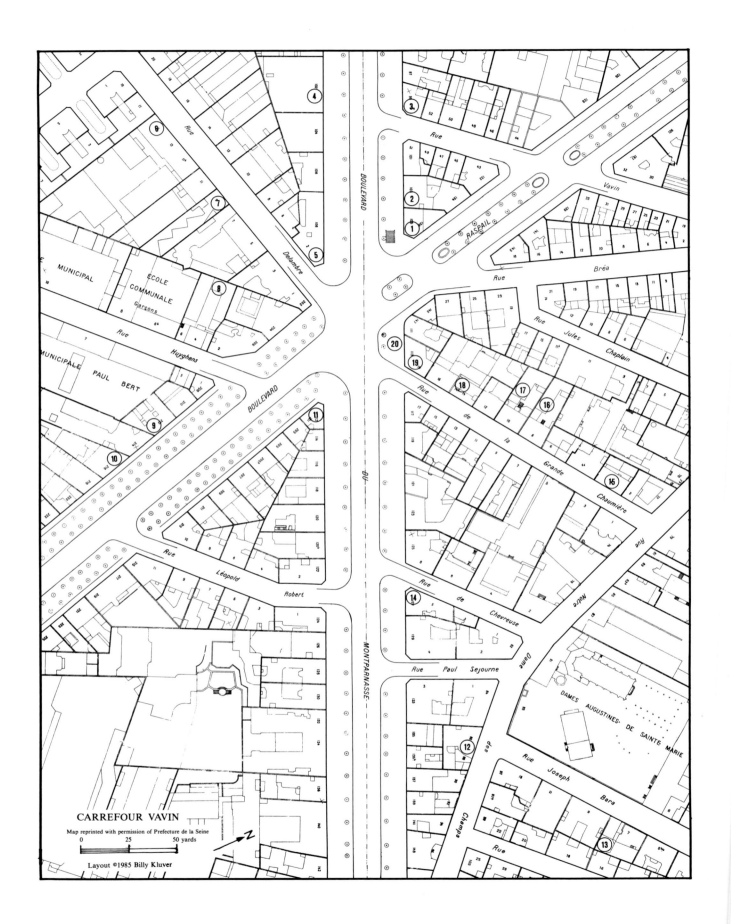

CARREFOUR VAVIN

Map reprinted with permission of Prefecture de la Seine

0 25 50 yards

Layout ©1985 Billy Kluver

CARREFOUR VAVIN

BY BILLY KLÜVER AND JULIE MARTIN

The section of Paris called Montparnasse traditionally delineates an area on the Left Bank stretching from the Place St.-Sulpice in the north to the Rue d'Alésia in the south, and from the Hôpital du Val de Grâce in the east to the Hôtel des Invalides in the west (shown on the map on facing page). Almost all of the artists' studio buildings and *cités* on the Left Bank were built within this area, with the exception of La Ruche and those surrounding the Ecole des Beaux-Arts. The main axis of Montparnasse is the Boulevard du Montparnasse and its center is the Carrefour Vavin, the intersection where the Boulevard du Montparnasse crosses the Boulevard Raspail.

Painters and sculptors began to settle in Montparnasse in the early part of the 19th century, attracted by the tranquillity of its natural surroundings and open space. In an area still full of truck gardens for the markets of Paris, artists found old farmhouses, tool sheds, summer cottages, and artisans' workshops, which they converted into studios. An analysis of the artist population of Paris shows that in the mid-1860s there were 1,500 artists living in Montparnasse. During the 1880s many artists' studio buildings were built throughout the area; the availability of studios attracted more and more artists, and by 1890, nearly one-third of all the painters and sculptors in Paris lived in Montparnasse. During the last years of the century the total artist population of Montparnasse surpassed that of Montmartre, and Montparnasse rapidly became the dominant artists' community in Paris.

Close to the Ecole des Beaux-Arts, Montparnasse attracted the art students, French and foreign alike, who came to study at the Ecole and at the ateliers of the academic maîtres, like Bouguereau, Carolus-Duran, Raphaël Collin, and Gérôme. The French system assured them that after a few years of studying with an approved teacher, they could have their work shown in the yearly official Salons, and even win prizes there.

The number of foreign artists in Paris rose steadily: Of the approximately 2,200 painters and sculptors who showed each year in the Salon, 14 percent were foreigners in 1868; by 1890, 20 percent were foreign artists. When these artists returned home to work and teach, they inspired a new generation to come to Paris. This cycle of attraction and seduction of foreign artists continued for many decades and was the driving force behind the rapid expansion of Montparnasse in the 20th century. While there was always a substantial number of foreign artists from France's neighbors, Switzerland, Belgium, and Holland, the largest single national group before 1870 was the Germans, who disappeared with the Franco-Prussian War of 1870, not to return until after the turn of the century and never again in such large numbers. Beginning in the 1880s, the Americans became the largest single group of foreign artists in Paris until World War I, and they settled almost exclusively in Montparnasse. The second most populous group in the last part of the 19th century was the artists from Russia and Eastern Europe, who after the war became the largest group. During the first three decades of the 20th century, the number of foreign artists living in Montparnasse remained between 30 and 40 percent of the total number of artists living there. Their presence made Montparnasse, as Marcel Duchamp said, "the first really international colony of artists we ever had . . . ; heretofore the essence of the art colonies had always been the students, as in the Latin Quarter, but Montparnasse was a more mature expression."

Montparnasse throughout the 19th century was a working-artists district and had none of the excitement and esthetic ferment of Montmartre café life. Students had heavy schedules of study and apprenticeship, and the academic artists were too sure of their esthetic positions and too busy fulfilling commissions to indulge in "frivolous" discussions in cafés. The first signs of

café life in the area appeared in the 1890s among the Scandinavians at the Café de Versailles opposite the Gare Montparnasse and at the old Closerie des Lilas just off the Avenue de l'Observatoire. By 1900 all activity was centered at the Carrefour Vavin, and with new generations of artists the cafés became the focal point of the open and democratic spirit of Montparnasse. That everything centered around the Carrefour Vavin during this period was underscored by the critic and writer Georges Charensol, who reminisced, "We never went to Closerie, it was too far away," although it was only 500 yards down the Boulevard du Montparnasse.

This essay is written as a walking tour around the Carrefour Vavin: The numbers on the map show the location of the places discussed, and correspond to the number in parentheses following each address. Lack of space in the catalogue has limited the number of stops on the walk, but the descriptions of some of the bars, cafés, restaurants, academies, and studio buildings give an idea of the environment the artists in this exhibition found when they arrived in Montparnasse.

La Rotonde
105 Boulevard du Montparnasse (1)

Although the southern part of the Boulevard Raspail had been open since 1760, it was not until 1906 that it opened north of the Boulevard du Montparnasse, connecting Montparnasse with the rest of the city by a major thoroughfare. A small bar opened in a mid-19th-century building that stood on the new corner. Most mornings, its U-shaped zinc bar was crowded with coachmen, workmen, cleaning women, models, and an occasional art student, all stopping for coffee—10 centimes standing at the bar or 20 centimes at the single indoor table or the tables out on the terrace. Lured by the sun on the terrace of the Rotonde, the artists who frequented the Dôme began to cross the boulevard to sit at what the Spanish painters called "Raspail Plage."

Around 1910 Victor Libion bought the café and the butcher shop next door and expanded and remodeled the Rotonde. Libion welcomed the artists and created an atmosphere where all kinds of artists, poets, writers, and critics could feel at home. He subscribed to foreign newspapers and let the artists sit for hours over a 20-centime café-crème. For the poorer artists, he accepted paintings in exchange for payment and looked the other way when they took rolls from the bread-basket. Thus the back room at the Rotonde became a meeting place where all nationalities mixed freely with each other, something that up till then had not happened in Montparnasse. Libion could also be very firm; he did not tolerate drunken brawls and took care of any disturbance himself without calling the police. Neither would he allow prostitutes or drug dealers. During World War I, the Rotonde was the single most important meeting place for the artists still in Paris—Picasso, Modigliani, Diego Rivera, Ilya Ehrenburg, Marevna, Ortiz de Zarate, Max Jacob—and for those home on leave or invalided out of the war, such as Léger, Kisling,

and Apollinaire. Because of the international mix of people and the large number of Russians, the police began to harass the Rotonde toward the end of 1917, making raids to look for deserters and "spies," and several times closing Libion down on what seem to have been trumped-up charges of selling American cigarettes. The artists remained loyal, but Libion suffered financial losses and felt compelled to sell the Rotonde in 1920.

The new owners had no feeling for artists, who thus fled the Rotonde after Libion left. However, the few years of his reign had made such an impression on the artists' community in Montparnasse that not only has Libion become legendary in countless memoirs, but André Salmon for many years carried on a campaign to replace the statue of Balzac on the Boulevard Raspail outside the Rotonde with one of Victor Libion.

Café du Parnasse
103 Boulevard du Montparnasse (2)

The Café Vavin, a small café with a zinc bar and a back room, opened before World War I and began to attract the artists. After the war, it changed its name to Café du Parnasse and became the first Montparnasse café to formally exhibit paintings. The first exhibition, organized by A. Clergé, opened on April 8, 1921. Works by forty-seven painters and sculptors were hung and placed wherever space could be found on the walls and counters. Among the artists were Abdul Wahab, Krémègne, Soutine, Mendjiszky, Nina Hamnett, Zawado, and Gontcharova. The exhibition was greeted with hostility from the critics and art dealers, who objected to the idea of paintings being sold by wine merchants. But André Salmon, in his review of the exhibition, defended the spirit of the young painters and declared, "The exhibition is one of the most interesting in Paris at the moment." At the second exhibition in March, there were 102 painters represented and Clergé continued to organize group exhibitions there and elsewhere for several years. The idea spread rapidly, and soon every café and restaurant in Montparnasse had paintings for sale on its walls.

The Parnasse for a couple of years became the headquarters for a monthly art and literary magazine, *Montparnasse*, edited by Paul Husson. In June 1924, the Café du Parnasse vacated the premises to make space for the ever-expanding Rotonde.

Le Select
99 Boulevard du Montparnasse (3)

The Select, which opened in 1925, was the first bar in Montparnasse to stay open all night, and it became famous for its Welsh rarebit. It attracted American

writers including Ernest Hemingway, Robert McAlmon, Harold Stearns, and the Canadian Morley Callaghan. The owners of the Select, M. and Mme. Jalbert, never had any interest in painters and it therefore never became a regular place for them to meet. Mme. Jalbert would call the police at the first sign of any disturbance, and she was suspected of being a police spy.

In her memoirs, Youki Desnos tells that she arranged for Soutine and Pascin to meet each other and chose the Select for the meeting, during which "each of us had at least 10 whiskeys." She continues, "In spite of the ambience that this created, no bond developed between the two artists. When he was about to leave, Soutine mischievously turned to Pascin and said, 'Don't think that I don't appreciate your paintings. Your girls excite me.' Pascin replied furiously, 'I forbid you to excite yourself in front of my women.' Then, suddenly inspired, he added, 'I am the son of God. Misfortune to those who don't love me.' Soutine was Slavic in origin, and therefore superstitious. He threw himself on Pascin and grabbed his hands, 'I love you a lot, Pascin, believe me, I love you a lot,' and disappeared into the night."

La Coupole
102 Boulevard du Montparnasse (4)

In 1924 Ernest Fraux and René Lafon bought the Dôme from Paul Chambon and tripled its profits in two years. But after Chambon's wife died, he began to miss the Dôme and paid 600,000 francs in penalties to cancel the sales contract. With this money, Fraux and Lafon bought a coal yard a few doors down on the Boulevard du Montparnasse and built La Coupole. Against the advice of their architect, they insisted that the restaurant be a large open space, with ceilings five meters high; the space was broken up and intimacy was achieved by the ingenious arrangement of the banquettes. An artist, Auffray, whom they had known at the Dôme, suggested that the artists of Montparnasse be involved in decorating the restaurant. When Fraux and Lafon agreed, Auffray enlisted thirty-two artists including himself, Fernand Léger, Pierre Dubreuil, Othon Friesz, Chantal Quenneville, Isaac Grünewald, Georges Kars, and Marie Wassilieff to paint the columns and a large mural on the back wall. Three thousand invitations were sent out, and La Coupole opened on the particularly cold and icy night of December 20, 1927, amid skepticism from other restaurant-owners that Montparnasse could support such a large restaurant-brasserie. M. Dufour of Maison Mumm would provide only 1,500 bottles of champagne; and when all these were drunk in two hours, he had to spend the evening in a taxi bringing more and more champagne. La Coupole was an overnight success. Fraux and Lafon created La Coupole in the democratic spirit of Mont-

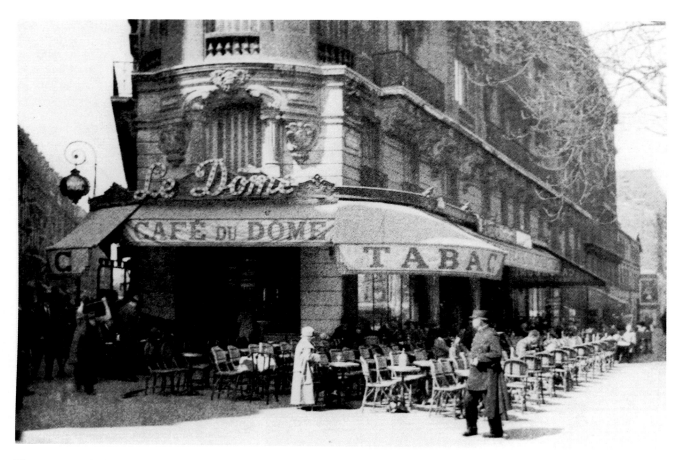

Figure 68 Le Dôme, ca. 1910. Billy Klüver Collection. All rights reserved.

parnasse itself: One could have a sandwich or a full meal, and for the same price eat on paper or linen tablecloths. Artists, writers, socialities, bourgeois families, and tourists all felt equally at home.

The artists went to the opening, looked around, and immediately settled in the bar, which was separated from the main restaurant by a partition. Derain, Foujita, Youki, Kisling, Pascin, Desnos, Kiki, Man Ray, and Fernande Barrey all became regulars there. The barman, Bob Lodewyck, looked after the artists, took messages, arranged meetings, and kept the curious tourists out. The bar at La Coupole was the place everybody met for drinks before embarking on the night's activities and where they came together again for the last drink of the evening.

Le Dôme
108 Boulevard du Montparnasse (5)

In 1896 a group of shacks were torn down to build a new, elevator-equipped, six-story apartment building, with space provided for a café on the ground floor left.

The Dôme opened in 1898, featuring a décor of marble-topped tables, leather banquettes, and mirrors lining the walls in the area of the café facing the Boulevard du Montparnasse. Behind the elaborate zinc bar was the back room, where two billiard tables were installed in 1902. American artists and art students who lived at the Hôtel de la Haute Loire and in the large studio complex at 22 Rue Delambre immediately discovered the billiard tables and the back room, where they set up a continuous poker game, thus establishing this area of the Dôme as American territory for the next fifteen years.

Arriving from Munich in the fall of 1903, Walter Bondy and Rudolf Levy came upon this undistinguished café, with coachmen in the front and Americans in the back, and began to meet there with friends. Bondy and Levy brought with them the tradition of café life from the Café Stephanie in Munich and were the nucleus of a growing group from Germany, including artists Albert Weisgerber, Rudolf Grossmann, Eugen Spiro, Hans Purrmann, Wil Howard, Friedrich Ahlers-Hestermann, Bela Czobel, and art dealers Alfred

Flechtheim and Wilhelm Uhde, who made the Dôme their headquarters for the next decade. So identified were these artists with the Dôme that in Montparnasse they became known as the "Dômiers"; and when in June 1914 Flechtheim held a group show of 23 of them in Düsseldorf, he titled it *Der Dôme.*

Later, Scandinavians from the Café de Versailles began to come to the Dôme, but the two groups never really mixed, as the American painter Abel Warshawsky related in 1909: "Very few foreigners mingled in our part of the Dôme. Jules Pascin, the Rumanian [sic], was one of the few exceptions and a French painter, Signac. . . . The café room facing onto Boulevard du Montparnasse was generally occupied by the Germans, Czechs, and Bulgarians, only the terrace outside being common ground."

The Swedish artist Carl Palme tells that between Christmas and New Year's Day of 1907–8, he, Max Weber, Patrick Henry Bruce, and Hans Purrmann met constantly at the Dôme with Sarah and Leo Stein to plan an academy where Matisse would be their teacher. Sarah Stein and Purrmann found studio space at a former convent taken over by the state at 86 Rue de Sèvres, and the Matisse Academy opened sometime within the first two weeks of 1908.

At the outbreak of World War I, the Germans disappeared overnight, the Americans left for safety at home, and many of the other foreigners volunteered for the army, leaving the Dôme empty. After the war, the Dôme was bought by Paul Chambon, whose generous and friendly personality attracted a new generation of artists, and the Dôme became a favorite meeting place throughout the 1920s. In *A Moveable Feast,* Hemingway described it as follows: "I passed the collection of inmates at the Rotonde and . . . crossed the boulevard to the Dôme. The Dôme was crowded too, but there were people there who had worked. There were models who had worked and there were painters who had worked until the light was gone and there were writers who had finished a day's work for better or for worse, and there were drinkers and characters, some of whom I knew and some that were only decoration. I went over and sat down at a table with Pascin and two models who were sisters."

Hôtel des Ecoles
15 Rue Delambre (6)

Built around 1900, the Hôtel des Ecoles was the most famous artists' hotel in Paris for sixty years. When Pascin arrived in Paris from Munich on December 24, 1905, he was met at the station by a group of German artists from the Dôme who took him to stay at the hotel; and as late as 1908 he still gave 15 Rue Delambre as his address in the official catalogue when he showed in the Salon d'Automne. André Breton lived there during his only stay in Montparnasse from December 1920 to September 1921, when he was active in the Dada movement. Man Ray, who arrived in Paris in July 1921, soon discovered Montparnasse where "all languages were spoken including French as terrible as my own." He moved into the Hôtel des Ecoles in December and set up his photographic studio there. He was especially attracted to the cafés, "where the clients sat at tables and changed their places from time to time to join other friends." It was in one of the cafés that he first met Kiki, who was then living with the Polish painter Mendjiszky. Kiki reluctantly agreed to pose for him; they fell in love and she moved in with him. In her memoirs, she describes her new situation as follows: "He photographs folks in the hotel room where we live, and at night, I lie stretched out on the bed while he works in the dark." They remained there until June 1922, when Man Ray took a studio at 31 bis, Rue Campagne-Première, which he kept throughout the 1920s.

Le Studio-Hôtel
9 Rue Delambre (7)

This modern building with an Art Deco façade and metalwork, designed by the architect Astruc, was completed in September 1926. It contained twenty studio-apartments whose residents could have food delivered from the kitchens of Le Parnasse Bar and Grill-Room on the ground floor. Most of the residents were Americans; one of the first was Isadora Duncan, who gave frequent parties in her apartment (she died on the Riviera less than a year later).

A 1931 guide to Paris describes Le Parnasse, which had an orchestra and dancing in a room underneath the restaurant, as "The most sumptuous place in Montparnasse with very chic doormen and clients in black tie. The ultra-modern décor with its use of mirrors and angles is usually found on the Champs-Elysées. But there or in Montmartre, in a place of this class, you would have to buy champagne at 300 francs. Here prices are possible; and champagne is not the thing to do in any of the dancing places in Montparnasse. 'Tout-Montparnasse' comes here. The clientele is primarily American. Very pretty women frequent this elegant place."

Lyre et Palette
6 Rue Huyghens (8)

When the war broke out in 1914, the French government closed all theaters, concert halls, and places of musical entertainment. This left composers and musicians completely without an audience. The young Swiss painter Emile Lejeune, who had a large studio at the

end of the courtyard at 6 Rue Huyghens, opened it to performers and began to hold regular Saturday evening concerts there in the summer of 1915. The concerts attracted the younger French composers Germaine Tailleferre, Arthur Honegger, Georges Auric, and Louis Durey, who performed Erik Satie's music, and later their own; after the war, this group—with Francis Poulenc and Darius Milhaud added—coalesced under the name "Les Six." Ortiz de Zarate suggested to Lejeune that Lyre et Palette hold regular exhibitions of paintings. The first exhibition opened on November 19, 1916, with works by Modigliani, Picasso, Matisse, Kisling, and Ortiz de Zarate; in addition, Paul Guillaume's collection of primitive sculpture was shown as art for the first time. In connection with the exhibition, a program of poetry readings by Apollinaire, Pierre Reverdy, Blaise Cendrars, Max Jacob, André Salmon, and Jean Cocteau (reading the poems of his six-year-old niece) was held on November 26. These activities attracted wealthy art lovers from the Right Bank, whose limousines would line the narrow street. The concerts, exhibitions, and poetry readings continued until the spring of 1918, when the Germans began to shell Paris with their new long-range artillery gun, nicknamed Big Bertha, and many artists were forced to flee the city.

Crémerie Leduc
212 Boulevard Raspail (9)

The poorer artists in Montparnasse were dependent for their survival on the credit extended to them by the owners of the small restaurants, cafés, and bars, by landlords, paint dealers, and other shopkeepers. Few debts were left unpaid. If an artist returned to his native land without paying, he would send the money from there or his countrymen paid for him; no one wanted his nationality to get a bad reputation among the merchants of Montparnasse and risk losing future credit. One eating place that extended credit to its regular customers was the Crémerie Leduc, where M. Leduc fried beefsteaks and cutlets for several generations of artists in his underground kitchen on the Boulevard Raspail, always emerging among his customers in a spotless chef's outfit. The cost of the entire meal was only one franc fifty. When a regular customer left, he just put his bill on the spindle in front of the smiling Mme. Leduc, who sat on a tall chair at the cash register. André Salmon remembers that when he first came to Montparnasse in 1903 and ate at Leduc's he didn't realize that the regulars were eating on credit and thought that he was "among people who were very wealthy and could have two meals a day there without even thinking about it." And later, Carl Palme wrote that "Crémerie Leduc never had cause to regret their credit policy. One day in 1911 Mme. Leduc told me:

'Today a check arrived from that Argentinian, the beautiful young man who owed for two years of meals.' It had been seven years since he left, and the check included accumulated interest—so Madame invited everyone to drink Burgundy."

Studio Building
216 Boulevard Raspail (10)

Ossip Zadkine remembers visiting Modigliani in his studio at No. 216 in the spring of 1913. "Through a passageway I penetrated into a long narrow courtyard which opened into a vacant lot, whose large trees shaded the two or three studios that lay along the wall of the courtyard. Modigliani's studio was like a glass box. Coming near, I saw him lying on his tiny bed. Around and everywhere the white sheets of his drawings covered the walls and the floor. He got up and put on his gray velvet suit. . . . Lifting up the sheets of drawings he showed me his sculptures, the stone heads, perfect ovals along which ran noses like arrows toward the mouth." Nina Hamnett added in her memoirs that "Modigliani would often come home at two or three in the morning and start to carve stone. The neighbors, hearing the tap, tap of his chisel decided that he was a crazy man."

On this site in 1932, Edward Titus and Helena Rubinstein built two modern studio buildings housing fourteen studios, designed by the architect Elkuken. The complex also contained a 300-seat theater, where Titus intended to produce "avant-garde plays not played elsewhere before, and perhaps to show some of the more modern cinematic productions," which he would choose in consultation with Man Ray.

Le Restaurant Baty
201 Boulevard Raspail (11)

The restaurant Baty occupied two rooms on the ground floor of the building that housed the Hôtel de la Haute Loire. Outside, baskets of oysters were stacked up, which were opened all day long by Mme. Baty. Inside, the floor was tiled and covered with sawdust. The old building still contained a vestige of the fighting that took place during the Commune of 1871—an unexploded shell lodged in the wall, which M. Baty would show diners with great pleasure. A dinner at Baty in 1913 cost 2 francs 50, but certain wines could double the bill. It was the wines that made Baty famous. According to Fuss-Amore in his history of Montparnasse, "If his kitchen did not arouse any enthusiasm among his clients, they could make up for it with an excellent Chateauneuf-de-Pape, a perfect Beaune, and a delicious Monlouis. Père Baty practiced the cult of the bottle, and his wine cellar was the object of his constant

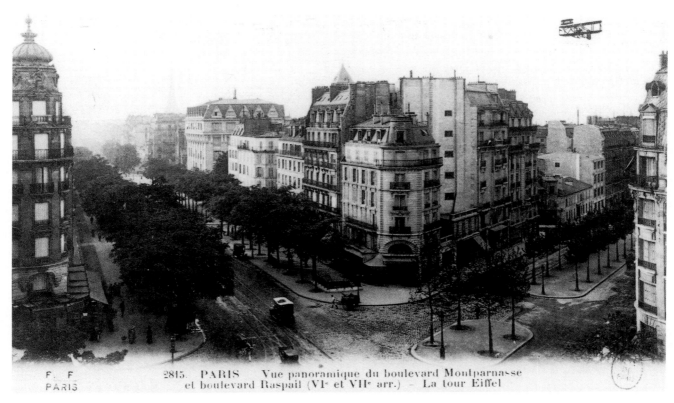

Figure 69 View of Boulevard Montparnasse and Boulevard Raspail. Billy Klüver Collection. All rights reserved.

care. He grumbled at all his customers, but he tested each bottle that was served and sent it back if it wasn't good enough."

Picasso moved to Montparnasse toward the end of the summer of 1912; and for the next four years he, Apollinaire, Max Jacob, André Salmon, and Ortiz de Zarate were regulars at Baty. In the fall of 1913 the Baroness Hélène Oettingen, who was a painter, poet, novelist, and critic—each activity pursued under a different pseudonym—took a studio on the top floor of a new building at 229 Boulevard Raspail. She and her cousin Serge Ferat took over the support of and became active contributors to the literary magazine *Les Soirées de Paris*, edited by Apollinaire. The headquarters of the magazine was in Ferat's studio on the ground floor of 278 Boulevard Raspail, so that activities surrounding the magazine and Oettingen's weekly salons increased the traffic at the Carrefour Vavin. Soon the group at Baty expanded to include Léger, Zadkine, Archipenko, Survage, Chagall, Maurice Raynal, Modigliani, Blaise Cendrars, Soffici, Severini, de Chirico, Gris, and other Cubist and Futurist artists and writers associated with the magazine.

Studio Building
86 Rue Notre-Dame-des-Champs (12)

Rue Notre-Dame-des-Champs is an old winding street that dates back at least to the 14th century. Painters, sculptors, and writers settled there in the early part of the 19th century, alongside the schools, convents, and residences of religious orders already there. In 1868 Bouguereau built his extravagant *hôtel-particulier* and studio in the courtyard on the south side of the building at No. 75. John Singer Sargent kept a studio on the top floor next door at No. 73 during the 1870s. In the early 1860s Gérôme occupied one of the studios across the street at No. 70. The studio building at No. 86, built in 1880, had four levels of studios with double-height floors. In 1888, on the top floor, Auguste Delécluse started an academy which held mixed courses where women drew the nude model alongside men. But three years later he moved his academy elsewhere, and Whistler moved into the studio with his etching press. In October 1901 Whistler left the studio, which was taken over by a German painter, Richard Goetz, who had come to Paris in 1900. Goetz showed in the Salon des Indépendants, but when he returned to Paris after World War I, he gave up painting and started to collect French art. Facing a severe shortage of studio space in

Montparnasse after the war, the Swedish painter Isaac Grünewald thought himself very lucky to find the top floor studio empty and in September 1920 moved in with his wife, the painter Sigrid Hjertén, their child, and a nursemaid. The floor below was occupied by Fernand Léger and his wife Jeanne; Léger moved there in 1916 and lived there for the rest of his life. Othon Friesz became a popular teacher for many years at the Académie Moderne, which opened in an adjoining studio building at No. 86 after the war; Amédée Ozenfant also taught there briefly.

Académie Ranson
7 Rue Joseph-Bara (13)

The painter Paul Ranson, a friend of Gauguin and later a founding member of the Nabis group, established an academy at 21 Rue Henri-Monnier in Montmartre in October 1908. When he died a few months later in February 1909, his wife took over the direction of his academy. In 1911 the Académie Ranson moved to Montparnasse. Members of the Nabis group, Pierre Bonnard, Maurice Denis, Paul Sérusier, Edouard Vuillard, were among those who taught there. In her memoirs Alice Halicka describes studying there in late 1913 and 1914.

La Jungle
127 Boulevard du Montparnasse (14)

This "bar-dancing" which opened in 1927 was typical of the many night clubs that opened in Montparnasse in the late 1920s. The Jungle was decorated by the American artist Hilaire Hiler, who in November 1923 had opened the first night club in Montparnasse, The Jockey, at 146 Boulevard du Montparnasse, and made it a success by inviting his artist friends to come there as if it were their home. Jimmy Charters, who was the first barman at The Jungle, describes it with a professional eye: "Henri, the former manager of the Jockey, bought the Monaco, a bar of the same sort, which he renamed The Jungle. The Jungle was filled with a young crowd of the rah-rah type. . . . We made money hand over fist, for we served inferior drinks at fancy prices on the excuse that we had an orchestra."

André Thirion, one of the young Surrealists at 54 Rue du Château, was introduced to The Jungle by Louis Aragon: "The Jungle was all the rage in 1928. People were packed into a gloomy, vaguely exotic setting. Cheek-to-cheek with their partners, people would dance to blues in an area the size of three sidetables. Some of the songs, sad and spell-binding—for instance, 'Crazy Rhythms, Crazy Blues'—were played over and over, creating a sensuous, sentimental, and depressing atmosphere. The most extreme tensions of love and

desire were achieved by the tune 'I Can't Give You Anything But Love.' "

Union des Artists Russes
4 Rue de la Grande-Chaumière (15)

This organization came into being in the early years of the century to represent the large Russian community in Paris and in 1905 was located at 25 Boulevard du Montparnasse; after World War I, the Union was located at 4 Rue de la Grande-Chaumière. Its long-time president was D. O. Widhopff, an older artist very well-respected in the Russian community, who was the subject of a major sculpture by Chana Orloff. Under his leadership during the 1920s, the Union organized exhibitions of Russian artists in Belgium, Italy, and America. To raise funds to help the poorer artists, the Union had from its earliest days organized costume balls at Bal Bullier and other dance halls. Marevna describes one such charity ball before the war: The Russian artists helped with the decorations which included greenery, flowers from the south, garlands, and many-colored lanterns. On the walls were paintings donated by the artists to be auctioned to raise additional money. Beginning at eleven o'clock, "the cream of the Russian colony came, and rich and eminent French society figures, industrialists and bureaucrats, journalists and art critics." After performances by some music hall personalities, the dancing started. Attractive ladies from the ball committee sold Russian food and drink from heavily laden buffet tables, and Marevna, dressed as a Russian peasant boy, circulated through the crowd selling vodka and hot honey. As the evening progressed, waltzes and tangos gave way to unbridled Russian folk dances. Impromptu groups formed to sing the old Russian songs, until the ballroom began to empty at about five or six the next morning. Proceeds from these prewar balls were also used to support the short-lived Russian Academy, started in 1910 by Marie Wassilieff at 54 Avenue de Maine, and taken over by Sergei Boulakovski, who headed the sculpture studio. During the 1920s, the Russian balls emphasized abstract themes and imaginative costumes. The Bal Banal, announced for March 14, 1924, took a slap at academic art and promised to set the record for banality in that year.

Studio Building
8 Rue de la Grande-Chaumière (16)

An artist named Emile Delaune constructed this building from material salvaged from the 1889 Paris World Exposition, and Gauguin lived here briefly in 1893. In June 1917, when Jeanne Hébuterne left her parents' home to live with Modigliani, Léopold Zborowski found them a studio here, on the top floor of the studio

building in the courtyard. It had two narrow connecting rooms, each of which was only 8 × 15 feet. The room in which Modigliani painted had only a small stove, a couple of chairs, an easel, and a large table with his painting materials. On the light-colored walls were painted large patches of different colors, which Modigliani used as backgrounds for his portraits. After Modigliani's death in January 1920, Nina Hamnett and the Polish painter Zawado took over Modigliani's studio.

Académie Colarossi
10 Rue de la Grande-Chaumière (17)

The Académie Colarossi grew out of the Académie Suisse, the first "free academy" in Paris, which was started in 1815 on the Quai des Orfèvres by M. Suisse, a former artist's model from Switzerland. It gave no classes, but it provided a large, well-lighted room with a model, where an artist could draw from 6 A.M. to 10 P.M. for only 10 francs per month. In 1870 it was taken over by Colarossi, who changed the name and moved it to the Rue de la Grande-Chaumière. A former model himself, Colarossi had been supervisor of models at the Ecole des Beaux-Arts and asked several of the academic maîtres he knew to conduct more formal studio classes at his academy. Most of the artists who arrived in Montparnasse from 1905 to 1913 did not enter (or did not stay long in) formal courses of study but instead would attend sessions at Colarossi's and other academies in Montparnasse for the opportunity to draw from the model. Marevna describes the Académie Colarossi when she drew there in 1912: "The crowd there was made up of all nationalities and all the rooms were generally packed. The clothed models—men, women and children—were usually Italian, and looked out of their element in the chilly fog of Paris. . . . In the room where we drew from the nude the air was stifling because of an overheated stove, and the model perspired heavily under the electric light. . . . It was an inferno, rank with the smells of perspiring bodies, scent and fresh paint, damp waterproofs and dirty feet, tobacco from cigarettes and pipes, but the industry with which we all worked had to be seen to be believed."

Académie de la Grande-Chaumière
14 Rue de la Grande-Chaumière (18)

This academy was started in 1906 by Castelucho, the artist brother of a paint dealer who had his shop next door at No. 16. Castelucho headed one of the studios at the academy himself, and for several years the sculpture studio was headed by Antoine Bourdelle, a long-time student of Rodin. Thora Dardel, who studied there in 1919, recalls her sculpture teacher: "M. Bourdelle, a charming and lively man, small, balding with a beard, had an unusually intelligent and alert look in his playful eyes. Sometimes he didn't come for three or four days, but when he arrived, everyone got very busy. His corrections were friendly and encouraging; but I couldn't understand how he could show so much interest in each student. All the students had, of course, warm regard for the teacher . . . even too warm from some quarters."

Model Market
113 Boulevard du Montparnasse (19)

The "*Pompiers*," or academic painters of the 19th century, needed a variety of models to portray the Greek goddesses, Roman warriors, saints, and madonnas that were the subjects of their paintings. To fill this need, every Monday morning whole families of Italians gathered outside 113 Boulevard du Montparnasse, spilling down the Rue de la Grande-Chaumière, where the artists or *massiers* (student monitors) from the academies would come to select models for the week's classes. Christian Krohg, a maître at the Académie Colarossi from 1902 to 1909, fluent in French, German, English, and Norwegian, taught an international mix of students whose work he corrected in all four languages. During that time, he lived with his family at 3 Rue Huyghens. His son, Per Krohg, remembers the two-story house next door, full of families of Italian models: "You heard laughter and screams, fights and singing, and little kids running up and down the staircase. They lived close together like the Arabs in the desert, completely separate from the rest of the world. Every Monday morning, they moved smiling and expectant,—old bearded and painterly men, women who had once been beautiful and who still had melancholy eyes, young ripe girls sometimes with an additional child in their arms—across the boulevard and down the Rue de la Grande-Chaumière. They stood outside the entrance to the Académie Colarossi, which was situated in a garden behind an ordinary apartment house. There were so many of them that they completely blocked the street. They were patient and waited for the different *massiers*, a kind of student monitor who got free tuition as payment, who came to make the first choice of three to four Italians for each class. They undressed behind a screen and there the students chose the model for the week and decided on the model's pose. When this was over, those not chosen went home and the usual commotion began there again."

At the outbreak of World War I, the French government decided that foreigners without a profession would have to leave France. Since modeling was not recognized as a profession, the Italian models had to

pack up and leave almost overnight. After the war, this decision led to a critical shortage of professional models for the academies and artists, who bitterly complained about their government's rash act.

Hazard
113 Boulevard du Montparnasse (20)

The large number of foreign artists in Montparnasse in the late 19th century led to the appearance of an extraordinary food store, described by Apollinaire as follows: "On one of the corners of the Boulevard du Montparnasse is a grand delicatessen which opened the eyes of artists of all nationalities with its enigmatic name: 'Hazard.' Its merchandise is more varied and its clients are of all sorts. Before the war, the Americans could find *pamplemousses*, which they called 'grapefruits,' and which are to lemons as watermelons are to cantaloupes; the Russians could find tomatoes which resemble large cherries; the Hungarians could find meat seasoned with paprika, etc."

During the 1920s, a generation of people the world over came to Montparnasse. Every day, thousands of people would sit at the cafés—the Rotonde, the Dôme—or meet at the bars—the Select, the Dingo, the Vikings—creating in Montparnasse an intoxicating mix of painters, writers, sculptors, poets, actors, industrialists, art dealers, collectors, stockbrokers, con-men, tourists, and long-time residents of the quarter. Jimmy Charters, who presided over a succession of bars in Montparnasse, describes the Montparnasse phenomenon: "From the ends of the earth thousands and thousands came to Montparnasse to drink to the discovery of new-found ideas in art, unaccustomed freedom, new loves . . . All kinds were for once woven into a close community determined to enjoy the things they had always wanted. . . . There was no limit to this freedom."

The Wall Street crash of 1929 and the world-wide depression that followed effectively put an end to this phase of Montparnasse life. The tourists disappeared seemingly overnight, the art market plunged, and some foreign artists returned home. However, the artists' community survived and the artists continued to live on under harsher economic conditions, preserving the spirit of friendliness, cooperation, and camaraderie through World War II. During the 1950s, though, all vestiges of the Montparnasse artists' community finally disappeared and, at the same time, Parisian intellectuals began to show a preference for a new activity—discussing philosophy and literature—which was centered in the cafés of St.-Germain-des-Prés. As tourism revived with post-war prosperity, this area attracted somewhat the same crowd as Montparnasse in the

1920s. During this period, even La Coupole had a hard time surviving.

However, a surprising number of the old studio buildings exist today, although the studios are seldom occupied by artists. The zinc bar at the Dôme is still there and the interiors of La Coupole and the Select have not been changed. Thus, the story of Montparnasse—the story of a vibrant artists' community that created an environment of openness and equality unequaled in our time—is over; but the spirit of Montparnasse, embodying the dream of personal and artistic freedom, survives to inspire new generations today.

Note: In the text and on the street map, all street names have been given according to present-day official usage.

Passages originally in French, Swedish, or Norwegian that have been quoted in the text were translated by Billy Klüver.

The authors wish to thank Jill Krauskopf, for her assistance in preparing this article and the accompanying maps, and Annie Tolleter and Mary Papadakis, for their assistance in research in Paris.

Copyright © 1985 by Billy Klüver and Julie Martin.

NOTES

Introduction and Conclusion: Harrison C. White and Cynthia A. White, *Canvases and Careers: Institutional Changes in the French Painting World* (New York: Wiley, 1965). Their original estimates of the population of Paris have been adjusted for women and foreign artists. James Charters, *This Must Be the Place* (London: Herbert Joseph, 1934).

La Rotonde: Gunnar Cederschiöld, *Efter levande modell* (Stockholm: Natur och Kultur, 1949); Ilya Ehrenburg, *People and Life 1891–1921*, translated by Anna Bostock and Yvonne Kapp (New York: Knopf, 1962); Gustave Fuss-Amore and Maurice des Ombiaux, *Montparnasse* (Paris: Albin Michel, 1925); André Salmon, *Montparnasse* (Paris: André Bonne, 1950); F. U. Wrangel, *Minnen från konstnärskretsarna och författarvärlden* (Stockholm: Norstedt & Söners, 1926).

Café du Parnasse: Fuss-Amore and Ombiaux, *Montparnasse*; André Warnod, *Les Berceaux de la jeune peinture* (Paris: Albin Michel, 1925).

Le Select: Jean-Emile Bayard, *Montparnasse: Hier et aujourd'hui* (Paris: Jouve 1927); Morley Callaghan, *That Summer in Paris* (New York: Coward McCann, 1963); Youki Desnos, *Les Confidences de Youki* (Paris: Fayard, 1957); authors' interview with Jacqueline Goddard.

La Coupole: Authors' interviews with René Lafon, Jacqueline Goddard, and André Thirion.

Le Dôme: Friedrich Ahlers-Hestermann, "Der Deutsch Künstlerkreis des Café du Döme in Paris," *Kunst und Künstler*, vol. 16 (1918), pp. 369–401; Archives de la Seine, Dossier Voll, Ernest Hemingway, *A Moveable Feast* (New York: Scribner, 1964); Carl Palme, *Konstens Karyatider* (Stockholm: Rabén & Sjögren, 1950); *Pariser Begegnungen 1904–1914*, catalogue for exhibition October 16–November 28, 1965, Wilhelm-Lehmbruck-Museum der Stadt Duisburg, Germany, 1965; Abel G. Warshawsky, *The Memories of An American Impressionist* (Kent, Ohio: Kent State University Press, 1980).

Hôtel des Ecoles: Thora Dardel, *Jag for till Paris* (Stockholm: Bonniers, 1941; Man Ray, *Self-Portrait* (New York: McGraw-Hill, 1963); *Kiki's Memoirs* (Paris: Black Manikin Press, 1930); Michel Sanouillet, *Dada à Paris* (Nice: Centre du XX Siècle, 1980);

Le Studio-Hôtel: Bayard, *Monparnasse*; Charters, *This Must Be the Place*; Marc Quelen and Isabelle Crosnier, *Analyse des immeubles d'artistes à Paris: De l'atelier d'artiste à la machine à habiter; et Inventaire des immeubles d'ateliers d'artistes à Paris: Elaboration du corpus d'étude*, unpublished thesis, L'Unité Pédagogique d'Architecture, Université de Paris No. 6. 1983; *Tous les amusements de Montparnasse* (Paris: Guides parisiens, 1931).

Lyre et Palette: Emile Lejeune, "Montparnasse à l'époque héroïque," *La Tribune de Genève*, 15 installments (January 25–March 19, 1962).

Crémerie Leduc: Palme, *Konstens Karyatider*; Salmon, *Montparnasse*; Wrangel, *Minnen*.

216 Boulevard Raspail: Hugh Ford, *Published in Paris* (New York: Macmillan, 1975); Nina Hamnett, *Laughing Torso* (New York: Long & Smith, 1932); Quelen and Crosnier, *Analyse des immeubles d'artistes*; Ossip Zadkine, "Souvenirs . . . ," *Paris-Montparnasse*, no. 13 (February 1930).

Le Restaurant Baty: Bayard, *Montparnasse*; Fuss-Amore and Ombiaux, *Montparnasse*; Hamnett, *Laughing Torso*; Salmon, *Montparnasse*; Jeanine Warnod, *Léopold Survage*, (Paris: André de Rache, 1983).

86 Rue Notre-Dame-des-Champs: Bayard, *Montparnasse*; *Pariser Begegnungen 1904–1914*; Quelen and Crosnier, *Analyse des immeubles d'artistes*; Stanley Weintraub, *Whistler: A Biography* (New York: Weybright and Talley, 1974); *William Bouguereau*, exhibition catalogue, Musée du Petit Palais, Paris, 1984.

Académie Ranson: Bayard, *Montparnasse*.

La Jungle: Henri Broca, "Hilaire Hiler," *Paris-Montparnasse* no. 3 (April 15, 1929); Charters, *This Must Be the Place*; Anatole Jakovsky, *Les Feux de Montparnasse* (Paris: Bibliothèque des arts, 1957); Jack Lindsay, *Cézanne: His Life and Art* (Greenwich, Conn.: New York Graphic Society, 1969); André Thirion, *Revolutionaries Without Revolution*, translated by Joachim Neugroschel (New York: Macmillan, 1975).

Union des Artistes Russes: Iliazd, exhibition catalogue, Musée National d'Art Moderne, Centre Pompidou, Paris, 1978; Marevna, *Life with the Painters of La Ruche*, translated by Natalie Heseltine (New York: Macmillan, 1974); Warnod, *Berceaux*.

8 Rue de la Grande-Chaumière: Archives de la Seine, Cadastre DIP4; Bengt Danielsson, *Gauguin in the South Seas* (Garden City, N.Y.: Doubleday, 1966); Hamnett, *Laughing Torso*; Quelen and Crosnier, *Analyse des immeubles d'artistes*; Pierre Sichel, *Modigliani: A Biography* (New York: Dutton, 1967).

Académie Colarossi: Bayard, *Montparnasse*; Lindsay, *Cézanne*; Marevna, *Life with the Painters*.

Académie de la Grande Chaumière: Bayard, *Montparnasse*; Dardel, *Jag for till Paris*; Warnod, *Berceaux*.

Model Market: Bayard, *Montparnasse*; Fuss-Amore and Ombiaux, *Montparnasse*; Per Krohg, *Memoarer* (Oslo: Gyldendal, 1966).

Hazard: Guillaume Apollinaire, *La Femme assise* (Paris: Gallimard, 1948).

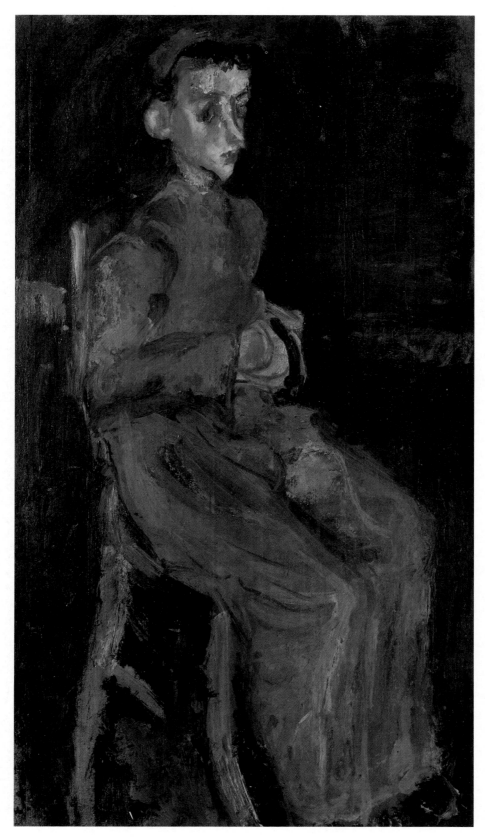

Figure 70 Chaim Soutine, *Choir Boy*, 1930 (cat. no. 105). Dr. Ernest Kafka
Collection

THE "ECOLE FRANÇAIS" VS. THE "ECOLE DE PARIS"

THE DEBATE ABOUT THE STATUS OF JEWISH ARTISTS IN PARIS BETWEEN THE WARS

BY ROMY GOLAN

In a poll carried out in August 1925, the Parisian magazine *L'Art vivant* asked prominent members of the art world which ten living artists should be represented in a new museum of modern French art, if one were to be built in the near future. Moïse Kisling, one of the most prominent figures of Montparnasse, answered thus: "Simon Lévy, Léopold Lévy, Rudolph Levy, Maxime Lévy, Irène Lévy, Flore Lévy, Isidore Lévy, Claude Lévy, Benoit Lévy, et Moïse Kisling."[1] This statement, which the editors hastily described as whimsical and which indeed sounded rather ludicrous, was not merely a joke. Kisling's answer was in fact a quite pointed response to an article published in the widely read and respected literary magazine *Mercure de France* exactly one month earlier, titled "Is There Such a Thing as Jewish Painting?," by the art critic Fritz Vanderpyl. Vanderpyl's attempt was a discrediting one and symptomatic of the climate that surrounded the sudden ascendency of Jewish artists on the Parisian art scene during the 1920s:

> In the absence of any trace of Jewish art in the Louvre [that is, in the whole evolution of western art, Vanderpyl argued], we are nevertheless witnessing a swarming of Jewish painters. In the post-war salons the Lévys are legion, Maxime Lévy, Irène and Flore Lévy, Simon Lévy, Alkan Lévy, Isidore Lévy, Claude Lévy, etc.... Without taking into account the Lévys who prefer to exhibit under pseudonyms, a move that would be quite in line with the ways of modern Jews, and without mentioning the Weills, the Zadoks, whose names one comes across on every page of the salon catalogues.[2]

The critic's conclusion was that there was no real Jewish style, although he specifically pointed to Kisling's as notably Jewish without offering any explanation as to how it was so. Trying to explain this so-called Jewish invasion of French art (and its market) in wider terms, he saw it as the result of the general decline of the French pictorial tradition since the Impressionists. He went on to declare that it was elicited by Jewish greed rather than the earnest desire for artistic creation, a greed that was gratified now that art had become such a speculative venture.

Vanderpyl's was the first in a series of three essays on the "problem" of the emergence of Jewish painting published in the *Mercure de France*, each one more defamatory than the next. It was followed a month later by Pierre Jaccard's pseudo-scientific "L'Art grec et le spiritualisme hébreux."[3] Jaccard's claim was that it was the utter incapacity of the Semitic race to produce any kind of naturalistic art that lay at the root of the secular iconoclasm of Judaism through the centuries. The diametrical opposite, according to the author, was the formal idealism of Hellenistic art.

To be sure, rampant xenophobia tinged with a good dose of anti-Semitism was hardly new in the country that had staged the Dreyfus affair—the *cause célèbre* of the 1890s—and that had been in the last decades of the 19th century the laboratory for much of the political theory of extreme chauvinism and nationalism.[4] Meanwhile, in the years during and immediately following World War I, political grievance was increasingly injected into the art historical discourse. Thus at a time of a general resurgence of anti-Semitism in the wake of the political national consensus of all French parties and minorities in order to face the war, the artistic avant-garde was nevertheless attacked for being not only "*boche*" (derogatory for "Germanic") but Jew-

ish as well. At the same time, the art world, far from being the last outpost of apolitical esthetic activity (which it is so often thought to be) was, on the contrary, the sector most vulnerable to the latent waves of xenophobia and anti-Semitism that were affecting French social and political life. The reason for these sporadic outbursts is all too easy to identify. More than any other cultural domain in France, it seems, the visual arts were characterized since the pre-war years by a conspicuous presence of Jews in nearly every area of activity. Thus in 1915 one can find a reference to a lecture titled *On the Influence of the Judeo-German Corporation of Parisian Art Dealers on French Art*, delivered and published by a man called Tony Tollet.

This state of affairs was all the more true in the 1920s, a decade of general confidence and contentment in France as a result of the rapid achievement of post-war prosperity there. It was also a period during which France intentionally accepted more immigrants than any other country in the world. This was partly in order to meet its need for manpower after the population loss in the war, which was made worse by the fall in the national birth rate. While immigration was welcomed as long as it was a means to make up for specific deficiencies in the economy, things went differently in the art world. Here one can see that the increasing prominence of the Jewish artists of Montparnasse, which came even to exceed that of Jewish dealers and collectors, was accompanied by a surge of anti-Semitism in response to it. Thus the debate taking place in the pages of *Mercure de France* in 1925 preceded by nearly a decade much of the argumentation on the so-called "Jewish problem," which began to be played out in the political arena by the mid-1930s and led directly to Vichy.

Another issue intrinsically related to everything said up to now was the almost obsessive desire to redefine and reassert the notion of French tradition in the visual arts. Born from the ashes and disruption of World War I,[5] it acquired an increasing intensity during the inter-war years.[6] What was at stake was the preservation of the purity of the *Ecole Française* (the French School, a term used to indicate art made in France by native Frenchmen) from the contamination of foreign artists living in Paris and from foreign artistic influences in general. In the process, terminology had to be readjusted. Thus the term *Ecole de Paris* (School of Paris, which had been used rather loosely in reference to all modern art produced in Paris during the immediate post-war years) came to be applied solely to foreign artists working in Paris—to a large extent, the Jewish artists of the circle of Montparnasse. More concrete measures had been taken already at the outset of the 1920s in order to separate things French from things foreign. In 1922 an annex to the Musée du Luxem-

bourg was established in the Musée du Jeu de Paume in the Tuileries Gardens to house and exhibit exclusively foreign art.[7] Less benign was the decision in 1923 of Paul Signac, then president of the Salon des Indépendants, to exhibit the works according to nationalities. This was the result of years of perennial complaints in the columns of the mildly conservative periodicals *L'Amour de l'art*, *L'Art vivant*, or *Le Carnet de la semaine* by prominent critics of the time, like Louis Vauxcelles, Jacques Guenne, and Maximilien Gauthier, every time they came to review the yearly salons. These exhibitions were, they argued, swamped, invaded, and debased by a torrent of foreigners with a noxious and weakening influence on indigenous artists. The decision provoked a controversy that came to be known as the "Quarrel of the Independents,"[8] and Louis Vauxcelles announced scornfully in the *Carnet de la semaine*, "It seems that the decision has caused the high society of Montparnasse [*le tout-Montparnasse*] to rise in indignation. The [Café de la] Rotonde, where all the dialects on earth are spoken, sometimes even French, will be the site of demonstrations against the nationalist committee of the [Salon des] Indépendants."[9] The names most commonly cited during the debate in contemporary art journals were those of Kisling, Simon Mondzain, Jacques Lipchitz, and Jules Pascin—i.e., the Jewish artists of Montparnasse.

Those who had come to exemplify the *Ecole Française* in the minds of these conservative spokesmen of French culture were such artists as André Derain, Dunoyer de Segonzac, Maurice Vlaminck, and Othon Friesz. These painters—ex-Fauves or ex-satellite Cubists—had been members of the avant-garde at the edges of the mainstream Parisian art scene during the pre-war years. Yet, by the 1920s, they had turned to a conservative style which, for lack of a better term, can be described as a form of Regional Naturalism. In the minds of these artists and the critics who supported them, the city of Paris had gradually come to merge with the pejorative descriptions of Montparnasse as a decadent, bohemian place. Accordingly, supported by their ideological convictions, they abandoned the metropolis in favor of the French countryside, often going back to their home provinces. Some of these artists belonged to the landed gentry and went to live on their estates; others conformed to the revived image of the artist/gentleman-farmer by acquiring some land. This kind of return to the soil was hailed as invigorating, virile, and moral, a pointed contrast to the goings-on of the metropolis. The new polarity set up between city and country was meant to exclude the foreigners from a rural world that came to be seen as the wellspring of French culture. Along with this ideological construct, the iconography of the *Ecole Française* was rustic and intentionally anachronistic. Accordingly, their paint-

ings were characterized by a predominance of earth colors and a stylistic emphasis on *métier* (craftsmanship, achieved through the slow elaboration of easel painting). Most important, these artists openly embraced the increasingly prevalent notion of "lineage" in French painting—the unbroken line in the history of French art from the 15th to the 19th century comprising such masters as Fouquet, Poussin, the Le Nain brothers, Corot, Courbet, and Cézanne.

Each of these characteristics was understood as a counterpoint to the "idiosyncrasies" of the art produced by the foreigners living in Paris—the allegedly "messy" painterliness, the "frenzied" Romanticism, the "hasty" and "weak" execution, the "harsh coloring" of painters such as Chaim Soutine (fig. 70), Michel Kikoïne, Pinchus Krémègne, and Mané-Katz—evidence of their incapacity to truly comprehend and appreciate the French tradition.

One often finds the sharpest attacks against Montparnasse in monographic articles and books supposedly devoted to the figures of the French School. In an article on the painter Othon Friesz, published in *L'Amour de l'art* in 1928, Charles Vildrac's introductory remarks went as follows: "The French School is virtually submerged by a wave of students coming from every corner of the earth. They hardly speak French, yet they speak it loudly and anyone gains French citizenship [*se fait naturaliser*] in Montparnasse."[10] Similar charges were made by the artists themselves—notably Vlaminck in his book *Tournant dangereux* of 1928. Louis Vauxcelles, himself a Jew (born Louis Meyer), in his review of a new monograph published on Dunoyer de Segonzac printed in *Le Carnet de la semaine*, went as far as to write:

> A barbarian horde has rushed upon Montparnasse, descending on [the art galleries of] Rue La Boëtie from the cafés of the 14th arrondissement [Montparnasse], uttering raucous Germano-Slavic screams of war. . . . Their culture is so recent! When they speak about Poussin, do they know the master? Have they ever really looked at a Corot? or read a poem by La Fontaine? These are people from "somewhere else" who ignore and in the bottom of their hearts look down on what Renoir has called the gentleness of the French School—that is, our race's virtue of tact.[11]

The apocalyptic image of the barbarian hordes invading from the East in order to destroy French culture was not new. It had been the most commonly used metaphor to describe the Germans during World War

I, and it re-emerged throughout the 1920s. In 1925, for instance, the literary review *Cahier du mois* devoted a whole issue to an inquiry on the pernicious influences of the Orient on French culture, interviewing such men of letters as André Gide, Paul Valéry, and the now-forgotten winner of that year's Prix Goncourt, the arch-regionalist writer Henri Pourrat.[12] The following year, Henri Massis published a book called *The Defense of the West*, the Splenglerian title of which speaks for itself. The vision of barbarian hordes from the East could all too easily be applied by the late 1920s and early 1930s to the large influx of Jewish immigrants—all the more since the overwhelming majority of them came from Eastern Europe as a result of pogroms in Russia and Poland. Vanderpyl invoked this apocalyptic image in his chapter on Marc Chagall in *Peintres de mon époque*, published in 1931.

When Adolphe Basler, also a Jew, and a man who was directly involved with the Jewish artists of Montparnasse both as a critic and as a dealer, was asked to reply to the articles by Vanderpyl and Jaccard in the *Mercure de France*, mentioned above, he argued in favor of assimilation.[13] The Jews, Basler explained, having overcome the stage of life in the ghettos, were able to reflect the artistic culture of the country in which they now lived, as opposed to continuing to express their ethnic heritage. By means of this argument, Basler managed to rescue the art of Amedeo Modigliani, Eugène Zak, Mondzain, and Kisling from the onus of their ethnicity, emphasizing instead their manifest debt to French painting. He obviously found this more difficult to do with Chagall, whom he merely dismissed as a folkloristic Russian image-maker, a crazy painter who had read too much Talmud. The artists on whom Basler centered his attacks—many of which, paradoxically, turned out to be similar to Vanderpyl's and Jaccard's—were Picasso and his followers, among whom he included the sculptors Lipchitz, Ossip Zadkine, and Chana Orloff. It was Picasso, he insisted, who was the authentic incarnation of the "pan-Semitic spirit," the true heir of the Arab ornamentalists and the Spanish Talmudists!

The problem of artistic assimilation of these foreign artists living in Paris was a particularly acute one in France, a nation traditionally inclined to accept the absorption of strangers as long as they spoke the French language or served the nation (for instance, by enlisting in its army). Just as the *Israélites*—the French word for French-born Jews—eagerly tried to differentiate themselves from the growing proportion of new East European émigrés by adhering to the values of the French gentile bourgeoisie, so painters like the Parisian Edmond Kayser and the Alsatians Léopold Lévy and Simon Lévy[14] were careful to adhere closely to the pictorial manner of the *Ecole Française*. Although Van-

derpyl had lumped these French-born Jews with the recent immigrants in his article in the *Mercure*, the prominent critic André Salmon, in his monograph of 1931 on Léopold Lévy, noted the distinction between the two groups. He included Lévy among the "natural heirs" of the French tradition, in contrast to the new-comers, who were merely dazzled by it, and described him as "A true Frenchman, . . . a man born with Mother France at his cradle." Yet the very fact that Salmon felt called upon to summon up such lofty na-tionalistic rhetoric to make his point testifies to the fact that, by the early 1930s, the distinction between indig-enous and foreign Jews was becoming less clear—in-deed, that the assumed "Frenchness" of the *Israélites* was no longer something to be taken for granted. The debate of the early 1930s in France concerning the two categories of Jews was powerful enough to bring forth a parody of the entire issue: Edmond Cahen's novel of 1930, *Juif, non. israélite! (Jewish, no, Israélite!)*, in which, as its title indicates, the French-born Jews can-not insist forcefully enough on their distinction from the foreign Jews. Cahen, for instance, tells of a gentile-looking young French lieutenant named Simon Lévy whose dying words to his young son were that he wished him to go on forever being what he himself so proudly was: "A farmer, a Frenchman, and an *Israél-ite*."

One can begin to see how the desire, conscious or not, to fit the French mold made itself felt even in the works of a number of Jewish artists of Montparnasse. The influence of Derain's slick classicizing is unmistak-able in the paintings of artists such as Adolphe Féder, Georges Kars, Mondzain, Zadkine, and Kisling (fig. 71). They succeeded in being compared to their exem-plars of the French School and in being connected to the historical lineage of French masters which the latter revered. Thus the critic Maurice Raynal in his 1924 monograph on Féder praised what he called Féder's native French brand of realism and saw him as one of the artists working to revive the venerable artistic values of the *Ecole Française*, values which, he argued, so many Frenchman persisted in ignoring.[15] The critic Jacques Guenne later compared Kars to Corot in an article in *L'Art vivant*,[16] and Waldemar George extolled the virtues of Mondzain's craftsmanship.[17] Mondzain and Zadkine, after having served in the French Army during World War I, both created openly nationalistic works in homage to France.[18] Mondzain sent the pastel *Pro Patria* (colorplate XIII) to the salons as his official entry in 1920; Zadkine participated in the 1925 *Expo-sition des Arts Décoratifs* with his work on the monu-mental sculpture *Pergola de la Douce France*, whose legendary Celtic figures—carved in a neo-Medieval style out of white stone from the quarries near the he-roic battlefield of Verdun—were adamantly chauvinis-

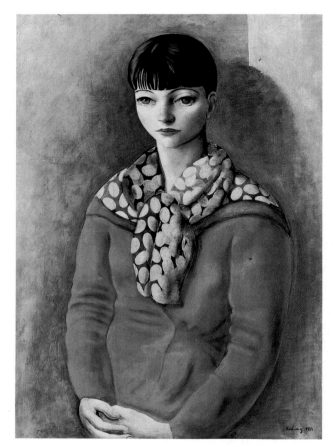

Figure 71 Moïse Kisling, *Kiki in a Red Dress*, 1933 (cat. no. 41). Petit Palais, Geneva

tic in their connotation.[19] Mondzain also produced in the following years a series of paintings with conspicu-ously Christian subjects, such as *The Monk* of 1919, The *Church of Auvers* of 1922, and *The Convent* of 1923. This was true even of Soutine who, although often considered the Jewish artist par excellence, in the 1920s made several paintings of choirboys (fig. 70) and in 1933, in one of his most ambitious paintings, de-picted Chartres Cathedral. Although signs of this same influence are somewhat less obvious, Féder, Kars, Mondzain, and Kisling were also following the lead of the *Ecole Française* in their representations of North African scenes, producing updated versions of French 19th-century "Orientalism." Whereas in the case of Chagall the lure of the Middle East was clearly a way to relate to a Jewish Biblical heritage, the sensuous Algerian female nudes of Kisling or the harbor scenes of Féder (fig. 72) corresponded instead to the main-stream type of representation of the French colonies produced by artists of the *Ecole Française* during the late 1920s and early 1930s, at a time when many

national schools in contemporary art.[22] The high-society portrait painter Jacques-Emile Blanche, although he commented on the Jews in general as being inbred and Soutine's paintings in particular as being degenerate, nonetheless indicated in the same article that the vigor of the Jewish artists on the Parisian scene compared favorably with what he considered to be the anemic and effeminate production of many French artists.[23] This kind of rhetoric reached an almost feverish pitch in a series of articles published by Camille Mauclair in 1928–29. These were obviously prompted by what had become the almost ubiquitous presence of the Jewish artists of Montparnasse both on the market and in the art journals and magazines. Mauclair was admittedly one of the most conservative spokesmen on the Parisian art scene, and *Le Figaro*, the newspaper for which he wrote, was a distinctly chauvinistic organ which consistently avowed the superiority of French culture in almost every field. Yet as biased as both the critic and the newspaper were, it is a fact that *Le Figaro* was among the most widely read and internationally respected French dailies. These articles were gathered together in 1930 in a book under the self-explanatory title *Les Métèques contre l'art français (The Foreigners Against French Art)*. The book was facetiously dedicated to dealers with fabricated names such as "Rosenshwein and Lévy-Tripp," as well as "to Montparnasse, filth of Paris," and, finally, to the "pseudo-critics" (whose names Mauclair would not divulge). His argument contained nothing new—it was largely a reiteration of the criticisms that had been raised elsewhere earlier in the debate over "the Jewish question" in art—but now it was carried on with a relentlessly evil tone. Montparnasse, Mauclair claimed, inhabited as it was "by 80 percent Semites and every one of them a loser," served as the breeding ground of all ills. Mauclair went so far as to urge the police to raid the place and to check the papers of its dwellers—a somber harbinger of what was to become a brutal reality, ten years before the actual advent of the collaborationist Vichy government. Calling for a defense of French art, he denounced the deceitfulness of the term *Ecole de Paris* to describe a school which was in fact composed of "foreigners" who pretended to teach the French how to paint.

For all of the intensity with which the argument was pursued, it was tame in comparison to the outcries against the Jews that were to be heard after the 1929 stock-market crash. France was affected slightly later than other European countries, but the effects, when they came, were far-ranging and long-lasting, and it can be said that the nation's economy never really recovered before World War II. With unemployment soaring to unprecedented levels, a new wave of generalized xenophobia arose against the foreign labor force that had been welcomed only a few years earlier. It

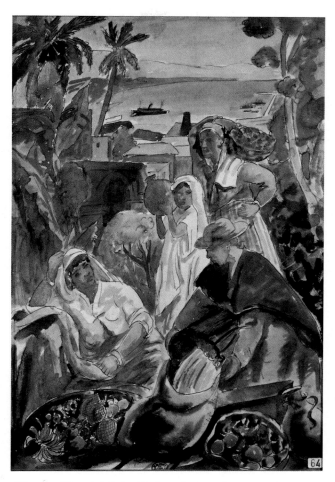

Figure 72 Adolphe Féder, *Colonial Harbor Scene*, ca. 1925–30. Tiroche Gallery, Tel Aviv.

seemed particularly eager to foster an image of "Imperial France."[20]

The ongoing debate on the status of Jewish artists in France was complex and became increasingly fraught with inconsistencies as the 1920s went on. Wilhelm Uhde, the German dealer and critic—not a Jew himself, but who had been close to a number of Jewish artists at the Café du Dôme (and who was briefly the husband of Sonia Delaunay)—considered the presence of Jews to be a mixed blessing.[21] Although he was opposed to Jewish dominance in cultural affairs, he nonetheless considered the Jews an indispensable element binding the disparate nations of Europe together and providing some degree of transcultural homogeneity. On the other hand, the critic Georges Rivière, making specific reference to Uhde's remarks, reversed the same argument: Where the German critic saw a healthy cosmopolitanism, the Frenchman saw only cultural pollution and lamented the resultant loss of recognizably

inevitably contained its share of anti-Semitism, all the more so since almost half of the Jews living in France by then were of foreign parentage. Furthermore, the Jewish émigrés lived for the most part in or near Paris. As could be expected, the crisis had direct repercussions on the art market, bringing it to a virtual standstill during the early 1930s.[24] Montparnasse was now accused of having been the hub of financial speculation and corruption during the years of the boom in the art market in the late 1920s, and its dealers were now blamed for having favored the art of foreigners at the expense of that of the French. The apocalyptic line of thought that had raised the specter of the barbarian hordes from the East mentioned earlier was now used to explain the crisis as a sort of Divine Purge. Not surprisingly, it is once again in an article on a prime figure of the *Ecole Française*—here, André Derain—that one finds comments such as these by André Flament in 1931:

> A powerful vacuum cleaner seems to have sucked up all the degenerates who used to show off on the hundred meters of sidewalk that stretch from the [Café du] Dôme to the [Restaurant] Pergola. . . . Sometimes one has to be thankful for financial disasters. The painters who have survived this frantic overproduction, this demonic storm, find themselves today freed from the influence that this savage mob had on their production.[25]

Titles of articles such as Elie Faure's "L'Agonie de la peinture" of 1930,[26] Georges Rivière's "Avons-nous encore un art français?" also of 1930, and Jacques-Emile Blanche's "La Fin de la peinture française" of the following year[27] sounded like so many trumpets of Jericho before what had once been the unassailable edifice of the French artistic tradition. They betray the feeling of decay and of a diminished sense of national purpose brought about by the Depression. A belief in the need to salvage an endangered French tradition on the brink of disintegration gathered such momentum as to elicit a radical shift of alliances on the part of two of the foremost supporters of the Jewish artists of the *Ecole de Paris*, André Salmon and Waldemar George. In 1931 Salmon asserted that, after having defended the foreign artists in Paris against attacks in the 1920s (which he sarcastically referred to as his *politique métècophile*—using the same word as Mauclair), he now found it necessary to insist upon the importance for French artists of drawing upon authentically French national sources transmitted down the centuries through a venerable lineage.[28] Even more extreme was the volte-face of Waldemar George—a French-born Jew—who, with the simultaneous publication in 1931 of a prominent two-part article entitled "Ecole Française ou Ecole de

Paris" in his new magazine *Formes*[29] and of the book *L'Esprit français et la peinture française*, became one of the staunchest champions of nationalism on the Parisian art scene. The wording of his title "Ecole Française *ou* [or] Ecole de Paris"—which is the inspiraton for the title of the present essay—sounded like a *sine qua non*, and implied nothing less than the total demise of the *Ecole de Paris*. The opening paragraph stated it bluntly:

> This term [*Ecole de Paris*], which dominates the world market, is a conscious, premeditated conspiracy against the notion of a School of France. It not only takes into consideration foreign contributions; it ratifies them and grants them a leading position. . . . It is a rather subtle, hypocritical sign of the spirit of Francophobia. It allows any artist to pretend he is French. . . . It has no legitimacy. It refers to French tradition but it in fact annihilates it. . . . Shouldn't France repudiate the works that weaken her genius?

And he continued:

> The School of Paris is a house of cards built in Montparnasse. . . . Its ideology is oriented against that of the French School. . . . The moment has come for France to turn in upon herself and to find on her own soil the seeds for her salvation.

The notion of conspiracy on the part of foreign Jews against the French heritage, which Waldemar George implied in so unfastidious a manner, was only too foreboding in the light of the events to come during World War II and, in retrospect, all the more chilling when heard from the mouth of a Jewish critic.[30] By the time of his book *Humanism and the Idea of the Fatherland*, published in 1936, George's political inclinations were clearly leaning in the direction of Italian Fascism. In the chapter called "Jewish Metamorphoses," which he acknowledged to be "a confession and a Mea Culpa," George set forth his belief—in agreement with many others at the time, including right-thinking Jews—that the only solution for what he saw as "the Jewish problem" was total and complete assimilation.

By the mid-1930s, as Michael R. Marrus and Robert O. Paxton have shown, it was generally agreed, even among political moderates, that there was something called "the Jewish problem" in France (and elsewhere).[31] As the debate gradually shifted to the political center stage and, by 1938, to even the upper echelons of the French administration—with the implementation of such concrete measures against the Jews as quotas, civil restrictions, and the need to present papers of identification upon demand, thus preparing the ground

for Vichy—the debate over the status of Jewish art in relation to French culture seemed no more than a discursive nicety. Not only did the general debate about the French School versus the School of Paris die out, but articles of any sort on individual Jewish artists became increasingly rare. Moreover, when such an article did occasionally make its way into print after 1931, it was marginalized—for instance, by 1935 articles on Chagall no longer appeared in mainstream publications but almost exclusively in Jewish magazines such as *Shalom* and *Cahiers juifs*, or in genuinely avant-garde periodicals with a liberal-left political stance, such as Christian Zervos's *Cahiers d'art*. The year 1933 seems to be the latest date for a full-fledged monograph on an artist like Mané-Katz. By the mid-late 1930s, the limelight fell almost solely on the *Ecole Française* both in the art publications and in the range of subjects of exhibitions, many of which had a frankly backward-looking and Francophilic slant. Shows like *Les peintres de la réalité en France* (at the Musée de l'Orangerie in 1934), *Potiers et imagiers de France* (at the Musée des Arts Décoratifs in 1938), and *Les Travaux et les jours dans l'ancienne France* (at the Bibliothèque Nationale in 1939) all carried connotations of medieval local trades, earnest craftsmanship, and unspoiled French rural tradition. By June 1940, when the Vichy government was established, Jewish artists could no longer exhibit in Paris at all.[32]

The tragic irony was that a year and a half later, it was Derain, Dunoyer de Segonzac, Vlaminck, and Friesz—precisely those guardians of the French tradition who had been singled out as models to be emulated by foreign artists—who with several other artists embarked upon an official tour of Nazi Germany in November 1941, at the invitation of the minister of culture of the Third Reich.[33]

NOTES

1. "Enquête: Pour un musée français d'art moderne," *L'Art vivant*, August 15, 1925, p. 37.
2. Fritz Vanderpyl, "Existe-il une peinture juive?" *Mercure de France*, July 15, 1925, pp. 386–96.
3. Pierre Jaccard, "L'Art grec et le spiritualisme hébreux," *Mercure de France*, August 15, 1925, pp. 80–83.
4. See Michael R. Marrus and Robert O. Paxton, *Vichy France and the Jews* (New York, 1981), chap. 2.
5. See Kenneth E. Silver, "Purism: Straightening Up After the Great War," *Artforum*, March 1977, pp. 56–63.
6. See Kenneth E. Silver, "*Esprit de Corps*: The Great War and French Art, 1914–1925," Ph. D. dissertation, Yale University, New Haven, Conn., 1981. See also Romy Golan, "The Landscape of Morality: French Art and Society, 1918–1945," Ph. D. dissertation (in progress), Courtauld Institute of Art, University of London.
7. The Musée du Luxembourg was devoted to so-called contemporary French art (that is, from Impressionism onward). The works exhibited there were generally transferred to the Louvre or sent to provincial museums about ten years after the death of the artist; this rule, however, was not very strictly observed.

8. "Enquête: La querelle des indépendants," *Le Bulletin de la vie artistique*, December 15, 1924/January 1–15, 1925.
9. Louis Vauxcelles, "Le Carnet des ateliers," *Le Carnet de la semaine*, 1923 [Fonds Vauxcelles, Bibliothèque Jacques Doucet, Institut d'Art et Archéologie, Paris].
10. Charles Vildrac, "Othon Friesz: En regard sur son époque," *L'Amour de l'art*, January 1928, pp. 1–5.
11. Louis Vauxcelles, "Le Carnet des ateliers," *Le Carnet de la semaine*, 1925.
12. "Enquête: L'Orient," *Cahier du mois*, 1925.
13. Adolphe Basler, "Y a-t-il une peinture juive?" *Mercure de France*, November 15, 1925, pp. 11–18.
14. Edmond Kayser (1882–?), realist painter, follower of Cézanne; a regular exhibitor at the Salon des Indépendants; specialized in seascapes.
Léopold Lévy (1882–?) studied with Othon Friesz; exhibited at the salons from 1918 onward; often painted in the French provinces, in the Var, in the Vaucluse, and in Provence.
Simon Lévy (1886–?) moved to Paris in 1911 from Alsace; exhibited at the salons from 1912 onward; often painted in the south of France.
15. Maurice Raynal, *Féder* (Rome, 1924).
16. Jacques Guenne, "Georges Kars," *L'Art vivant*, October 1934, p. 405.
17. Waldemar George, untitled excerpt, ca. 1928, from *Simon Mondzain*, exhibition catalogue, Musée Granet, Aix-en-Provence, 1984, pp. 148–49.
18. Both Mondzain and Zadkine executed a series of sketches at the front during World War I; see collection, Musée des Deux Guerres Mondiales, Musée des Invalides, Paris.
19. The other sculptors who participated in the realization of *Pergola de la Douce France*—Joachim Costa and André Aball—were responsible for most of the state commissions of World War I memorials all around France.
20. In 1931 Féder helped design and execute the mural decorations of the pavilions of the Paris *Exposition Coloniale*. In 1934, Féder, Kars, and Mondzain were exhibited along with the Orientalists of the French School—Delacroix to Matisse—in the permanent collection of the newly refurbished Musée de la Ville d'Algers. And in 1937, Mondzain worked on the mural decorations for the Algerian pavilion at the 1937 Paris World's Fair.
21. Wilhelm Uhde, *Picasso and the French Tradition* (Paris, 1928).
22. Georges Rivière, "Avons-nous encore un art français?" *L'Art vivant*, September 15, 1930, pp. 721–22.
23. Jacques-Emile Blanche, "La Fin de la peinture française," *L'Art vivant*, 1931, pp. 297–98.
24. Malcom Gee, *Dealers, Critics, and Collectors of Modern Painting: Aspects of the Parisian Art Market Between 1910 and 1930*, Ph.D. dissertation, Courtauld Institute of Art, University of London, 1977 (New York: Garland, 1981), part 1, pp. 283–85.
25. Albert Flament, "André Derain," *La Revue de Paris*, ca. 1931 [Fonds Vauxcelles, Bibliothèque Jacques Doucet, Paris].
26. Elie Faure, "L'Agonie de la peinture," *L'Amour de l'art*, June 1931, pp. 231–38.
27. See notes 22 and 23, above.
28. André Salmon, *Léopold Lévy* (Paris, 1931).
29. Waldemar George, "Ecole française ou Ecole de Paris," *Formes*, part I (June 1931), pp. 92–93; part II (July 1931), pp. 110–11.
30. In about 1933, in an article entitled "Art et national-socialisme [Nazism]" in *La Revue mondiale*, George thanked the critic Rudolf Grossmann—another figure who had been involved with Jewish artists of Montparnasse—"for making a distinction between France and Montparnasse" in his attacks against the licentiousness of the Parisian art scene.
31. Marrus and Paxton, chapter 2.
32. *L'Art face à la crise; L'art en occident, 1929–1939*, symposium, Université de St.-Etienne, Travaux XXVI, 1980.
33. Editorial: "Peintres et sculpteurs français en Allemagne," *Comoedia* (November 22, 1941), p. 6.

CHRONOLOGY 1894–1947

Prepared by Stephen R. Frankel, with the assistance of Grace Ross

	GENERAL HISTORY/JEWISH HISTORY	JEWISH ARTISTS IN MONTPARNASSE	OTHER ARTISTIC EVENTS IN PARIS
1894		Max Jacob arrives in Paris. Abraham Berline is born in Niegine, Ukraine.	
1899	Appeals court calls for the French Jewish Colonel Alfred Dreyfus to be released from Devil's Island and retried before a new court-martial at Rennes; the military, unable to admit to an error of justice, find him guilty of treachery with extenuating circumstances and sentence him to 10 years' more detention; it is clear that the verdict is unjust, and a presidential pardon is issued.	Léopold Gottlieb arrives in Paris.	
1900		Eugène Zak arrives in Paris (ca. 1900).	Picasso arrives in Paris.
1901			Max Jacob meets Picasso.
1902	Renewal of Triple Alliance among Germany, Austria, and Italy; Leon Trotsky escapes from prison in Siberia and settles in London.		Opening of La Ruche, 2 Passage Dantzig, Paris, 15th arondissement. Emile Zola dies.
1903		Walter Bondy, Rudolf Levy, and Louis Marcoussis arrive in Paris.	Founding of the Salon d'Automne. Gertrude Stein arrives in Paris.
1904		Bela Czobel and Elie Nadelman arrive in Paris.	
1905	Wave of anti-Jewish pogroms in Russia. Revolt in St. Petersburg crushed by Russian police, triggers new wave of pogroms; mutiny on the *Potemkin* crushed. *Protocols of Zion* (anti-Semitic tract written by Russian secret police) published anonymously in Paris; law separating Church and State passed in France.	Sonia Delaunay, Jacques Gotko, as a child with his family, Jules Pascin, and Max Weber arrive in Paris. Czobel exhibits with the Fauves at the Salon d'Automne.	The Fauves exhibit together at the Salon d'Automne.
1906	Mass emigration of Russian Jews to the U.S. as a result of the abortive revolution and the new pogroms in Russia. Retrial of the Dreyfus case before the appeals court, which quashes the 1899 Rennes verdict.	Oscar Miestchaninoff, Amedeo Modigliani, and Eugen Spiro arrive in Paris. Miestchaninoff moves into the Cité Falguière.	Juan Gris arrives in Paris. Cézanne dies.
1907		Henri Hayden and Walter Rosam arrive in Paris.	Picasso completes the *Demoiselles d'Avignon*. Opening of D. H. Kahnweiler's gallery, at 20 Rue Vignon. First Cubist exhibition in Paris.

1908 The Matisse Academy opens in January.

1909 First Futurist Manifesto by Marinetti published in *Le Figaro* on February 20. First major Cubist show at the Salon d'Automne and at the Salon des Indépendants. Henri ("Douanier") Rousseau dies.

1910 Performances of Diaghilev's Ballets Russes at the Théâtre du Châtelet.

1911 Matisse paints *Red Studio.*

1912 Lipchitz meets Picasso. Piet Mondrian arrives in Paris. First Futurist exhibition at the Galerie Bernheim-Jeune. Cubist exhibition *La Section d'Or* at Galerie de la Boétie.

1908 Isaac Grünewald and Georges Kars arrive in Paris. Isis Kischka is born in Paris. Sonia Terk marries the critic and art dealer Wilhelm Uhde. Leo Stein introduces Nadelman to Picasso. Levy and Weber help set up the Matisse Academy, which they attend along with Epstein, Féder, Grünewald, and Rosam. Henri Rousseau hosts a farewell banquet for Weber, who returns to America at the end of 1908.

1909 Jacques Lipchitz and Ossip Zadkine arrive in Paris. Simon Mondzain makes his first visit to Paris. Nadelman has his first solo show at Galerie Druet. Modigliani moves into the Cité Falguière (where he lives on and off until 1918).

1910 Marc Chagall, Adolphe Féder, Moïse Kisling, Moishe Kogan, and Chana Orloff arrive in Paris. Chagall and Zadkine move into La Ruche. Sonia Terk Uhde marries Robert Delaunay. Pascin has his first Parisian solo show at Galerie Berthe Weill (ca. 1910).

1911 Léon Indenbaum arrives in Paris. Mondzain makes a second visit to Paris. Modigliani begins working with the sculptor Brancusi (ca. 1911–12). Grünewald returns to Sweden. Helena Rubinstein begins collecting Nadelman's works.

1912 Isaac Dobrinsky, Henri Epstein, Morice Lipsi, and Marevna arrive in Paris. Michel Kikoïne, Pinchus Krémègne, and Chaim Soutine also arrive in Paris (ca. 1912). Mondzain moves to Paris, joining his friend Kisling, Dobrinsky, Epstein, and Lipsi move into La Ruche; Indenbaum, Kikoïne, Krémègne, and Soutine also move in (ca. 1912). Works by Marcoussis included in the Cubist exhibition *La Section d'or.*

1913 Alice Halicka and Mané-Katz arrive in Paris. Halicka and Marcoussis get married. Levy, Miestchaninoff, Nadelman, Pascin, and Zak send works to the Armory Show in New York. Bondy moves to Berlin.

1909 Jewish world population (in millions): Russ. 5.2; Aus.-Hung., 2.0; U.S., 1.7; Ger., 0.6; Turk., 0.4; Gr. Br., 0.2; Fr., 0.1.

1910 Another wave of anti-Jewish pogroms in Russia.

1912 Beginning of Balkan war (Bulgaria, Serbia, Montenegro, and Turkey); Triple Alliance renewed again for 6 more years.

1913 Fr. institutes military draft.



1921 Hitler's stormtroopers (SA) begin to terrorize political opponents. General election in It.; 29 Fascists elected.

1922 Mussolini marches on Rome, forms military gov't.

1923 Union of Soviet Socialist Republics estab'd. U.S. recalls occupation forces from Rhineland. Allies assign Vilna and Galicia to Poland.

1925 Hitler's *Mein Kampf* publ'd.

1927 "Black Friday" (May 13) leads to breakdown of Ger. econ. system. Socialist riots in Vienna. Fr. gov't ratifies liberal law on naturalization of foreign immigrants.

1928 Leftist parties win in Fr. and Ger. elections.

1929 Stock-market crash on Wall Street; beginning of world econ. crisis.

(continued)



1921 Abraham Rattner moves to Paris. The Delaunays return to Paris and host many of the avant-garde. Grünewald returns from Sweden. Max Jacob leaves to live in a Loire valley monastery.

1922 Kars has his first Parisian solo show at the Galerie de la Licorne. Orloff has her first solo show at Galerie Povolozky.

1923 Sigmund Menkès arrives in Paris. Chagall returns from Russia, via Berlin. Léon Zack moves to Paris for good. Mané-Katz has his first solo show at the Galerie Percier. Orloff visits Palestine. Collector Albert C. Barnes buys large number of paintings by Soutine, establishing his career.

1924 Miestchaninoff and Lipchitz commission twin studio-houses in Boulogne-sur-Seine from Le Corbusier.

1925 Jacques Chapiro arrives in Paris. Czobel returns from Berlin. Zadkine works on the sculpture *Pergola de la douce France* at the 1925 Paris Exposition des Arts Decoratifs. Mondzain visits Algeria.

1926 Gottlieb returns to Paris from Poland. Orloff commissions a house in Montparnasse from Auguste Perret. Eugène Zak dies of natural causes; retrospective exhibition at Galerie Bing. Miestchaninoff sent by French Government to Burma and Siam to work on archaeological excavation. Rattner joins Minotaure Group.

1927 Abraham Berline arrives in Paris. Nadelman becomes a U.S. citizen. Soutine has his first solo show at Galerie Bing. First publication of the series of monographs "Les Artistes juifs" by Editions Le Triangle, Paris.

1929 Exhibition of the Paul Guillaume Collection at Galerie Bernheim-Jeune; includes 18 Modiglianis and 6 Soutines. Adolphe Basler opens the Galerie de Sèvres, 13 Rue de Sèvres. Eugène Zak's widow opens the Galerie Zak, 16 Rue de l'Abbaye.

(continued)

Right column (institutions/exhibitions)

1921 First sale of Kahnweiler's sequestered collection, put up for public auction (in four sales over three years) by French government as part of German war reparations.

1922 An annex of the Musée du Luxembourg is installed in the Musée du Jeu de Paume for the works of foreign artists. Max Ernst arrives in Paris.

1923 Decision of the Committee of the Salon des Indépendants to exhibit the works according to the artists' nationalities.

1924 Publication of André Breton's "First Manifesto of Surrealism."

1925 First Surrealist painting exhibition at Galerie Pierre. Exposition des Arts Décoratifs et Industriels Modernes.

1929 Founding of the group Cercle et Carré by Michel Seuphor and Joaquim Torrés-Garcia.

(continued)

1940

Ger.: first Fr. internment camp for foreigners; massive internment of Ger. refugees in Fr.

Ger. invades Den., Nor., Holl., Bel., and Lux.; Nazi camp establ'd at Auschwitz; in June, Ger. occupies Paris, the Fr. Army capitulates to the Nazis; DeGaulle starts Free French mvmt.; Pétain heads Vichy gov't; Vichy gov't ratifies laws on "Special Status of Jews" and internment of foreign Jews in the Free Zone of Fr.

Algeria. Kikoïne and Kisling volunteer for French Army; Lipsi and Mané-Katz drafted. Mané-Katz is imprisoned by the Germans.

After the Vichy collaborationist government is established, foreign artists are no longer allowed to exhibit in France. Breton, Mondrian, Duchamp, Léger, Dali, and others leave for the United States.

Chagall, Halicka, Krémègne, Lipchitz, Lipsi, Marcoussis, Soutine, and Spiro flee to the French provinces; Mané-Katz (after escaping from prison) and Rattner leave for the U.S. Bondy allows himself to die of diabetes.

1941

Ger. invades Yug., Greece, and Russ.; Vichy gov't ratifies law requiring Jews to be sent to concentration camps; U.S. enters WWII.

Derain, Dunoyer de Segonzac, Friesz, Despiau, Vlaminck, and others accept official invitation from the Nazis to visit Germany.

The Nazis confiscate major French Jewish collections (including those of the Rothschilds, Wildensteins). Marevna flees to the provinces; Chagall, Kisling, Lipchitz, Miestchaninoff, Spiro, and Zadkine escape to the U.S. Marcoussis dies. Berline and Kischka arrested and sent to deportation camps at Compiègne and Drancy.

1942

Nazis put into law the "Final Solution" aimed at annihilation of all Jews; Ger. invades Fr. Free Zone and occupies Vichy France; first deportation of prisoners from Compiègne to Auschwitz.

Exhibition of the works of Arno Breker (the official sculptor of the Third Reich) at the Musée de l'Orangerie, Paris.

Hayden, Kikoïne, and Orloff go into hiding in the French provinces; Orloff, Kars, and Lipsi escape to Switzerland. Gotko and Kogan arrested and sent to deportation camps at Compiègne and Drancy; Berline is sent from Drancy to a concentration camp, where he dies. Féder and his wife arrested for harboring Resistance members; they are sent to Drancy and deported to Auschwitz.

1943

Churchill, Roosevelt, and Stalin meet at Yalta.

Soutine dies of natural causes. Rudolf Levy is arrested by the Gestapo in Florence and sent to a deportation camp; Kogan is deported to a concentration camp, where he dies; Féder dies at Auschwitz.

1944

Allies enter Rome (June 4), land in Normandy (June 15), and liberate Paris from Nazi occupation (Aug. 25). Warsaw ghetto uprising (Oct. 2).

Zadkine teaches in New York. Epstein and Jacob are sent to Drancy; Jacob dies of pneumonia; Epstein and Gotko are sent to a concentration camp, where they die. Levy is sent to Auschwitz but dies on the way. Hayden returns to Paris, after the Liberation.

1945

Russians liberate Vienna and reach Berlin (Apr. 21); Mussolini executed (Apr. 28); Hitler's suicide (Apr. 30); Berlin surrenders to Allies (May 2); unconditional surrender of all Ger. forces to the Allies (May 7); Japan surrenders, ending WWII.

Kars commits suicide in Switz. Delaunay, Dobrinsky, Halicka, Kikoïne, Kischka, Lipsi, Mané-Katz, Orloff, Zack, and Zadkine return to Paris after the Liberation.

1946

Kisling back in Paris from U.S. Nadelman dies in America of natural causes.

1947

Chagall is back in Paris from the U.S.

ARTISTS IN THE EXHIBITION

BIOGRAPHIES, EXHIBITIONS, AND BIBLIOGRAPHIES

In the lists of Selected Exhibitions and Selected Bibliography that follow each artist's Biography, our emphasis has been on the period surveyed in this show, 1905 to 1945, in order to present as thorough a history of the period as possible; as is indicated, however, they are selected rather than complete. They are arranged chronologically, and the reader can therefore glance at each list for a quick idea of the frequency of exhibitions and/or references in the critical literature. All exhibitions are one-person shows unless a title for the exhibition or the words "group show" are provided. Please note that if an exhibition and its catalogue are both listed, the bibliographic reference does not repeat all of the information given in the exhibition listing but rather just the title, the words "exhibition catalogue," the city, and the date of the catalogue publication.

A name in brackets indicates an artist's full original name; a name in parentheses indicates a partial (first or last) original name. A question mark in place of a date indicates that it is unknown.

BERLINE, ABRAHAM
(1894–CA. 1943)

Berline was born in Niegine, in the Ukraine. After finishing high school, he arrived in Paris in the late 1920s and enrolled at the Ecole des Beaux-Arts. He soon started exhibiting at the Salon d'Automne and the Salon des Indépendants. Having remained in Paris after the Nazi invasion, he was arrested in May 1941 and interned for seventeen months in the deportation camps of Compiègne and Drancy, outside of Paris. Like his fellow-artist friends Gotko and Kischka—who were also interned at Compiègne—he managed to

make drawings of life in the camps. In 1942 he was deported to a concentration camp, where he died soon after.

SELECTED LIST OF EXHIBITIONS:
Exhibited at the Salon des Indépendants and the Salon d'Automne [dates unknown]; *Memorial in Honor of Jewish Artists Victims of Nazism,* University of Haifa, Israel, 1978; *Résistance, Déportation — Création dans le Bruit des Armes,* Musée de l'Ordre de la Libération, Paris, April–June 1980.

SELECTED BIBLIOGRAPHY:
Memorial in Honor of Jewish Artists Victims of Nazism, exhibition catalogue. Haifa, 1978.

BONDY, WALTER
(1883–1940)

Bondy was born in Budapest, of a wealthy Jewish family; his father was an industrialist. In 1902–3 he studied at the art academies in Vienna and Berlin, as well as at the Academy Holosi in Munich where he met Jules Pascin. Bondy arrived in Paris with Rudolf Levy in 1903, the first of the so-called Dômiers (artists who frequented the Café du Dôme), and they were soon joined by Levy's fellow German artist friends. For the next ten years Bondy lived in Montparnasse and spent his summers in the south of France. In 1913 he moved back to Berlin where he participated in group exhibitions such as the Berlin Secession; the following year he participated in the first group exhibition at the Galerie Flechtheim in Düsseldorf. In 1927 Bondy founded the art magazine *Kunstauktion* in Munich and started collecting art. In 1931, at the first signs of anti-

Semitism in Germany, he left for Switzerland; from there he went to Sanary, on the Riviera, where a number of German refugees resided, then on to Vienna and Prague in the mid-1930s; and he finally moved to Toulon in 1937. At the outbreak of World War II, due to illness (diabetes) he managed to avoid being sent to the deportation camp at Les Milles along with the other German and Austrian refugees. Despondent at the German betrayal and the French collaboration with the Nazis, however, he let himself die of his illness in September 1940.

SELECTED EXHIBITIONS:
Exhibited at the pre-war Salon des Indépendants and Salon d'Automne in Paris and at the Berlin Secession. Other exhibitions: *Pariser Begegnungen 1904–1914*, Wilhelm Lehmbruck Museum, Duisburg, Germany, 1965.

SELECTED BIBLIOGRAPHY:
Walter Bondy. "Maurice Utrillo", *Kunst und Kunstler*, vol. 23 (April 1925), pp. 253–63.
Walter Bondy et al. [Series of recollections on the Dôme.] *Die Kunstauktion* (1928). Munich.
Rudolph Grossmann. "Dômechronik." *Kunst und Kunstler*, vol. 20 (January 1922), pp. 29–32.
Pariser Begegnungen 1904–1914, exhibition catalogue. Duisburg, 1965.
Barbara and Erhard Göpel. *Hans Purrmann, Schriften*. Wiesbaden, Germany, 1961.

CHAGALL, MARC
[MOYSHE SHAGAL]
(1887–1985)

Chagall was born in Vitebsk, Russia, of a poor family. He began to study painting in his hometown in 1906 and moved the following year to St. Petersburg, where he studied at the Zvantseva School with Léon Bakst from 1908 to 1910. Chagall arrived in Paris in 1910 and moved into La Ruche (a residence for poor artists, near the Vaugirard slaughterhouses on the outskirts of Paris), where he remained until 1914. At that time he met the poets Max Jacob, Blaise Cendrars, and Apollinaire and the painters Léger, Delaunay, Modigliani, and Soutine. In 1911, he exhibited for the first time at the Salon des Indépendants. Through Apollinaire, he met Herwarth Walden, the owner of the Galerie Der Sturm, an important gallery of modern art in Berlin. Chagall had returned to Vitebsk by the outbreak of World War I and in 1915 married his fiancée, Bella Rosenfeld. When the Russian Revolution began in 1918, he was appointed Commissar of Fine Arts for the city of Vitebsk, where he founded an art academy. By 1922, however, he had fallen out of favor with the revolutionary government and went back to France via Berlin, arriving in Paris in 1923 and settling in a studio on Avenue d'Orléans. Around 1927 he became friends with Jean Paulhan and Jacques Maritain. Chagall was commissioned by Ambroise Vollard in 1930–31 to illustrate several books, including the Bible (for which he traveled to Palestine in 1931). In 1933 his works were publicly burned in Mannheim, Germany, on the orders of Goebbels. At the outbreak of World War II, Chagall left Paris and went into hiding in the Loire Valley, then in the town of Gordes in the south of France. He managed to escape to the United States thanks to the rescue of artists organized by the Emergency Rescue Committee. Arriving in New York on June 23, 1941 together with his wife Bella, he found there many other Europeans in exile, including Zadkine, Lipchitz, Kisling, Léger, and Breton. Bella died suddenly in upstate New York in September 1944. Back in France in 1947, he settled in Orgeval outside of Paris. In 1950, he moved to Cap-Ferrat on the Riviera and the following year to St.-Paul-de-Vence outside of Nice. In 1952 he married Valentina Brodsky. During the 1950s he traveled frequently to Israel and other countries to work on official commissions for such projects as murals, stained glass, and tapestries. Chagall died at St.-Paul-de-Vence at the age of 97.

SELECTED EXHIBITIONS:
Exhibited at the Salon des Indépendants for the first time in 1911, at the Salon d'Automne in 1912, and at the Salon des Tuileries in 1924. First one-person show at Galerie Der Sturm, Berlin, 1914. Other exhibitions: *Paintings and Sculpture by Jewish Artists*, Galerie Lemercier, Moscow, 1917; Galerie Le Portique, Paris, 1918, 1928, 1931; Galerie Barbazanges-Hodebert, Paris, 1924; Galerie Katia Granoff, Paris, 1926; Galerie Bernheim-Jeune, Paris, 1930 (catalogue preface by Ambroise Vollard); Kunsthalle, Basel, 1933; *Les Maîtres de l'Art Indépendant*, Petit Palais, Paris, 1937; Pierre Matisse Gallery, New York, 1941 and regularly thereafter; *Artists in Exile*, Pierre Matisse Gallery, New York, 1942; *European Artists in Exile*, Whitney Museum of American Art, New York, 1945; The Museum of Modern Art, New York, 1946; Musée National d'Art Moderne, Paris, 1947 (catalogue preface by Jean Cassou); Tate Gallery, London, 1948; Galerie Maeght, Paris, 1950 (regular shows thereafter); Bezalel National Museum of Art, Jerusalem, and Tel Aviv Museum, 1951; Musée du Grand Palais, Paris, 1969; Musée National d'Art Moderne, Centre Pompidou, Paris, 1984; Galerie Maeght, St.-Paul-de-Vence 1984–85; The Royal Academy of Arts, London, 1985.

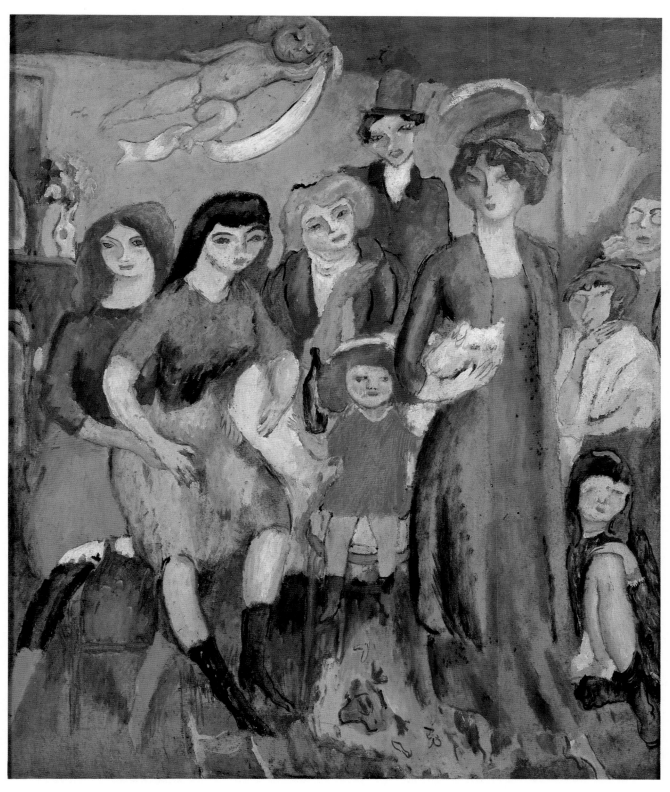

Colorplate I Jules Pascin
The Turkish Family, 1907 (cat. no. 92) Mr. and Mrs. Kurt Olden Collection

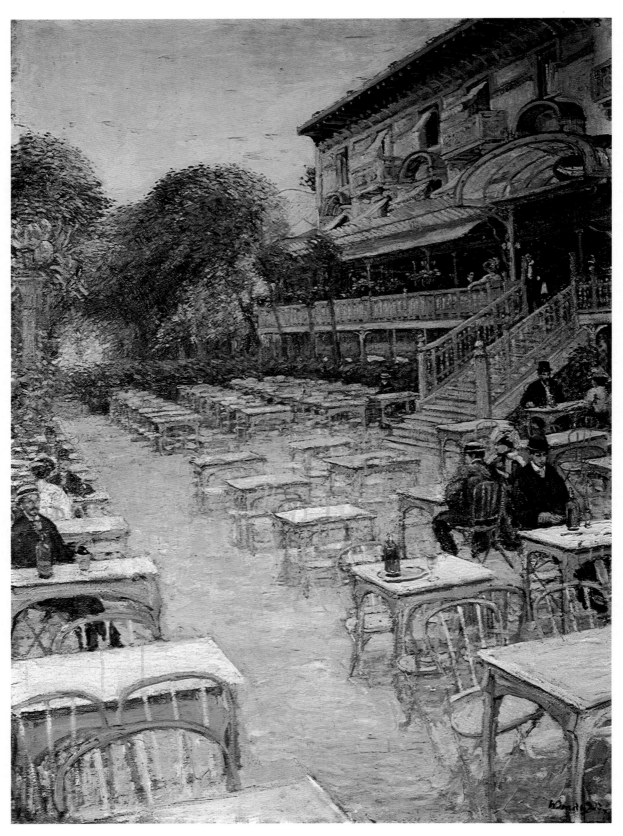

Colorplate II Walter Bondy
The "Pavillon Bleu" at St.-Cloud, 1907 (cat. no. 2) Catherine Cozzano Collection, Paris

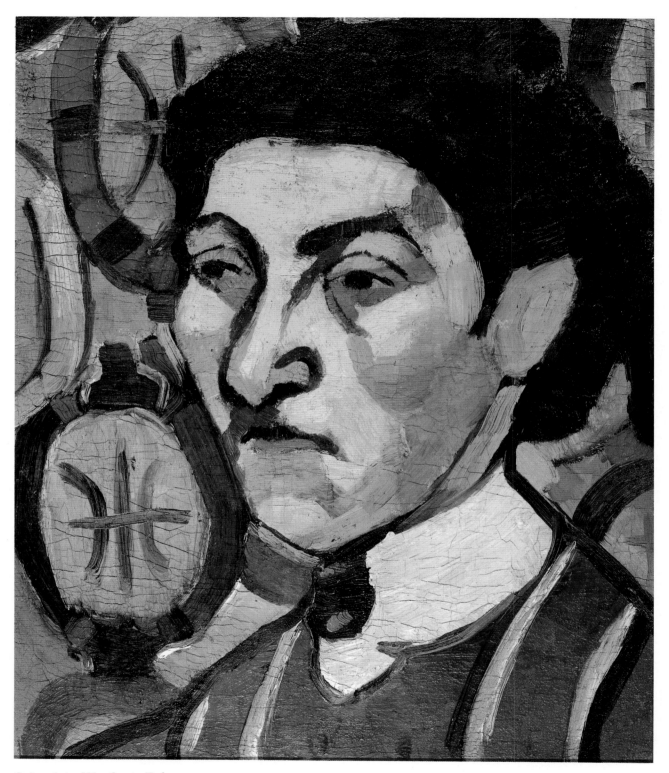

Colorplate III Sonia Delaunay
Philomène, 1907 (cat. no. 13) Edythe and Saul Klinow Collection

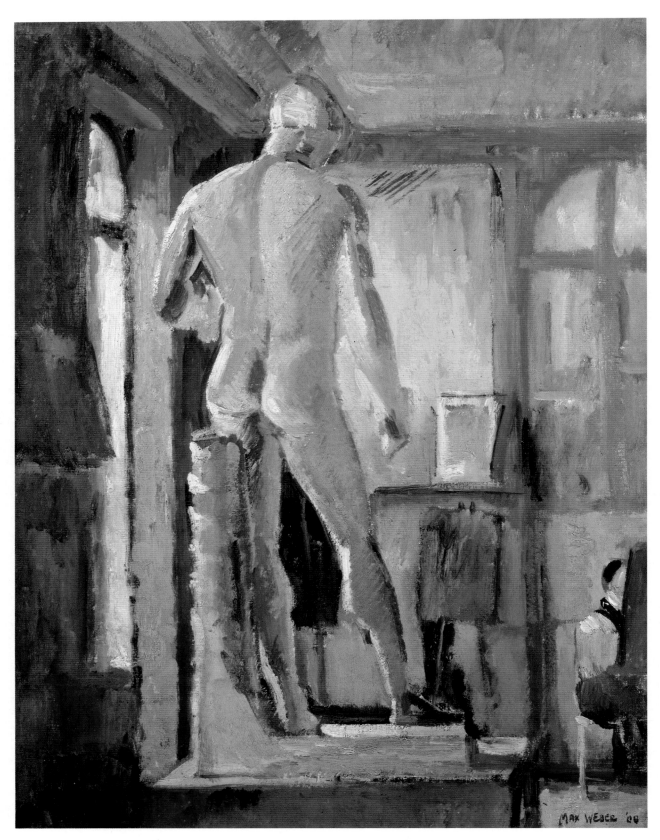

Colorplate IV Max Weber
The Apollo in the Matisse Academy, 1908 (cat. no. 108) Forum Gallery, New York

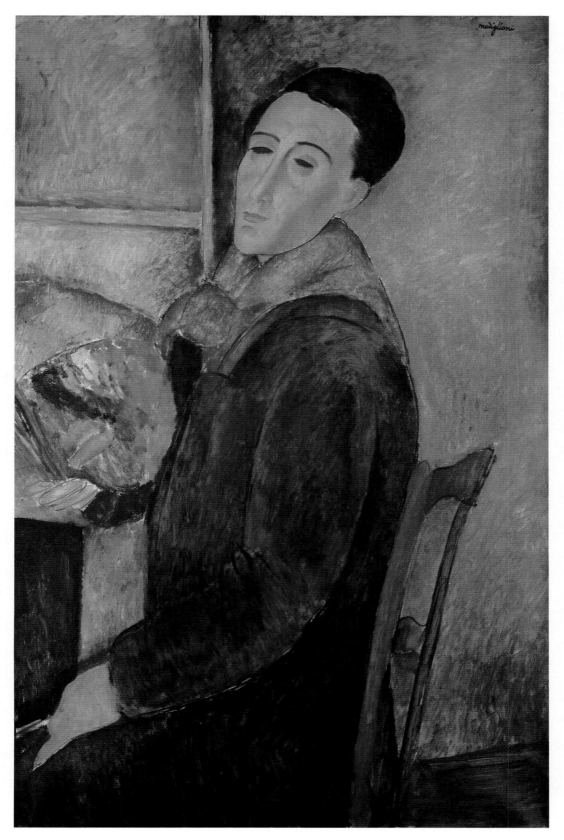

Colorplate V Amedeo Modigliani
Self-Portrait, 1919 (cat. no. 80) Museu de Arte Contemporânea,
University of São Paulo, Brazil, Gift of Yolanda Penteado and Francisco Matarazzo Sobrinho

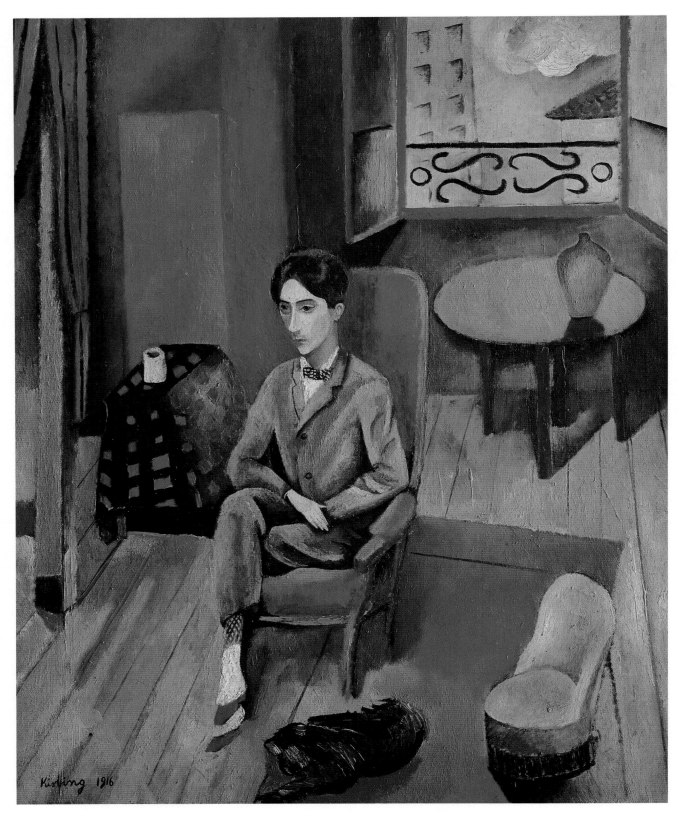

Colorplate VI Moïse Kisling
Jean Cocteau in the Studio, 1916 (cat. no. 40) Petit Palais, Geneva

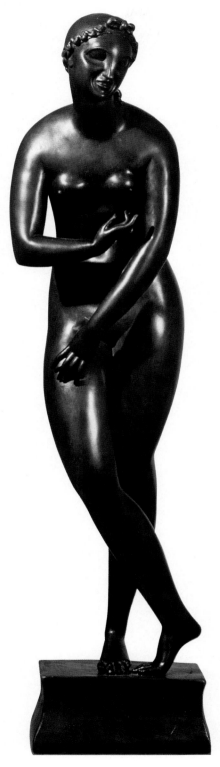

Colorplate VII Elie Nadelman
Standing Nude Figure, ca. 1907 (cat. no. 83) Bernard Goldberg Collection

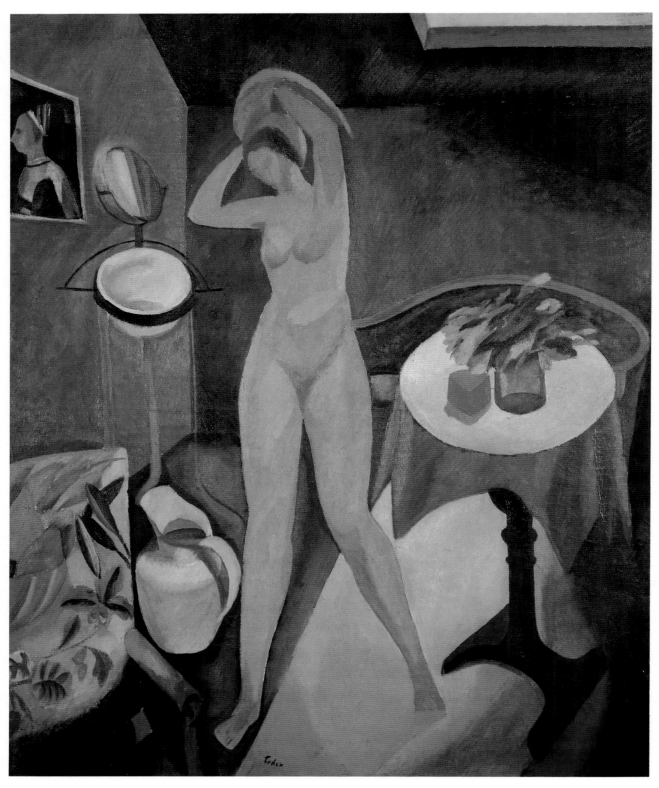

Colorplate VIII Adolphe Féder
Bather in the Studio, ca. 1915 (cat. no. 17) Tiroche Gallery, Tel Aviv, Israel

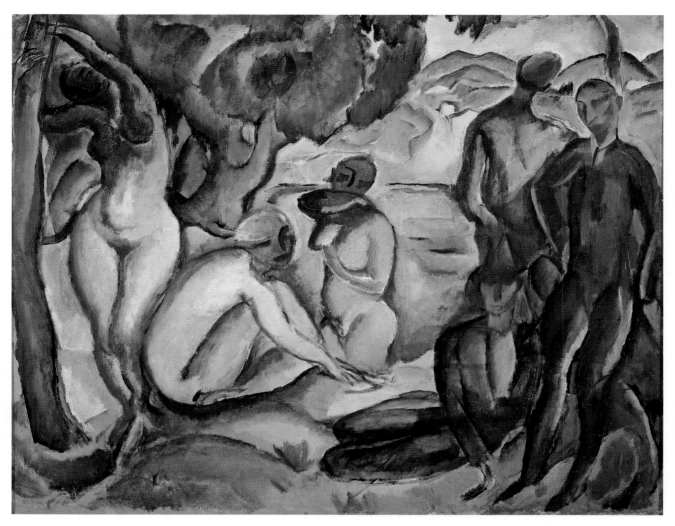

Colorplate IX Georges Kars
The Bathers, 1912 (cat. no. 33) Tiroche Gallery, Tel Aviv, Israel

Colorplate X Isaac Dobrinsky
Portrait of Wiera Dobrinsky, 1933 (cat. no. 15) Wiera Dobrinsky Collection

Colorplate XI Marc Chagall
Study for (or after?) *Paris through the Window (1913)*, n.d. (cat. no. 7) Galerie Beyeler, Basel

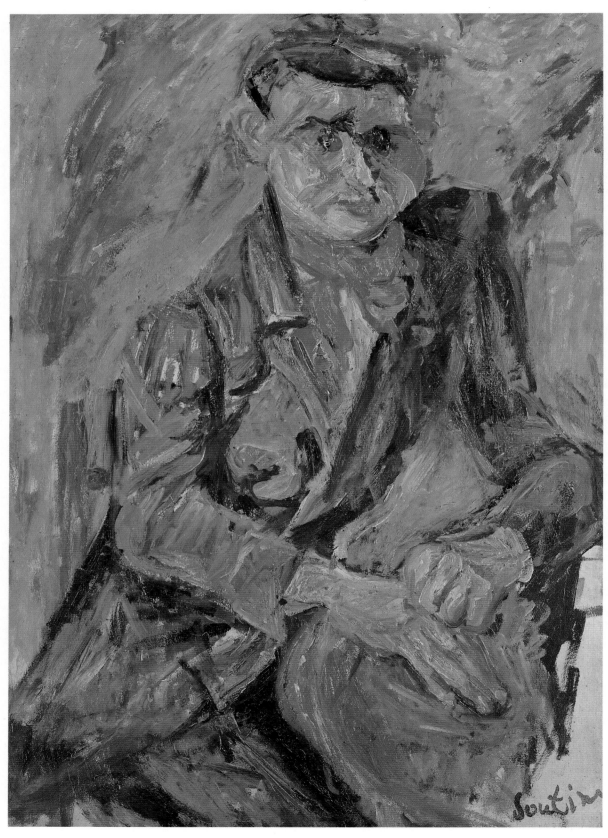

Colorplate XII Chaim Soutine
Portrait of Moïse Kisling, ca. 1925 (cat. no. 103) Philadelphia Museum of Art,
The Louis E. Stern Collection

Colorplate XIII Simon Mondzain
Pro Patria, 1920 (cat. no. 82) Marie-José Baudinet-Mondzain Collection

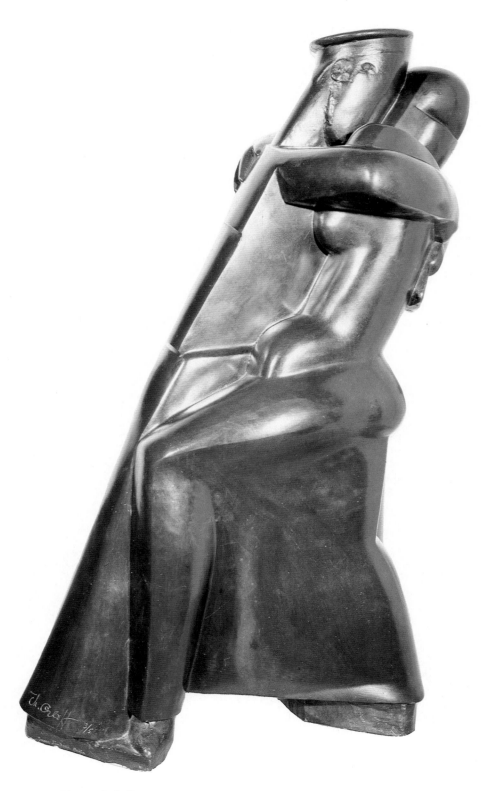

Colorplate XIV Chana Orloff
The Dancers (Sailor and Sweetheart), 1923 (cast 1929) (cat. no. 86), Philadelphia Museum of Art (Photograph courtesy of Galerie Vallois, Paris)

Colorplate XV Henri Hayden
The Three Musicians, 1920 (cat. no. 29) Musée National d'Art Moderne, Centre Georges Pompidou, Paris

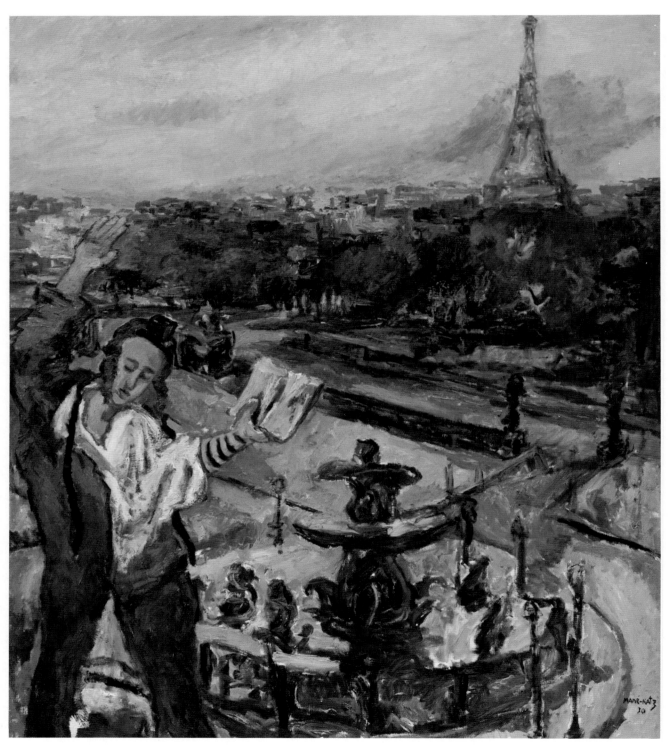

Colorplate XVI Mané-Katz
Homage to Paris, 1930 (cat. no. 59) Mané-Katz Museum, Haifa, Israel

SELECTED BIBLIOGRAPHY:
Guillaume Apollinaire. "Les Arts: Marc Chagall." *Paris-Journal* (June 2, 1914).
Florent Fels. "Marc Chagall." *Les Nouvelles Littéraires* (June 14, 1924).
Waldemar George. "Chagall à Paris." *Séléction*, no. 3 (January 1924). Antwerp.
Christian Zervos. "Marc Chagall." *L'Art d'Aujourd'hui* (Winter 1924), pp. 25–30.
André Salmon. "Marc Chagall." *L'Art Vivant* (November 15, 1925), pp. 1–3.
Christian Zervos. "Marc Chagall." *Cahiers d'Art*, no. 6 (1926), pp. 123–27.
Jacques Guenne. "Marc Chagall." *L'Art Vivant* (December 15, 1927), pp. 999–1004.
Waldemar George. *Marc Chagall.* Paris, 1928.
André Salmon. *Chagall.* Paris, 1928.
René Schwob. "Chagall, peintre juif." *L'Amour de l'Art* (August 1928), pp. 305–9.
Paul Fierens. *Marc Chagall.* Paris, 1929.
Jean Cassou. "Marc Chagall." *Art et Décoration* (September 1930), pp. 65–76.
Marc Chagall. *Ma vie.* Paris, 1931.
René Schwob. *Chagall et l'âme juive,* Paris, 1931.
James Johnson Sweeney. "An Interview with Marc Chagall." *Partisan Review* (Winter 1944), pp. 88–93.
———. *Marc Chagall,* exhibition catalogue, New York, 1946.
Jacques Lassaigne. *Chagall.* Paris, 1957.
Franz Meyer. *Chagall.* New York, 1963.
Werner Haftmann, *Marc Chagall.* New York, 1972.
Ziva Amishai-Maisels. "Chagall's Jewish In-jokes." *Journal of Jewish Art*, vol. 5 (1978), pp. 76–93.
Musée National d'Art Moderne, Centre Pompidou. *Marc Chagall, Oeuvres sur papier,* exhibition catalogue. Paris, 1984.
Susan Compton. *Marc Chagall,* exhibition catalogue. London, 1985.

CHAPIRO, JACQUES
(1887– ?)

Chapiro was born in Dvinsk, Latvia, the son of a wood carver. He began his artistic training while in his teens. In 1915 he went to study at the school of fine arts in Kharkov and, three years later, at the art academy in Kiev. From 1919 to 1925 he taught painting in Dnepropetrovsk and Leningrad. In 1921 he designed sets for the Meyerhold Theater in Moscow, where he participated in group shows. Chapiro arrived in Paris in 1925, moving into La Ruche, where he remained for the next five years. He was a regular exhibitor at the Parisian salons from 1926 on. Chapiro wrote an anecdotal history of the artists who resided at La Ruche, which was published in 1960.

SELECTED EXHIBITIONS:
Starting in 1926, exhibited at the Salon d'Automne, the Salon des Indépendants, and the Salon des Tuileries. Other exhibitions: *La Ruche et Montparnasse 1902–1930*, Musée Jacquemart-André, Paris, 1978–79.

SELECTED BIBLIOGRAPHY:
Jacques Chaprio. *La Ruche.* Paris, 1960.
Jeanine Warnod. *La Ruche et Montparnasse.* Paris and Geneva, 1978.
Grace C. Grossman. *The French Connection: Jewish Artists in the School of Paris 1900–1940. Works in Chicago Collections.* Spertus Museum of Judaica, Chicago, 1982.

CZOBEL, BELA
(1883–1976)

Czobel was born in Budapest. In 1902 he spent a year with the artists' colony in Nagybanya, moving subsequently to Germany and studying at the art academy in Munich, where he became friends with Jules Pascin, Rudolf Levy, and Walter Bondy. He arrived in Paris in 1904 and enrolled at the Académie Julian. He entered the orbit of the Fauvist movement, exhibiting with Matisse, Derain, Vlaminck, Braque, and the other so-called Fauves at the Salon d'Automne of 1905. During World War I, he moved to the small village of Bergen in Holland. By 1919 he was in Berlin, where he associated with the German Expressionists. From 1925 to 1927 Czobel was in Paris again and became involved with a group of artists in Montparnasse. He spent World War II in the village of Szentes near Budapest, and thereafter he divided his time between Paris and Budapest. He died in Budapest in 1976.

SELECTED EXHIBITIONS:
Exhibited at both the Salon du Champs-de-Mars, Paris, and at the National Autumn Salon, Budapest, in 1903, and at the Salon d'Automne, Paris, in 1905. First one-person show at Galerie Berthe Weill, Paris, 1907. Participated in the Free Secession, Berlin, 1919. Other exhibitions: Galerie Paul Cassirer, Berlin, 1920; Galerie Wallerstein, Berlin, 1923; the Belvedere, Budapest, 1924; Galerie Pierre, Paris, 1926 and 1929; Galerie Bing, Paris, 1927, 1930, 1932; R. S. Johnson International Galleries, Chicago, 1961, 1968, 1971, 1981; *Pariser Begegnungen 1904–1914*, Wilhelm Lehmbruck Museum, Duisburg, Germany, 1965;

Hungarian Art: The Twentieth-Century Avant-Garde, Indiana University Art Museum, Bloomington, Ind., 1972.

SELECTED BIBLIOGRAPHY:
Adolphe Basler. "Bela Czobel." *Les Chroniques du Jour* (1926).
Claude Roger-Marx. "Bela Czobel." *L'Europe Nouvelle* (1930).
Genthon Istvan. *Czobel*. Budapest, 1961.
Clarisse Philipp. *Bela Czobel: The Early Years 1902–1922*. Budapest, 1963.
Pariser Begegnungen 1904–1914, exhibition catalogue. Duisburg, 1965.
Clarisse Philipp. *Czobel*. Budapest, 1970.
Hungarian Art: The Twentieth-Century Avant-Garde, exhibition catalogue. Bloomington, 1972.
R. S. Johnson. *Homage to Bela Czobel 1886–1976*. R. S. Johnson International Galleries, Chicago, 1981.

DELAUNAY, SONIA
(STERN-TERK)
(1885–1979)

Sonia Delaunay was born in the Ukrainian village of Gradizhsk, the daughter of a factory worker. She was adopted by her maternal uncle, Henri Terk, a wealthy lawyer in St. Petersburg. From 1903 to 1905 she studied art at the University of Karlsruhe, Germany. She arrived in Paris in 1905, living at first in the Latin Quarter with Russian friends, and in 1906 she moved to a studio in Montparnasse. She enrolled at the Académie de la Palette and took classes in engraving with Rudolf Grossmann. In 1908 she married the German critic and art dealer Wilhelm Uhde, who introduced her to, among others, Jules Pascin, Rudolf Levy, and Hans Purrmann, as well as Robert Delaunay, the French painter (who would become her second husband in 1910). Through Uhde she also met Picasso, Braque, and Vlaminck and, in 1912, Chagall, and soon after that the poet Blaise Cendrars. Around this time she started working in the decorative arts and making collages and posters. Sonia and Robert Delaunay spent World War I in Spain and Portugal, and did not return to Paris until 1921. They moved into an apartment on the Boulevard Malesherbes, where they were hosts to many members of the Parisian avant-garde. During the 1920s she worked principally as a designer of clothes, textiles, and theater costumes. With the couturier Jacques Heim, she organized the Boutique Simultanée for the Exposition Internationale des Arts Décoratifs et Industriels Modernes, Paris, 1925; in 1931, she joined the newly founded group Abstraction-Création. In 1935 the Delaunays moved to the Rue Saint-Simon, where Sonia would live until the end of her life. During World War II the couple left Paris for the Auvergne region and from there went to Mougins in the south of France by 1941. That year, Robert died of cancer and Sonia moved to Grasse until the end of the war, returning to Paris in 1945. During the 1950s she started working on a number of official commissions and was named Chevalier des Arts et des Lettres in 1958 and then Chevalier de la Légion d'Honneur in 1975. She lived in Paris until her death in 1979.

SELECTED EXHIBITIONS:
First one-person show at Galerie Notre-Dame-des-Champs, Paris, 1908 (organized by Wilhelm Uhde). Exhibited at the Salon des Indépendants for the first time in 1914. Other exhibitions: Galerie "Fermé la nuit," Paris, 1929; *Abstraction-Création*, Galerie Zak, Paris, 1932; Galerie Bing, Paris, 1953; Galerie Denise René, Paris, 1962 and 1968; Musée National d'Art Moderne, Paris, 1967–68 and 1975–76; Musée National d'Art Moderne, Tokyo, 1979; Albright-Knox Art Gallery, Buffalo, 1980.

SELECTED BIBLIOGRAPHY:
André Lhote, ed. *Sonia Delaunay: Ses Peintures, ses objets, ses tissus simultanés, ses modes.* Paris, 1925.
Luc Benoist. "Les tissus de Sonia Delaunay." *Art et Décoration* (November 1926), pp.142–45.
Sonia Delaunay. *Tapis et tissus.* Paris, 1931.
Musée National d'Art Moderne. *Retrospective Sonia Delaunay*, exhibition catalogue. Paris, 1967.
Jacques Damase. *Sonia Delaunay: Rythmes et couleurs.* Paris, 1971.
Arthur A. Cohen. *Sonia Delaunay.* New York, 1975.
Robert T. Buck and Sherry A. Buckberrough. *Sonia Delaunay, a Retrospective*, exhibition catalogue. Buffalo, 1980.

DOBRINSKY, ISAAC
(1891–1973)

Born in the Ukrainian village of Makaroff, the son of a religious man, Dobrinsky grew up in dire poverty. After attending a religious high school he moved to Kiev, where he lived for the next six years and began sculpting. Dobrinsky arrived in Paris in 1912 and moved into La Ruche (which remained his home until 1934). Soon after his arrival in Paris he turned from sculpture to painting. At the outbreak of World War I, he volunteered for service in the Foreign Army but was dis-

missed for health reasons. He moved to a studio in Montparnasse in 1934. During World War II, he fled Paris and went into hiding in the south of France. After the war, Dobrinsky lived in Paris until his death in 1973.

SELECTED EXHIBITIONS:
Exhibited at the Salon d'Automne for the first time in 1914; subsequently he exhibited at the Salon de la Société Nationale des Beaux-Arts and regularly at the Salon des Tuileries after 1923. First one-person show at Galerie L'Epoque, Paris, 1930. Other exhibitions: Galerie Charpentier, Paris, 1938; Galerie Bosk, Paris, 1947; Galerie Vidal, Paris, 1971; Galerie ·Rimion, Paris, 1971; Galerie Passali, Paris, 1975; *La Ruche et Montparnasse 1902–1930*, Musée Jacquemart-André, Paris, 1978–79; Galerie du Salon de la Rose + Croix, Paris, 1984.

SELECTED BIBLIOGRAPHY:
Waldemar George. "Isaac Dobrinsky." *Beaux-Arts* (May 20, 1938).
Maximilien Gauthier. *Dobrinsky 1891–1973*, exhibition catalogue. Paris, 1975.
Moussia Toulman. "Isaac Dobrinsky." *Chronique Artistique de A.M.I.F.* (May 1973).
Jeanine Warnod. *La Ruche et Montparnasse*. Paris and Geneva, 1978.

EPSTEIN, HENRI
(1891–1944)

Epstein was born in Lodz, Poland. After having started studying art in his hometown, he enrolled in the art academy of Munich but left to serve in the Russian army. He arrived in Paris in 1912 and moved into La Ruche, where he met Soutine, Chagall, Krémègne, and other emigré artists. Epstein studied at an open art school, the Académie de la Grande Chaumière. During the 1920s and '30s Epstein often traveled outside Paris to paint rural settings and coastal towns. He remained in Paris after the outbreak of World War II; in February 1944, he was sent to the Drancy deportation camp near Paris and from there to a concentration camp, where he died.

SELECTED EXHIBITIONS:
Exhibited at the Salon d'Automne, the Salon des Indépendents, and (after 1923) the Salon des Tuileries [dates unknown]. Other exhibitions: *Oeuvres d'artistes juifs morts en déportation*, Galerie Zak, Paris, 1955; *Mané-Katz et son temps*, Petit Palais, Geneva, 1969; *Memorial in Honor of Jewish Artists Victims of Nazism*, University of Haifa, Israel, 1978; *La Ruche et Montpar-*

nasse 1902–1930, Musée Jacquemart-André, Paris, 1978–1979.

SELECTED BIBLIOGRAPHY:
Maximilien Gauthier. "Henri Epstein." *La Renaissance des Arts Français* (May 1930), p. 146.
Waldemar George. *Henri Epstein*. Paris, 1932.
Georges Peillex. *Mané-Katz et son temps*, exhibition catalogue. Geneva, 1969.
Memorial in Honor of Jewish Artists Victims of Nazism, exhibition catalogue. Haifa, 1978.
Jeanine Warnod. *La Ruche et Montparnasse*. Paris and Geneva, 1978.
Donation Jean et Geneviève Masurel à la Communauté Urbaine de Lille. Musée d'Art Moderne, Villeneuve d'Ascq, 1984, pp. 67–69.

FÉDER, ADOLPHE
(AIZIK)
(1887–1943)

Féder was born in Odessa. At the age of nineteen he went to study in Berlin. Arriving in Paris in 1910, he enrolled at the Académie Julian for two years, then for a year at the Matisse Academy. He was elected as a member of the Salon d'Automne soon after exhibiting there in 1912. Féder became very close to the Montparnasse circle of artists (particularly Modigliani) and could be seen most evenings sitting with them at the Café de la Rotonde. During the early 1920s he went to the south of France as well as to Algeria, and in 1926 he visited Palestine. Around this time he obtained French citizenship. When the Germans occupied Paris he had no means of escaping, and in June 1942 Féder was arrested with his wife by the Gestapo and charged with harboring members of the Resistance. Incarcerated at the Cherche-Midi prison, he was subsequently transferred to the Drancy camp and from there deported to Auschwitz, where he was killed at the end of 1943.

SELECTED EXHIBITIONS:
Exhibited at the Salon d'Automne for the first time in 1912; first one-person show at Galerie Drouet, Paris, ca. 1928. Other exhibitions: *Oeuvres d'artistes juifs morts en déportation*, Galerie Zak, Paris, 1955; Galerie Jean Tiroche, New York, n.d. [1970?]; *Memorial Exhibition in Honor of Jewish Artists Victims of Nazism*, University of Haifa, Israel, 1978; *Spiritual Resistance 1940–1945: Art from the Concentration Camps*, The Baltimore Museum of Art, Baltimore, 1978.

SELECTED BIBLIOGRAPHY:
Maurice Raynal. *Féder*. Rome, 1925.
Gustave Kahn. *Adolphe Féder*. Paris, ca. 1929.
Simon Lissim. "Adolphe Féder." *Mobilier et Décoration* (April 1932), pp. 163–66.
A. Frechet. "Adolphe Féder." *Mobilier et Décoration*, vol. 14 (1934), pp. 151–56.
Maximilien Gauthier. "Adolphe Féder." *L'Art Vivant* (October 1934), p. 381.
Memorial Exhibition in Honor of Jewish Artists Victims of Nazism, exhibition catalogue. Haifa, 1978.
Spiritual Resistance 1940–1945: Art from the Concentration Camps, exhibition catalogue. Baltimore, 1978.

GOTKO, JACQUES
(1900–1944)

Gotko was born in Odessa. His family moved to Paris in 1905. Growing up in difficult economic conditions, Gotko succeeded nevertheless in studying architecture and set design at the Ecole des Beaux-Arts. In the mid-1920s he decided to devote himself exclusively to painting. In 1942, having remained in Paris after the Occupation, he was arrested and interned in the Compiègne deportation camp, where he continued to paint and draw scenes from the life of the camp. He was then sent to the Drancy camp and from there to a death camp, where he died around 1944.

SELECTED EXHIBITIONS:
Exhibited at the Salon des Indépendants for the first time in 1927; also exhibited at the Salon d'Automne [dates unknown]. Other exhibitions: Galerie Zak, Paris, 1935(?); Galerie Jean Castel, Paris, 1939; *Oeuvres d'artistes juifs morts en déportation*, Galerie Zak, Paris, 1955; *Memorial in Honor of Jewish Artists Victims of Nazism*, University of Haifa, Israel, 1978; *Spiritual Resistance 1940–1945: Art from the Concentration Camps*, The Baltimore Museum of Art, Baltimore, 1978; *Résistance, Déportation—Création dans le Bruit des Armes*, Musée de l'Ordre de la Libération, Paris, 1980.

SELECTED BIBLIOGRAPHY:
Memorial in Honor of the Jewish Artists Victims of Nazism, exhibition catalogue. Haifa, 1978.
Spiritual Resistance 1940–1945: Art from the Concentration Camps, exhibition catalogue. Baltimore, 1978.
Résistance, Déportation—Création dans le Bruit des Armes, exhibition catalogue. Paris, 1980.

GOTTLIEB, LÉOPOLD
(1883–1934)

Gottlieb was born in Drohobycz, in Austrian-occupied Poland. The son of a Talmudist, he was one of thirteen children. In 1897–98 he studied at the fine arts academy in Cracow, traveling subsequently to Munich and to Vienna. Gottlieb arrived in Paris in 1899 and soon after was invited to teach for a few months at the Bezalel Art Academy in Jerusalem. Back in Paris, he lived in the Rue Joseph-Bara and became a close friend of Diego Rivera and of Oscar Miestchaninoff, both of whose portraits he painted. Gottlieb fought a duel with his compatriot and fellow-artist Kisling in June 1914 and two months later volunteered for service in the Polish Army at the outbreak of World War I. When the war was over, he remained several years in Poland, returning to Paris in 1926. After his return to France, he often painted the countryside at Vaison-La-Romaine. Gottlieb remained in Paris until his death in 1934.

SELECTED EXHIBITIONS:
Exhibited at the Salon d'Automne for the first time in 1905; also exhibited at the Salon des Indépendants during the 1920s. First one-person show at Galerie des Quatre Chemins, Paris, 1927. Other exhibitions: Musée Rath, Geneva, 1928; Galerie d'Art de Montparnasse, Paris, 1929 (catalogue preface by Van Dijen); Carnegie Institute, Pittsburgh, 1933; *The Jewish Experience in the Art of the Twentieth Century*, The Jewish Museum, New York, 1975.

SELECTED BIBLIOGRAPHY:
Léopold Gottlieb. *Memories of a Legionnaire*. Warsaw, 1922 (in Polish).
André Salmon. *Léopold Gottlieb*. Paris, 1927.
Marie Dormoy. "Léopold Gottlieb." *L'Amour de l'Art* (December 1927), p. 472.
Jan Topass. "Léopold Gottlieb." *The Menorah Journal* (June 1928), pp. 560–62. New York.
Waldemar George. "Léopold Gottlieb, ou le retour au thème." *Art et Décoration* (March 1933), pp. 77–84.
Ramon Favela. *Diego Rivera: The Cubist Years*. Phoenix Art Museum. Arizona, 1984.

GRÜNEWALD, ISAAC
(1889–1946)

Grünewald was born in Stockholm. He began to study painting in his hometown. Grünewald arrived in Paris in 1908, settling in Montparnasse, where he associated with the group of German emigrés known as the "Dômiers" (for their meetings at the Café du Dôme),

including Lévy, Rosam, Pascin, Bondy, Purrmann, and Grossmann. He studied at the newly founded Matisse Academy on the Rue de Sèvres. In 1911 Grünewald returned to Sweden, where he worked on set and costume designs for the Stockholm Opera. He was back in Paris again in 1921 and stayed for several years. From 1932 to 1942 Grünewald taught at the art academy in Stockholm. He died in 1946 in a plane accident.

SELECTED EXHIBITIONS:
Galerie Georges Bernheim, Paris, 1931; *Pariser Begegnungen 1904–1914*, Wilhelm Lehmbruck Museum, Duisberg, Germany, 1965.

SELECTED BIBLIOGRAPHY:
André Warnod. *Isaac Grünewald*. Paris, 1928.
S. Strömbom. *Isaac Grünewald*. Stockholm, 1934.
J. Holdin. *Isaac Grünewald*. Stockholm, 1949.
Barbara and Erhard Göpel. *Hans Purrmann, Schriften.* Wiesbaden, Germany, 1961.
Pariser Begenungen 1904–1914, exhibition catalogue. Duisburg, 1965.
Eva Sundler. *Isaac Grünewalds Scenografi 1920–30, Vision, Och, Verklighet.* Stockholm, Marit Werenskiold. *The Concept of Expressionism, Origins and Metamorphoses.* Oslo, 1984.

HALICKA, ALICE
(1894–1975)

Halicka was born in Cracow, Poland, of a prosperous family; her father was a doctor. She spent her childhood with her grandparents in Merano, in the South Tyrol, and went to Germany in 1912 to study at the academy of art in Munich. In 1913 Halicka moved to Paris, enrolling at the Académie Ranson, where she studied with ex-Nabis Maurice Denis and Paul Sérusier. She married her compatriot Louis Marcoussis and together they fraternized with Apollinaire, Braque, Max Jacob, André Salmon, and others in the avant-garde. After Marcoussis joined the army, Halicka moved to Normandy where she spent the war years alone, working intensively. Beginning in 1920 she exhibited regularly at the major annual Parisian salons and, increasingly, much of her work involved the decorative arts, stage sets, and costume designs. After the war, Halicka traveled to Poland where she made a series of paintings of the Cracow Ghetto, and to London where she was welcomed by the members of the Bloomsbury group, including Roger Fry. From 1935 to 1938 she was in New York, producing stage designs for the Metropolitan Opera House. Halicka returned to France in 1938, but in May 1940, a month before the

occupation of Paris, she and Marcoussis fled with their daughter, seeking refuge in Cusset, near Vichy, and then in a number of different towns throughout France. Widowed in 1941, Halicka returned to Paris in 1945 and continued to live there until her death in 1975.

SELECTED EXHIBITIONS:
Exhibited at the Salon d'Automne for the first time in 1912, at the Salon des Indépendants in 1920, and at the Salon des Tuileries in (probably) 1924. First one-person show at the Galerie Druet, Paris, 1924. Other exhibitions: Galerie Georges Petit, Paris, 1930–31; Leicester Gallery, London, 1935; Julien Levy Gallery, New York, 1937; Galerie Pascaud, Paris, 1938; Galerie Bignou, Paris, 1961.

SELECTED BIBLIOGRAPHY:
Guillaume Apollinaire. "Alice Halicka." *Les Soirées de Paris* (1912).
Lucien Murat. "Séléctions: Romances capitonnées." *L'Art Vivant* (January 1, 1926), p. 3.
Maurice Raynal. *Modern French Painters.* New York, 1928.
Alice Halicka. *Hier (Souvenirs).* Paris, 1946.
Pierre Callier. "Alice Halicka." *Cahiers d'art-documents*, no. 171 (1962), pp. 1–16. Geneva.
Jeanine Warnod. "Alice Halicka et ses souvenirs." *Terres d'Europe*, no. 48 (May 1974). Brussels.
Lea Vergine. *L'Altra metà dell'Avanguardia 1910–1960.* Milan. 1980.
Robert L. Herbert et al., eds. *The Société Anonyme and the Dreier Bequest at Yale University, A Catalogue Raisonné.* New Haven, 1984.

HAYDEN, HENRI
(1883–1970)

Hayden was born in Warsaw, the son of a rich merchant. He began his studies in engineering at the polytechnic institute in 1902 but left three years later to go to the fine arts academy in Warsaw. In 1907 he moved to Paris, where he studied with Desvallières and Guérin at the Académie de la Palette, living and working at first in great isolation. Beginning in 1909 he spent his summers in Brittany, painting at Pont-Aven and Le Pouldu. In 1910 he met the dealer Adolphe Basler, who later introduced him to André Salmon. Exempted from military service in 1914, he moved to a studio in Montparnasse. There, he met Max Jacob and Lipchitz, who brought him to the attention of the dealer Léonce Rosenberg. From 1916 to 1920, his passion for music brought him in contact with Poulenc, Milhaud, and four other young composers who were grouped

together from 1920 on as "Les Six"; he also worked in collaboration with the composer Erik Satie. In the summer of 1920 he discovered the south of France at Cassis and Sanary. Around this time, he obtained French citizenship. Forced to flee Occupied Paris in June 1942, Hayden stayed at first in the Auvergne with Robert and Sonia Delaunay, then in Mougins (near Cannes), and finally in hiding in the Vaucluse region until the Liberation. Back in Paris in 1944 he found his studio ransacked and all his works stolen. Hayden continued to live and work in Paris until his death in 1970.

SELECTED EXHIBITIONS:

Exhibited at the Salon d'Automne for the first time in 1909; also exhibited regularly at the Salon des Indépendants after 1909 and at the Salon des Tuileries after 1923. First one-person show at Galerie Druet, Paris, 1911 (catalogue preface by André Salmon). Other exhibitions: Galerie de L'Effort Moderne, Paris, 1919; Galerie Marcel Bernheim, Paris, 1928; Galerie Zborowski, Paris, 1928; Galerie Drouant, Paris, 1928; Galerie Zak, Paris, 1928; Galerie Pétrides, Paris, 1939; Waddington Galleries, London, 1959; Musée National d'Art Moderne, Paris, 1968; Musée des Beaux-Arts, Rennes, 1979.

SELECTED BIBLIOGRAPHY:

Nino Frank. "Henri Hayden." *L'Art Vivant* (December 1928), p. 967.
Germain Bazin. "Henri Hayden." *L'Amour de l'Art* (January 1931), pp. 40–41.
André Salmon. "Henri Hayden." *La Revue de France* (1933), pp. 517–20.
André Salmon. "Henri Hayden et l'Eternelle Jeunesse." *Prisme des Arts*, no. 12 (1957), pp. 24–26.
Jean Selz. *Henri Hayden.* Geneva, 1962.
Jean Cassou. *Hayden: Soixante ans de peinture: 1908–1968*, exhibition catalogue. Paris, 1968.

INDENBAUM, LÉON
(1892–1981)

Indenbaum was born in Vilna, Lithuania, the son of a lace merchant. He started studying woodcarving in an arts and crafts school in his hometown. In 1908 he obtained a grant to study at the fine arts academy in Odessa for the next three years. Indenbaum moved to Paris in 1911, settling first in the Cité Falguière as a guest of the fellow-Russian sculptor Miestchaninoff. He soon moved into La Ruche, where he remained until 1927. Indenbaum took sculpture classes in the atelier of Antoine Bourdelle. During the 1920s the fashion designer and art collector Jacques Doucet started buy-

ing his work. Indenbaum's studio was ransacked during World War II. After the war he remained in Paris until he moved to Grasse in the south of France, where he died in 1981.

SELECTED EXHIBITIONS:

Exhibited at the Salon des Indépendants for the first time in 1912 and at the Salon des Tuileries after 1924. Other exhibitions: *Vingt-deux sculpteurs témoignent de l'homme*, Galerie Vendôme, Paris, 1964; *1er Festival de Sculpture Contemporaine*, St.-Ouen, France, 1967; *La Ruche et Montparnasse 1902–1930*, Musée Jacquemart-André, Paris, 1978–79.

SELECTED BIBLIOGRAPHY:

Adolphe Basler. *Léon Indenbaum*, Paris, n.d. [1929?]
Waldemar George. "Formes et Lumières: Variations sur Léon Indenbaum." *La Renaissance des Arts Français* (1932), pp. 61–64.
Jeanine Warnod. *La Ruche et Montparnasse.* Paris and Geneva, 1978.
François Chapon. *Mystères et splendeurs de Jacques Doucet.* Paris, 1984.

JACOB, MAX
(1876–1944)

Max Jacob was born in Quimper, Brittany. In 1894 he entered the Ecole Coloniale in Paris but left three years later for an artistic career. Around 1898 Jacob became an art critic for the *Moniteur des Arts* and the *Gazette des Beaux-Arts*. He met Picasso in 1901, and André Salmon and Apollinaire in 1904. In 1907 Jacob moved to the Rue Ravignan in Montmartre and associated with the poets and writers of the Bateau-Lavoir. He claims to have had a vision of Jesus Christ in 1909, which led to his conversion to Catholicism (he was christened in 1915, with Picasso as his godfather). Draft-exempt at the outbreak of World War I, he remained in Paris and acted as the home-front liaison for many of the artists and writers of Montparnasse; he was especially close to Modigliani and Kisling. His collection of poems *Le Cornet à des* was published in 1917. In 1921 Jacob went to the village of St.-Benoît-sur-Loire, where he lived in a monastery; he returned to Paris in 1927 until he decided to retire definitively to St.-Benoît nine years later. This period was the high point of Jacob's career as a visual artist; beginning in 1926 and continuing well into the 1930s, Jacob was under contract to two important Parisian galleries, Percier and Georges Petit, both of which exhibited his gouaches, paintings, and drawings. He was named Chevalier de la Légion d'Honneur in 1933. Although

he believed that his conversion would protect him from the Nazis (even after watching his entire family be sent to Hitler's concentration camps), Jacob himself was arrested by the Gestapo in February 1944 and sent to the deportation camp at Drancy, outside of Paris, in preparation for his own deportation. He caught pneumonia, however, and died at Drancy on March 5, 1944.

SELECTED EXHIBITIONS:
First one-person exhibition in a gallery in the Boulevard de Clichy, Paris, 1914. Other exhibitions: Galerie Térisse, Paris, 1919; Galerie Bernheim-Jeune, Paris, 1920; regular exhibitions at Galerie Percier and Galerie Georges Petit, from 1926; Galerie Monique de Groote, Paris, 1951; Musée des Beaux-Arts de Quimper, Brittany, 1961; Bibliothèque Municipale d'Orléans, 1964; Musée de Montmartre, Paris, 1976–77; *Memorial in Honor of Jewish Artists Victims of Nazism,* University of Haifa, Israel, 1978.

SELECTED BIBLIOGRAPHY:
M. Quiette. "Max Jacob peintre." *L'Art et les Artistes* (1931), pp. 113–19.
André Billy. *Max Jacob.* Paris, 1946.
Leroy Bruening. "Max Jacob et Picasso." *Mercure de France,* vol. 331 (December 1957), p. 581.
P. Quinioux, *Hommage à Max Jacob,* exhibition catalogue. Quimper, 1961.
Gerald Kamber. *Max Jacob and the Poetics of Cubism.* Baltimore, 1971.
Marcelin Pleynet, Jeanine Warnod, and C. Parisot. *Max Jacob, Dessins.* Paris, 1978.
Memorial in Honor of Jewish Artists Victims of Nazism, exhibition catalogue. Haifa, 1978.
Pierre Andreu. *Viet et mort de Max Jacob.* Paris, 1982.

KARS, GEORGES
[JIRI KARPELES]
(1882–1945)

Kars was born in Kralupy near Prague, of a wealthy German family. From 1899 to 1905 he studied at the art academy in Munich while attending art history classes at the university. At that time, he met Jules Pascin, Rudolf Levy, and the Swiss painter Paul Klee. During the next three years, he lived in Prague and traveled to Spain and Portugal. Kars arrived in Paris in 1908 and began to exhibit his paintings at the salons from 1909 on. In1914, at the outset of World War I, he went to Belgium and then to Prague. Back in France by 1919, he met Maurice Utrillo and Suzanne Valadon. In 1923 he became a member of the Salon des Tuileries. Forced to leave Paris in 1939, Kars found refuge in

Lyons, but by the end of 1942 he had to escape to Switzerland, where he spent a short time in a refugee camp. In February 1945, only a few days before he had planned to return to Paris, he committed suicide in his hotel room in Geneva.

SELECTED EXHIBITIONS:
Exhibited at the Salon d'Automne for the first time in 1909, at the Salon des Indépendants from 1913, and at the Salon des Tuileries from 1923. First one-person show at H. Goltz in Munich, 1913, (catalogue preface by Adolphe Basler). Other exhibitions: Galerie de la Licorne, Paris, 1922; Galerie Berthe Weill, Paris, 1928 and 1931; The Art Institute, Chicago, 1933; Galerie Katia Granoff, Paris, 1954; *L'Ecole de Paris et la Belle Epoque de Montparnasse,* Musée du Petit Palais, Geneva, 1973; *Donation Pierre Lévy,* Musée de l'Orangerie, Paris, 1978; *Memorial in Honor of Jewish Artists Victims of Nazism,* University of Haifa, Israel, 1978; *Spiritual Resistance 1940–1945: Art from the Concentration Camps,* The Baltimore Museum of Art, Baltimore, 1978; *Georges Kars, une Rétrospective,* Musée d'Art Moderne de la Ville de Troyes, France, 1982–83.

SELECTED BIBLIOGRAPHY:
Florent Fels. *George Kars.* Paris, 1930.
Jacques Guenne. "Georges Kars." *L'Art Vivant* (October 1934), p. 405.
Joseph Solignon. *La vie et l'oeuvre de Georges Kars.* Lyons, 1958.
Memorial in Honor of Jewish Artists Victims of Nazism, exhibition catalogue. Haifa, 1978.
Spiritual Resistance 1940–1945: Art from the Concentration Camps, exhibition catalogue. Baltimore, 1978.
Grace C. Grossman. *The French Connection: Jewish Artists in the School of Paris 1900–1940, Works in Chicago Collections.* Spertus Museum of Judaica, Chicago, 1982.
Georges Kars, une Rétrospective, exhibition catalogue. Troyes, 1982.

KIKOÏNE, MICHEL
(1892–1968)

Kikoïne was born in the town of Gomel, Russia, the son of a banker in Minsk; both his grandfathers were rabbis. He first attended a painting school in Minsk with Chaim Soutine. They were prohibited from attending the Imperial Academy in St. Petersburg because they were Jews, and therefore they went to the school of fine arts in Vilna from 1908 to 1911, where they met Pinchus Krémègne. Kikoïne arrived in Paris around 1912 and moved into La Ruche, where he lived until 1927.

He was soon joined by Soutine, and the two of them enrolled at the Ecole des Beaux-Arts, and while there studied with Cormon. At the outbreak of World War I, he volunteered for service in the French army. Through Modigliani, Kikoïne obtained contracts with art collectors such as Eugène Descaves and Léon Zamaron. During World War II, he entered active service as a reservist wearing the yellow star. Demobilized in 1942, he went into hiding in the Free Zone, with his family in Toulouse. Back in Paris after the war, Kikoïne visited Israel several times in the 1950s. He continued to live in Paris until his death in 1968.

SELECTED EXHIBITIONS:
Exhibited at the Salon des Indépendants for the first time in 1912, at the Salon d'Automne in 1920, and at the Salon des Tuileries after 1923. First one-person show at the Galerie Chéron, Paris, 1919. Other exhibitions: Galerie Marcel Bernheim, Paris, 1920; Galerie de la Licorne, Paris, 1922; Brummer Gallery, New York, 1925, 1927, 1947; Galerie Zborowski, Paris, 1928; Galerie Billet-Worms, Paris, 1931; Galerie Katia Granoff, Paris, 1948; Redfern Gallery, London, 1955; Galerie de Paris, Paris, 1973; *Mané-Katz et son temps*, Petit Palais, Geneva, 1969; *The Jewish Experience in the Art of the Twentieth Century*, The Jewish Museum, New York, 1975; *La Ruche et Montparnasse 1902–1930*, Musée Jacquemart-André, Paris, 1978–79; *The French Connection: Jewish Artists in the School of Paris 1900–1940*, Spertus Museum of Judaica, Chicago, October–December 1982.

SELECTED BIBLIOGRAPHY:
Charles Fegdal. "Michel Kikoïne." *L'Art Vivant* (1929).
Adolphe Basler. "Michel Kikoïne." *Paris-Montparnasse* (1933).
Nesto Giacometti. *Michel Kikoïne*. Paris, 1938.
N. Bettex-Callier. "Kikoïne." *Cahiers d'Art-Documents*, no. 58 (1957). Geneva.
Chil Aronson. *Scènes et Visages de Montparnasse*. Paris, 1963.
Jean Cassou. "Kikoïne." *La Galerie des Arts*, no. 76 (September 15, 1969), pp. 18–19.
Edouard Roditi et al. *Kikoïne*. Paris, 1973.
Janine Warnod. *La Ruche et Montparnasse*. Paris and Geneva, 1978.
Grace C. Grossman. *The French Connection: Jewish Artists in the School of Paris 1900–1940*, exhibition catalogue. Chicago, 1982.

KISCHKA, ISIS
(1908—?)

Kischka was born in Paris, his parents having emigrated from Russia two years earlier. His father worked

at first in a bakery, then opened a grocery where Kischka worked as well from 1921 to the early 1930s. By 1935 he began to attend open art schools, most notably the Académie de la Grande Chaumière. At the Salon des Indépendants in 1938, his work attracted the notice of Waldemar George. In 1941, arrested by the Gestapo, he was imprisoned in Fort Romainville, subsequently transferred to Stalag 122 at Compiègne and finally sent to the Drancy deportation camp, where he remained until the Liberation in August 1944. Kischka managed to draw scenes of life in the deportation camps, like his fellow-artists Gotko and Berline, who would die in concentration camps. When Kischka returned to Paris in 1945, he found his studio ransacked. He remained in Paris thereafter.

SELECTED EXHIBITIONS:
Exhibited at the Salon des Indépendants for the first time in 1938. Other exhibitions: Galerie Drouant, Paris, ca. 1940; *Oeuvres d'artistes juifs morts en déportation*, Galerie Zak, Paris, 1955; Galerie Saint-Placide, Paris, 1957; Galerie Maurice Oeuillet, Toulouse, 1958; Musée de Cagnes-sur-Mer, 1958; Galerie Monique de Groote, Brussels, 1958; Galerie 65, Cannes, 1960; Galerie Ecole de Paris, Paris, 1965; *Spiritual Resistance 1940–1945: Art from the Concentration Camps*, The Baltimore Museum of Art, Baltimore, 1978; *Résistance, Déportation—Création dans le Bruit des Armes*, Musée de l'Ordre de la Libération, Paris, 1980.

SELECTED BIBLIOGRAPHY:
Jean Cassou and Waldemar George. "Kischka." *Les Cahiers de la Peinture*, no. 1 (May 1957). Paris.
Jean Bouret. "Isis Kischka." *Les Cahiers d'Art-Documents*, no. 81 (1958). Geneva.
Robert Rey et al. *Vision sur Kischka*. Béziers, France, 1966.
Spiritual Resistance 1940–1945: Art from the Concentration Camps, exhibition catalogue. Baltimore, 1978.
Résistance, Déportation—Création dans le Bruit des Armes, exhibition catalogue. Paris, 1980.

KISLING, MOÏSE
(1891–1953)

Kisling was born in Cracow, Poland, of a well-to-do family. Originally intended by his father to become an engineer, Kisling went instead to the fine arts academy in Cracow. He arrived in Paris in 1910 and lived at first in Montmartre, but by 1913 he had moved to a studio in the Rue Joseph-Bara in Montparnasse. There he met

the leading figures of the Parisian avant-garde, such as Max Jacob, André Salmon, and Modigliani. In 1912, after exhibiting at the Salon d'Automne, Kisling signed a contract with the art dealer Adolphe Basler. He fought a duel with his compatriot, the painter Léopold Gottlieb two months before joining the French Army at the outbreak of World War I. Wounded in battle in 1915, Kisling was dismissed from active duty and awarded with French citizenship for the service he had rendered to the country as a combatant. In 1916 Kisling returned to Montparnasse, and when the war ended his studio became one of the main meeting places for the circle of Montparnasse. He married Renée Gros, the daughter of a high-ranking French military officer. Having gained recognition in the Parisian art world, he was named Chevalier de la Légion d'Honneur in 1933. Kisling spent increasingly long periods of time in the south of France and in 1938 had a house built in Sanary, on the Riviera. He volunteered again for service in the French army at the beginning of World War II, but after the Germans took Paris in June 1940 he fled, first to Marseilles, then to Portugal, and finally to America, arriving in New York in 1941. He spent the next five years in New York and California. Back in Paris by 1946, he found his studio ransacked. He divided his time between Paris and Sanary until his death in 1953.

SELECTED EXHIBITIONS:
Exhibited at the Salon d'Automne for the first time in 1912, at the Salon des Indépendants in 1914, and at the Salon des Tuileries in 1925. First one-person show at Galerie Druet, Paris, 1919 (catalogue preface by André Salmon). Other exhibitions: Galerie Paul Guillaume, Paris, 1924 (catalogue preface by André Salmon); Galerie C. A. Girard, Paris, 1931; Galerie Guy Stein, Paris, 1937; Whitney Museum, New York, 1941; Galerie Drouant-David, Paris, 1951; Redfern Gallery, London, 1957; Musée du Petit Palais, Geneva, 1983; Musée du Grand Palais, Paris, 1984.

SELECTED BIBLIOGRAPHY:
Florent Fels. "Kisling." *Action* (October 1921), pp. 29–30.
Waldemar George. "Kisling." *L'Amour de l'Art* (January 1922), pp. 25–26.
Jacques Guenne. "Portraits d'artistes: Kisling". *L'Art Vivant* (June 15, 1925), pp. 9–12.
Emile Tériade. "Kisling". *L'Art d'Aujourd'hui*, no. 11 (1926), pp. 29–34.
Georges Gabory. *Moïse Kisling*. Paris, 1928.
Florent Fels. *Kisling*. Paris, 1928.
André Salmon. "Kisling." *L'Art et les Artistes* (December 1928).
Georges Charensol. "Kisling". *Art et Décoration* (January 1934), pp. 11–18.
Joseph Kessel and Jean Kisling. *Moïse Kisling*. Paris, 1971.
Henry Troyat. *Moïse Kisling*. 2 vols. Paris, 1982.
Musée du Grand Palais: *Moïse Kisling*, exhibition catalogue. Paris, 1984.

KOGAN, MOISHE
(1879–1943)

Kogan was born of a respectable old religious family in Orgeyev, Bessarabia (Russia). He studied chemistry in Odessa but decided to become a sculptor. In 1903 Kogan went to Munich, where he enrolled at the art academy and developed a strong interest in arts and crafts. He became a member of the New Artists Circle (which included members of the Blaue Reiter group) and exhibited with them in 1909–10. Meanwhile, he moved to Paris in 1910, settling in the Hôtel du Sport (in the Rue Bréa, off the Carrefour Vavin) and associating with the artists who frequented the Café du Dôme. He was also in contact with the sculptor Aristide Maillol. In 1925, after exhibiting for the first time at the Salon d'Automne, Kogan was elected vice-president of the sculpture committee of this salon, a high honor for a non-French artist. He continued to work both as a sculptor and as a decorative artist, experimenting in a wide variety of mediums. He also continued to be deeply interested in the Bible and in Jewish history and mysticism. After Paris was taken by the Germans, Kogan did not flee. He was arrested by the Vichy police in 1942 and was interned in the Drancy camp outside Paris; the following year he was deported to a concentration camp, where he died.

SELECTED EXHIBITIONS:
Exhibited at the Salon d'Automne for the first time in 1908 and at the Salon des Tuileries in 1926 and 1927; participated in the Berlin Secession beginning in 1909 and at the Werkbund exhibition in Cologne in 1914; also participated in group shows at Galerie Bernheim-Jeune (Paris) in 1921, Galerie Flechtheim (Berlin) in 1923 and at the Brummer Gallery (New York) in 1927. Other exhibitions: *Oeuvres d'artistes juifs morts en déportation*, Galerie Zak, Paris, 1955; Clemens Sels Museum, Neuss, Germany, 1960; *Memorial in Honor of Jewish Artists Victims of Nazism*, University of Haifa, Israel, 1978.

SELECTED BIBLIOGRAPHY:
Clemens-Sels Museum. *Moishe Kogan*, exhibition catalogue. Neuss, 1960.
Jacques Chapiro. *La Ruche*. Paris, 1960.
Memorial in Honor of Jewish Artists Victims of Nazism,

exhibition catalogue. Haifa, 1978.
Solomon R. Guggenheim Museum. *Kandinsky in Munich, 1896–1914*. New York, 1982.

KRÉMÈGNE, PINCHUS
(1890–1981)

Krémègne was born in Vilna, Lithuania. In 1909–10, he studied at the school of fine arts there. He arrived in Paris in 1912 and moved into La Ruche, where he was soon joined by Soutine and Kikoïne, with whom he had become friends at the art school in Vilna. Having begun as a sculptor, Krémegne switched to painting around 1912. His first buyers were Paul Guillaume, Leopold Zborowski, Gustave Coquiot, and Père Chéron. In the 1920s he often painted on the Riviera in Cagnes, on the island of Corsica, and in the Pyrenees. He spent World War II hiding in the Free Zone in Ceret in the south of France and moved to Israel in 1952.

SELECTED EXHIBITIONS:
Exhibited at the Salon des Indépendants for the first time in 1913. First one-person exhibition at Galerie Povolozky, Paris, 1919. Other exhibitions: Galerie de la Licorne, Paris, 1922; Galerie Champigney, Paris, 1925; Galerie Van Leer, Paris, 1927, 1929, 1931; Galerie Druet, Paris, 1931; Galerie Durand-Ruel, Paris, 1959 (catalogue preface by Waldemar George); The Adams Gallery, London, 1960; *La Ruche et Montparnasse 1902–1930*, Musée Jacquemart-André, Paris, 1978–79.

SELECTED BIBLIOGRAPHY:
Maximilien Gauthier. "Pinchus Krémègne." *L'Art Vivant* (August 1931).
André Salmon. "Pinchus Krémègne." *Gringoire* (July 24, 1931).
Waldemar George. *Pinchus Krémègne*. Paris, n.d. [1930s].
Gustave Coquiot. *Les Indépendants*. Paris, n.d.
Jacques Brielle, "Les peintres juifs." *L'Amour de l'Art* (June 1933), pp. 141–47.
Waldemar George. *L'humble et le colossal Krémègne*. Paris, 1959.

LEVY, RUDOLF
(1875–1944)

Levy was born in Stettin, Pomerania (Germany), the son of a very wealthy merchant family. In 1895 he went to study for two years at the arts and crafts school in

Karlsruhe, and at that time he met Hans Purrmann. In 1899 he went to the art academy in Munich, where he was the pupil of Zugel, as well as to the private art school of H. V. Knirr, where he met Paul Klee and Georges Kars. Levy arrived in Paris in 1903 with Walter Bondy. They were the first "Dômiers" and Levy played a focal role in the pre-war gatherings of the German artists at the Café du Dôme. In 1908 Levy helped set up the Matisse Academy, which he attended for the next three years. He spent his summers on the Riviera in Sanary, where there was a community of artists. At the outbreak of World War I, he had to leave Paris and join the German army. During the 1920s Levy lived in Germany, moving from Munich to Düsseldorf to Berlin. In 1933, at the time of the Nazi takeover, he left Germany; by 1938, after traveling in France and Spain, he moved to Italy. At the outbreak of World War II, he was living at the Pensione Baldini in Florence. In 1943 Levy was arrested by the Gestapo and sent to a deportation camp in Carpi, in central Italy. He died the following year on the way to Auschwitz.

SELECTED EXHIBITIONS:
Works of the "Domier," group show, Galerie Flechtheim, Düsseldorf, 1914. First one-person show at Galerie Flechtheim, Berlin, 1922. Other exhibitions: Galerie Flechtheim, Düsseldorf, 1925; *Hans Purrmann, Rudolf Levy, Oscar Moll*, Galerie F. A. C. Prestel, Frankfurt-am-Main, 1960; *Pariser Begenungen 1904–1914*, Wilhelm Lehmbruck Museum, Duisburg, Germany, 1965; *Levy bei Levy*, Galerie Levy, Hamburg, 1977.

SELECTED BIBLIOGRAPHY:
Hans Purrmann. *Rudolf Levy*. Düsseldorf, 1922.
Rudolf Grossmann. "Dômechronik." *Kunst und Kunstler*, vol. 20 (January 1922), pp. 29–32.
Barbara and Erhard Göpel. *Hans Purrmann, Schriften*. Wiesbaden, Germany, 1961.
Pariser Begenungen 1904–1914, exhibition catalogue. Duisburg, 1965.

LIPCHITZ, JACQUES
(CHAIM-JACOB)
(1891–1973)

Lipchitz was born in Druskieniki, Lithuania, the son of a building contractor from a wealthy banking family. He began his studies in Bialystok, Poland, and after a pogrom was sent to high school in Vilna. Lipchitz arrived in Paris in 1909, living at the Hôtel des Mines on

the Boulevard St.-Michel until 1911, when he moved to Montparnasse. He studied at first as a free pupil at the Ecole des Beaux-Arts with Injalbert, then at the Académie Julian and the Académie Colarossi. Around 1912 he met the Cubist painters through Diego Rivera and became friends with Max Jacob, Modigliani, Soutine, and Picasso. He was able to remain in Paris after having avoided the draft by receiving a medical exemption from the Russian army. While Lipchitz was on a trip to Spain in 1914, the war began, so he prolonged his stay there. Back in Paris in 1915, he signed a contract with the art dealer Léonce Rosenberg which ran from 1916 to 1920. In those years he became close friends with Juan Gris and Jean Cocteau. He obtained French citizenship in 1924. Lipchitz moved again in 1925, this time to the Parisian suburb of Boulogne, where he and the sculptor Miestchaninoff had commissioned Le Corbusier to build them twin studio-houses. In 1937 he received a gold medal for his monumental sculpture at that year's Universal Exposition. When the Germans invaded Paris in 1940, Lipchitz and his wife were forced to flee to France's Free Zone, staying for a few months near Toulouse. Thanks to his reputation as an international artist by this date, he was helped by the newly formed Emergency Rescue Committee which provided him with a visa, passage money, and an escape route to the United States. Lipchitz arrived in New York in 1941, leaving behind most of his work and belongings. Thereafter, he lived in America, with frequent trips to Paris, to Israel and Italy. He died on the island of Capri in 1973 and was buried in Jerusalem.

SELECTED EXHIBITIONS:

Exhibited for the first time in a gallery probably called Gil-Blas, Paris, 1911. Exhibited at the Salon d'Automne and the Salon de la Société National des Beaux-Arts in 1912. First one-person show at Galerie de l'Effort Moderne, Paris, 1920 (catalogue preface by Maurice Raynal). Other exhibitions: Galerie de la Renaissance, Paris, 1930; Brummer Gallery, New York, 1935 (catalogue preface by Elie Faure); Buchholz Gallery, New York, 1943, 1944, 1948; *European Artists in Exile*, Whitney Museum of American Art, New York, 1945; Galerie Maeght, Paris, 1946 (catalogue preface by Jean Cassou); The Museum of Modern Art, New York, 1954; traveling exhibition: Stedelijk Museum, Amsterdam, Musée National d'Art Moderne, Paris, and Tate Gallery, London, 1958–59; Marlborough Gallery, London and New York, from 1964 on; Tel Aviv Museum, Israel, 1970–71; Israel Museum, Jerusalem, 1971; Metropolitan Museum of Art, New York, 1972; *The Golden Door: Artist-Immigrants of America, 1876–1976*, Hirshhorn Museum and Sculpture Garden, Washington, D.C., 1976; Musée National d'Art Moderne, Centre Pompidou, Paris, 1978.

SELECTED BIBLIOGRAPHY:

Roger Bissière. "Lipchitz". *Action*, no. 4. (1920), pp. 39–42.

Maurice Raynal. *Lipchitz*. Paris, 1920.

Paul Dermée. "Lipchitz." *L'Esprit Nouveau*, no. 2 (November 1920), pp. 169–82.

Waldemar George. "Jacques Lipchitz." *L'Amour de l'Art*, vol. 2 (1921), pp. 255–58.

Jean Cocteau. "Jacques Lipchitz and My Portrait Bust." *Broom* (June 1922), pp. 207–9.

Waldemar George. "Bronzes de Jacques Lipchitz." *L'Amour de L'Art*, vol. 7 (1926), pp. 299–302.

Waldemar George. *Jacques Lipchitz*. Paris, n.d. [1928?].

Vincente Huidobro. "Jacques Lipchitz." *Cahiers d'Art*, vol. 3 (1928), pp. 153–58.

Roger Vitrac. *Jacques Lipchitz*. Paris, 1929.

Jacques Baron. "Jacques Lipchitz." *Documents*, vol. 2, no. 1 (1930), pp. 17–26.

Emile Tériade. "A propos de la récente exposition de Jacques Lipchitz." *Cahiers d'Art*, vol. 5 (1930), pp. 259–65.

James Johnson Sweeney. "An interview with Jacques Lipchitz." *Partisan Review* (Winter 1945), pp. 83–89.

Henry R. Hope. *The Sculpture of Jacques Lipchitz*, exhibition catalogue. New York, 1954.

A. M. Hammacher. *Jacques Lipchitz: His Sculpture*. New York, 1960 and 1965.

Jacques Lipchitz. *My Life in Sculpture*. London, 1972.

Ziva Amishai-Maisels. "Lipchitz and Picasso: Thematic Interpenetrations." *Journal of Jewish Art*, vol. 1 (1974), pp. 80–92.

Nicole Barbier. *Lipchitz: Oeuvres de Jacques Lipchitz*, exhibition catalogue. Paris, 1978.

LIPSI, MORICE
(LIPSZYC)
(1898–)

Lipsi was born in Lodz, Poland. He was still in high school when he came to Paris in 1912 to stay with his brother Samuel, who worked as an ivory sculptor at La Ruche. Lipsi soon decided to move to Paris permanently and began his art studies as an apprentice to his brother, then enrolled at the Ecole des Beaux-Arts and took sculpture classes with Mercié and Injalbert. By the early 1920s he started sending his works to the salons and having one-person exhibitions in galleries. Lipsi stayed at La Ruche until 1927, when he moved to a studio in the Rue de Vanves; in 1933 he moved again, to the southern suburbs of Paris in Chatilly-la-Rue. Every summer during the 1930s he went to Italy. He

obtained French citizenship in 1933. In 1937 Lipsi received a gold medal for his participation at that year's Universal Exposition. Drafted in 1940, he was forced, after the occupation of Paris and the armistice with Germany, to go into hiding in the south of France, then in Savoy in 1942, finally reaching Switzerland where he joined his family. He came back to France on May 7, 1945, the day the Armistice was signed ending the war in Europe. He now lives in Chatilly-la-Rue and in Switzerland.

SELECTED EXHIBITIONS:
Exhibited at the Salon d'Automne and the Salon des Indépendants from the early 1920s until 1950. First one-person show at Galerie Hébrard, Paris, 1922. Other exhibitions: Galerie d'Art Contemporain, Paris, 1927 (catalogue preface by André Warnod); Galerie Druet, Paris, 1935; Galerie Pierre Maurs, Paris, 1946; Galerie Denise René, Paris, 1959; Keukenhof, Holland, 1965; *La Ruche et Montparnasse 1902–1930*, Musée Jacquemart-André, Paris, 1978–79; Centre National des Arts Plastiques, Paris, March–April 1985.

SELECTED BIBLIOGRAPHY:
Thiébault-Sisson. "Un sculpteur en ivoire: Lipsi." *Le Temps* (1921).
Louis Vauxcelles. *Lipsi*. Paris, 1935.
Bernard Champigneulle. "Morice Lipsi." *Mobilier et Décoration* (January 1936).
R. V. Gindertael. *Morice Lipsi*. Neuchâtel, 1965.
Jeanine Warnod. *La Ruche et Montparnasse*. Paris and Geneva, 1978.
Centre National des Arts Plastiques. *Lipsi*, exhibition catalogue. Paris, 1985.

MANÉ-KATZ
[EMMANUEL (?) KATZ]
(1894–1962)

Mané-Katz was born in Kremenchug, in the Ukraine, the son of a synagogue beadle. He received a religious education, then went to study at the Vilna and Kiev schools of fine arts from 1911 to 1913. He arrived in Paris in 1913 and enrolled at the Ecole des Beaux-Arts, studying in Common's class, where he met Soutine and Chagall. In 1914, after having tried to enlist in the Foreign Army and having been turned down because of his small stature, Mané-Katz went back to his hometown in Russia. After the Russian Revolution began, in 1917, he was appointed professor in Kharkov. Three years later Mané-Katz was back in Paris and in 1927 he became a French citizen. In 1928 he traveled to the Middle East, to which he returned many times, espe-

cially to Palestine. At the outbreak of World War II, he was mobilized as an orderly at the Ecole Militaire in Paris and was subsequently imprisoned by the Germans in Royan. In 1940 Mané-Katz managed to flee to Marseilles and to escape to the United States, where he joined Kisling. He was back in Paris again by 1945. In 1951 he was named Chevalier de la Légion d'Honneur. Although Mané-Katz traveled frequently to the Middle East and the Far East throughout the 1950s, Paris remained his home. He died in Israel in 1962.

SELECTED EXHIBITIONS:
Exhibited at the Salon d'Automne and the Salon des Indépendents for the first time in 1924. First one-person exhibition at Galerie Percier, Paris, 1923 (catalogue preface by Waldemar George). Other exhibitions: Galerie Percier, Paris, 1924, 1928; Galerie Katia Granoff, Paris, 1929, 1938, 1945, 1949; Galerie Manteau, Brussels, 1929 (catalogue preface by Pierre Courthion); Galerie Brummer, Paris, 1930; Galerie Georges Petit, Paris, 1934; Galerie Charpentier, Paris, 1937; Wildenstein Gallery, New York, 1938, 1942, 1944; *European Artists in America*, Whitney Museum of American Art, New York, 1945; Tel Aviv Museum, Israel, 1948 and 1954; Musée Rath, Geneva, 1959 (catalogue preface by Jean Cassou), *The French Connection: Jewish Artists in the School of Paris 1900–1940*, Spertus Museum of Judaica, Chicago, 1982.

SELECTED BIBLIOGRAPHY:
J. H. Aimot. *Mané-Katz*. Preface by Paul Fierens. Paris (or Brussels?), 1933.
Maximilien Gauthier. *Mané-Katz*. Paris, 1951.
R. Ariès. *Mané-Katz: The complete works*. London, 1970.

MARCOUSSIS, LOUIS
[LOUIS CASIMIR LADISLAS MARKUS]
(1878–1941)

Marcoussis was born in Warsaw, the son of a rich industrialist. In 1903, after two years of studyng law and painting in Cracow, he arrived in Paris, enrolling for a short period at the Académie Julian. Around 1905 he was working as an illustrator for the journals *La Vie Parisienne* and *L'Assiette au Beurre*. In 1910 he met Apollinaire, Braque, and Picasso. That year, on Apollinaire's suggestion, he adopted the name Marcoussis (after a small village in the Seine-et-Oise district). In 1912 he showed with the other Cubists at the *Section d'Or* exhibition. Marcoussis married his compatriot the painter Alice Halicka in 1913 and moved with her to

the Rue Caulaincourt, where they lived until 1939. He became a French citizen by serving in the army during World War I. Marcoussis traveled to Poland in 1919, 1921, and 1923. Around 1933 he taught engraving at Schapfer's studio in Montparnasse. He spent a year in New York in 1934–35. In Paris Marcoussis led a cosmopolitan life, frequenting the worlds of French aristocrats and of numerous artists and critics both from France and abroad. In May 1940, a month before the occupation of Paris, Marcoussis and his family left for Cusset, near Vichy, in central France. There he died of a terminal disease in the fall of 1941.

SELECTED EXHIBITIONS:
Exhibited at the Salon d'Automne for the first time in 1905, at the Salon des Indépendants in 1906, and at the Salon des Tuileries in 1924; also at the *Section d'Or* exhibition at the Galerie de la Boétie, Paris, 1912. First one-person show at Galerie Pierre, Paris, 1925 (catalogue preface by Tristan Tzara). Other exhibitions: Galerie Sélection, Brussels, 1920; Galerie Der Sturm, Berlin, 1920; Galerie Georges Bernheim, Paris, 1929; Galerie Jeanne Bucher, Paris, 1929; Knoedler & Co:, New York, 1933 and 1935; Palais des Beaux-Arts, Brussels, 1936; Kunstverein, Cologne, 1960; Musée National d'Art Moderne, Paris, 1964; *The Cubist Circle*, University Art Gallery, University of California at Riverside, 1971.

SELECTED BIBLIOGRAPHY:
Waldemar George, "Louis Marcoussis." *L'Amour de l'Art*, vol. 5 (1924), pp. 334–36.
H. Achel. "Marcoussis." *Cahiers d'Art*, no. 6 (1926), pp. 141–44.
Jean Lurçat. "Louis Marcoussis." *L'Art d'Aujourd'hui* (January 1926), pp. 35–36.
E. Tériade, Tristan Tzara, Max Jacob, Waldemar George, et al. "Louis Marcoussis." *Selection*, special issue (June 1929). Antwerp.
Jean Cassou. *Louis Marcoussis*. Paris, 1930.
———. "Braque, Marcoussis et Juan Gris." *L'Amour de L'Art* (November 1933), pp. 227–31.
Jean Lafranchis. *Louis Marcoussis*. Paris, 1961.

Around 1910 she started traveling around Europe, visiting a number of Russian emigrés. In Capri she stayed with Maxim Gorky, who gave her the nickname Marevna. She arrived in Paris in 1912, studying at the Académie Colarossi and the Académie Russe in Montparnasse, where she met Soutine, Krémègne, and Zadkine. In 1918 Marevna met the Mexican painter Diego Rivera, with whom she lived until his departure for Mexico in 1921. He left her with a daughter, Marika. During the 1920s she became increasingly involved with the more remunerative field of decorative arts. She left Paris for France's Free Zone during World War II. After the war, Marevna settled in London but moved back to France by the 1960s. She divided her life between Paris and London thereafter until her death in London in 1984.

SELECTED EXHIBITIONS:
Exhibited at the Salon des Indépendants for the first time in 1913, at the Salon d'Automne in 1919, and at the Salon des Tuileries in 1924. Other exhibitions: Galerie du Quotidien, Paris, 1929; Galerie Zborowski, Paris, 1936; Galerie Roux, Paris, 1952; Galerie Lefèvre, London, 1952; Galerie Claude, Paris, 1953; *Neo-Impressionism*, Solomon R. Guggenheim Museum, New York, 1968; Petit Palais, Geneva, 1971; *La Ruche et Montparnasse 1902–1930*, Musée Jacquemart-André, Paris, 1978–79.

SELECTED BIBLIOGRAPHY:
Gustave Kahn. "Marevna." *Mercure de France* (June 15, 1929).
———. "Marevna." *Le Quotidien* (January 10, 1936).
P. Descargues. "Marevna." *Les Lettres Françaises* (July 2, 1953).
Marevna. *Life in Two Worlds*. London, 1962.
Robert L. Herbert. *Neo-Impressionism*, exhibition catalogue. New York, 1968.
Georges Peillex. *Marevna*, exhibition catalogue. Geneva, 1971.
Marevna. *Life with the Painters of La Ruche*. Translated by Natalie Heseltine. London, 1974.
Lea Vergine. *L'Altra Metà dell'Avanguardia*. Milan, 1980.

MAREVNA
[MARIA VOROBIEFF]
(1892–1984)

Marevna was born in Cheboksary, Russia, the daughter of a Russian nobleman and an actress. At the age of fifteen she moved to Moscow, where she studied at the open university and at the school of decorative arts.

MENKÈS, SIGMUND
(ZYGMUNT)
(1896–)

Menkès was born in Lvov, Poland. In 1912, at the age of sixteen, he interrupted his high school studies to go to the school of decorative arts there, at which time he

also learned fresco painting and worked on the restoration of orthodox churches. After World War I, he attended the fine arts academy in Cracow for two years. The next year, he was in Berlin. Menkès moved to Paris in 1923. During the 1920s and '30s he often went to paint in the south of France near Toulon and also visited Poland several times. At the outbreak of World War II, he left France for America, where he arrived in 1939. Menkès remained in the United States and still lives in Riverdale, New York.

SELECTED EXHIBITIONS:
Exhibited at the Salon d'Automne and the Salon des Indépendants from the mid-1920s on. First one-person show at Galerie le Portique, Paris, 1928. Other exhibitions: Galerie Bernheim, Paris, 1930; The Cleveland Museum of Art, Ohio, 1930; Marie Sterner Gallery, New York, 1930; Galerie de France, Paris, 1931; Galerie Le Portique, Paris, 1932; Associated American Artists Gallery, New York, n.d.; *The Jewish Experience in the Art of the Twentieth Century*, The Jewish Museum, New York, 1975.

SELECTED BIBLIOGRAPHY:
Henri Segel. "Sigmund Menkès." *La Nouvelle Aurore* (November 1924), p. 7.
Maurice Raynal. *Anthologie de la peinture française de 1906 à nos jours*. Paris, 1927.
Emile Tériade. *Sigmund Menkès*. Paris, n.d. [1930?].
André Salmon. "Sigmund Menkès." *Les Chroniques du Jour*, no. 3 (March 1930).
Albert Dreyfus. "A propos de Menkès." *Les Chroniques du Jour*, no. 5 (May 1930).
————— . "L'Apport étranger dans la peinture française." *Les Chroniques du Jour*, no. 7 (July 1930).
Jacques Brielle. "Les peintres juifs." *L'Amour de l'Art* (June 1933), pp. 141–47.

MIESTCHANINOFF, OSCAR
(1886–1956)

Miestchaninoff was born in Vitebsk, Russia, the son of a shopkeeper. In 1905–6 he studied at the school of fine arts in Odessa. He arrived in Paris in 1906 and studied for a few months at the Ecole des Arts Décoratifs, then at the Ecole des Beaux-Arts. From 1906 to 1924 Miestchaninoff lived at the Cité Falguière. In 1925 he moved to the Parisian suburb of Boulogne, where he and Lipchitz had commissioned Le Corbusier to build them twin studio-houses. The French government sent him on official missions to the Far East for archeological excavations (in 1918–19 to India and in 1926–27 to Burma and Siam). In 1937 he won a prize

medal at the Universal Exposition for the sculpture *Girl Arranging Her Hair*. After World War II broke out he left occupied France for America, arriving in New York in 1941. There Miestchaninoff associated with other Europeans in exile and frequently exhibited with them. He subsequently moved to California, where he lived in Los Angeles until his death in 1956.

SELECTED EXHIBITIONS:
Exhibited at the Salon des Artistes Français for the first time in 1908, at the Salon de la Société Nationale des Beaux-Arts in 1909, and at both the Salon d'Automne and the Salon des Indépendants in 1912. Other exhibitions: Musée du Petit Palais, Paris, 1939; *Artists in Exile*, Pierre Matisse Gallery, New York, 1942; *European Artists in Exile*, Whitney Museum of American Art, New York, 1945; Los Angeles County Museum of Art, 1955.

SELECTED BIBLIOGRAPHY:
Waldemar George. "Un sculpteur russe d'influence française: Oscar Miestchaninoff." *L'Amour de l'Art* (June 1923), pp. 576–78.
Yvanohé Rambosson. "Oscar Miestchaninoff." *Art et Décoration* (February 1925), pp. 57–64.
Richard F. Brown. *Oscar Miestchaninoff*. Los Angeles County Museum of Art, 1955.
Waldemar George. *Oscar Miestchaninoff: Sculpteur, explorateur, collectionneur*. Paris, 1966.

MODIGLIANI, AMEDEO
(1884–1920)

Modigliani was born in Leghorn, Italy. His father was a tradesman and both parents came from prominent Sephardic families. His eldest brother, Emanuele, became a socialist deputy. Modigliani's health was weak all through his childhood, and he was eventually diagnosed as tubercular. In 1898 he entered the art school of Guglielmo Micheli in his hometown. In 1901, in order to cure his tuberculosis, he traveled around Italy on a convalescent tour. From 1903 to 1906 he studied at the fine arts academies in Florence and Venice. Modigliani arrived in Paris in 1906, living at first in Montmartre and meeting the members of the Bateau-Lavoir group around Picasso. He became friendly with the painters Gino Severini and Maurice Utrillo. It was at this time that he started frequenting the cabarets of Montmartre and indulging in heavy drinking and smoking hashish. In 1909 he abandoned Montmartre for Montparnasse, never staying in one place for long, except sporadically at the Cité Falguière. He began working on sculpture together with Brancusi around

1911–12. In 1915 Lipchitz introduced Modigliani to Soutine. The following year he was introduced by Max Jacob to the dealer and collector Paul Guillaume and at the same time also obtained a contract with the poet-dealer Leopold Zborowski that provided a regular allowance. After going through a series of girlfriends Modigliani met Jeanne Hébuterne, with whom he lived the last few years of his life. They spent 1918–19 in Nice. In January 1920, a few months after returning to Paris, while staying in the Rue de la Grande Chaumière, he was striken with tubercular meningitis and died in a charity hospital. The day after he died, Hébuterne committed suicide.

SELECTED EXHIBITIONS:
Exhibited at the Salon des Indépendants for the first time in 1908, and at the Salon d'Automne in 1912. Exhibited in a group show at Lyre et Palette, Paris, 1915. First one-person show at the Galerie Berthe Weill, Paris, 1917. Other exhibitions: Modigliani, memorial retrospective at the *2ème Exposition de la Peinture Française*, Galerie Manzi-Joyant, Paris, 1920; Galerie Levêque, Paris, 1921; Galerie Bernheim-Jeune, Paris, 1922; Galerie Bing, Paris, 1925; *Rétrospective Modigliani*, Salon des Indépendants, Paris, 1926; *La Grande Peinture Contemporaine dans la Collection Paul Guillaume*, Galerie Bernheim-Jeune, Paris, 1929; Demotte Galleries, New York, 1931: Galerie Marcel Bernheim, Paris, 1931; Palais des Beaux-Arts, Brussels, 1933; Galerie Claude, Paris, 1945; Galerie de France, Paris, 1946; The Museum of Modern Art, New York, 1951; Galleria Nazionale d'Arte Moderna, Rome, 1959; Perls Galleries, New York, 1963 and 1966; Galerie N.R.A., Paris, 1977; Musée d'Art Moderne de la Ville de Paris, 1981; National Gallery of Art, Washington D.C., 1984.

SELECTED BIBLIOGRAPHY:
Francis Carco. "Modigliani." *L'Eventail* (July 15, 1919).
Florent Fels. "Chronique artistique: Modigliani". *Les Nouvelles Littéraires* (October 24, 1925).
Waldemar George. "Modigliani." *L'Amour de l'Art* (October 1925), pp. 383–88.
André Salmon. *Modigliani: Sa vie, son oeuvre*. Paris, 1926.
Giovanni Schweiller. *Modigliani*. Paris, 1927.
Waldemar George. *La Grande Peinture Contemporaine dans la Collection Paul Guillaume*, exhibition catalogue, n.d. [1929].
Arthur Pfannstiel. *Modigliani*. Paris, 1929.
Adolphe Basler, Ossip Zadkine, André Salmon, et al. "Modigliani." *Paris-Montparnasse*, special issue (June 1930).
Adolphe Basler. *Modigliani*. Paris, 1931.
James Thrall Soby. *Modigliani: Paintings, Drawings, Sculpture*, exhibition catalogue. New York, 1951.
Jacques Lipchitz. *Amedeo Modigliani*. Paris, 1954.
Jeanne Modigliani. *Modigliani, Man and Myth*. New York, 1958.
H. I. Hibbard. *Modigliani and the Painters of Montparnasse*. New York, 1970.
Musée d'Art Moderne de la Ville de Paris, 1981. *Modigliani 1884–1920*, exhibition catalogue. Paris, 1981.

MONDZAIN, SIMON
(CA. 1890–1979)

Mondzain was born in Chelm, Poland. At an early age, he went to study at the school of arts and crafts in Warsaw, then from about 1908 to 1912 at the fine arts academy in Cracow. He participated in national art exhibitions and obtained a grant to travel to Paris in 1909 and again in 1911. During his second trip he met the painters Dunoyer de Segonzac and André Derain, and the poets Max Jacob and Apollinaire. Mondzain moved to Paris the following year, joining his childhood friend Moïse Kisling. At the outbreak of World War I, he joined the Foreign Legion and served in the light infantry. Mondzain obtained French citizenship in 1923 and that same year became a founding member of the Salon des Tuileries. He developed close friendships with Elie Faure, Othon Friesz, and André Salmon. During the 1920s, he traveled around France and painted, particularly in the south. Mondzain went to Algeria in 1925, returned there with increasing frequency, and finally settled in Algiers during World War II. He remained in North Africa until 1963 when he moved back to Paris. Mondzain died in Paris in 1979.

SELECTED EXHIBITIONS:
Exhibited at the Salon des Indépendants for the first time in 1911 and at the Salon des Tuileries in 1923. Other exhibitions: Galerie Paul Guillaume, Paris, 1922; Galerie Druet, Paris, 1923 and 1931; Galerie Hodebert, Paris, 1925; Galerie Jacques Callot, Paris, 1927; Galerie Allard, Paris, 1934; Galerie de l'Elysée, Paris, 1937 and 1950; *Mondzain et ses Amis*, Musée des Beaux-Arts de Besançon, 1978; Musée Granet, Aix-en-Provence, 1983.

SELECTED BIBLIOGRAPHY:
Waldemar George, "Simon Mondzain." *L'Amour de l'Art* (September 1923), pp. 688–90.
Emile Tisserand. "Mondzain." *L'Art et les Artistes* (December 1931), pp. 99–103.
J. Guéhéno. *Mondzain*. Paris, n.d. [1926?].
Charles Kunstler. *Mondzain*. Paris, 1942.

C. de Perretti. *Mondzain.* Musée Granet, Aix-en-Provence, 1983.

NADELMAN, ELIE
(1882–1946)

Nadelman was born in Warsaw, the youngest of seven children; his father was a jeweler. Between 1899 and 1901, he studied irregularly at the fine arts academy in Warsaw. In 1904 Nadelman left for Paris, stopping for a few months in Munich on the way. In Paris, he enrolled at the Académie Colarossi and took a studio on the Avenue du Maine in Montparnasse. In 1908 the American collector Leo Stein introduced Nadelman to Picasso; Helena Rubinstein started buying his work in 1911. At the outbreak of World War I, he went to the Russian embassy in Brussels to try to enlist in the Russian army, but when informed of the impossibility of crossing Europe, he left instead for the United States, with the help of Rubinstein. Arriving in New York in 1914, Nadelman lived in Greenwich Village and became involved with the group of artists associated with Alfred Stieglitz's Photo-Secession Gallery. In 1927 he became an American citizen and moved just north of Manhattan to Riverdale. In 1942 Nadelman joined the Riverdale Air Warden Service, and until the end of the war he volunteered to teach occupational therapy to wounded soldiers. He died in 1946 of heart disease.

SELECTED EXHIBITIONS:
Exhibited at the Salon d'Automne for the first time in 1905 and at the Salon des Indépendants in 1907. First one-person show at Galerie Druet, Paris, 1909 and again in 1913. Other exhibitions: Galerie Berthe Weill, Paris, 1907; Paterson's Gallery, London, 1911; Photo-Secession Gallery ("291"), New York, 1915; Knoedler & Co., New York, 1919 and 1927; Galerie Bernheim-Jeune, Paris, 1927 and 1930; The Museum of Modern Art, New York, 1948; Zabriskie Gallery, New York, 1967; Whitney Museum of American Art, New York, 1975; *The Golden Door: Artist-Immigrants of America, 1876–1976.* Hirshhorn Museum and Sculpture Garden, Washington, D.C., 1976.

SELECTED BIBLIOGRAPHY:
Adolphe Basler. "Eli Nadelman." *Sztuka.* (1912), pp. 72–74. Lwow, Poland.
André Salmon. "Elie Nadelman." *L'Art Décoratif* (March 1914), pp. 107–14.
——————— . "Elie Nadelman." *L'Art Vivant* (1926), pp. 259–60.
Adolphe Basler. *La Sculpture Moderne en France.* Paris, 1928.
Athena T. Spear. "Elie Nadelman's Early Heads (1905–1911)." *Allen Memorial Art Museum Bulletin,* Oberlin College, vol. 28, 1971, pp. 201–22.
——————— . "The Multiple Styles of Elie Nadelman: Drawings and Figure Sculptures ca. 1905–1912." Ibid., vol. 31 (1973–74), pp. 34–58.
Lincoln Kirstein. *Elie Nadelman.* New York, 1973.
Abraham Lerner, ed. *The Hirshhorn Museum and Sculpture Garden.* New York, 1974.
John I. H. Baur. *The Sculpture and Drawings of Elie Nadelman.* Whitney Museum of American Art, New York, 1975.

ORLOFF, CHANA
(1888–1968)

Chana Orloff was born in Tsare-Constantinovska, a small village in the Ukraine. Her family emigrated to Palestine in 1905. In 1910 she went to Paris and was accepted at the Ecole des Arts Décoratifs; she also took sculpture classes at the Académie Russe in Montparnasse. Orloff soon entered the orbit of the Montparnasse artists who frequented the Café du Dôme and the Café de la Rotonde. In 1916 she married the poet Ary Justman and illustrated his book *Réflections Poétiques.* She became a widow only two years later and was left with a one-year-old son. In the early 1920s Orloff became a leading portraitist of Parisian high society. In 1923 she illustrated *Figures d'Aujourd'hui,* an anthology of portrait-poems of the Parisian art world by Gaston Picard. Three years later, Orloff obtained French citizenship and was named Chevalier de la Légion d'Honneur. She traveled to Palestine in 1923 and 1925. In 1926 Orloff moved into a studio-house in Montparnasse that she had commissioned from the architect Auguste Perret. She continued to work in occupied Paris until 1942. Alerted by her friends that her arrest was imminent, she left with her son for Lyons, where they met the painter Georges Kars and managed to cross the border to Switzerland; she remained there until the end of World War II. Back in Paris in 1945, she found her studio ransacked and most of her sculpture stolen. In the late 1940s Orloff traveled again to Israel, where she executed a number of official commissions. She died during a visit to Israel in 1968 on the occasion of a retrospective for her eightieth birthday.

SELECTED EXHIBITIONS:
Exhibited at the Salon d'Automne for the first time in 1913, at the Salon des Indépendants in 1918, and at the Salon des Tuileries in 1924. First one-person show at Galerie Povolozky, Paris, 1922. Other exhibitions: *Exposition de peintures, Série C,* Galerie Bernheim-

Jeune, Paris, 1916; *Sic Ambulant,* in Orloff's studio, Paris, 1917; Galerie Briant-Robert, Paris, 1923; Galerie Druet, Paris, 1926; Weyhe Gallery, New York, 1929; Leceister Gallery, London, 1936; *Les Maîtres de l'Art Indépendant,* Musée du Petit Palais, Paris, 1937; Tel Aviv Museum, Israel, 1935, 1949, 1969; Galerie de France, Paris, 1946; Galerie Katia Granoff, Paris, 1946, 1959, 1962; Musée Rodin, Paris, 1956 and 1971; Galerie Valois, Paris, 1983.

SELECTED BIBLIOGRAPHY:
Robert Rey. "Les Portraits sculptés de Chana Orloff." *Art et Décoration* (March 1923), pp. 57–60.
"A Group of Chana Orloff's Portrait Busts in Wood: A Russian Woman Who Is Leading a New Movement of Sculpture in Paris." *Vanity Fair* (June 1924), p. 55.
André Salmon. "Chana Orloff." *L'Art d'Aujourd'hui* (Spring 1925), pp. 11–13.
Edmond des Courrières. *Chana Orloff.* Paris, 1927.
Léon Werth. *Chana Orloff.* Paris, 1927.
Georges Charensol. "Chana Orloff." *L'Art Vivant* (January 1927), p. 40.
Chana Orloff. "Mon ami Soutine." *Evidences* (November 1951), pp. 17–21.
Jean Cassou. *Chana Orloff.* Tel Aviv Museum, Israel. 1961.
G. Salmon-Coutard. "Chana Orloff." Unpublished Ph.D. dissertation, University of Paris, 1980.
Haim Gamzu, Jean Cassou, Cecile Goldscheider, and Germaine Coutard-Salmon. *Chana Orloff.* Brescia, Italy, 1980.

PASCIN, JULES
[JULIUS MORDECAI PINCAS]
(1885–1930)

Pascin was born in Vidin, Bulgaria, the eighth of eleven children; his father was an important grain merchant. The family moved to Bucharest in 1892. In 1902 Pascin left for Vienna and in 1903–4 studied at the Heymann Art School in Munich. During the next five years he worked as an illustrator for the German periodicals *Simplicissimus* and *Jugend.* He adopted the name Pascin in 1905 and in December of that year he moved to Paris. There he became part of the circle of artists who frequented the Café du Dôme, including Walter Bondy, Rudolf Lévy, Hans Purrmann, Walter Rosam, and Eugène Spiro. In 1907 he met Hermine David, whom he later married (in 1918). To evade conscription by the Romanian army at the outbreak of the war in 1914, Pascin emigrated to the United States. He spent the war years traveling in the southern states and in Cuba

until 1919. Having obtained American citizenship in 1920, he then returned to Paris. In the early 1920s he illustrated books by Pierre Mac Orlan, André Warnod, and André Salmon. Around this time he also traveled to North Africa. He was back in the United States in 1927–28 and traveling again in Europe the following year. In 1930 he committed suicide in his Paris studio.

SELECTED EXHIBITIONS:
First one-person show at Galerie Paul Cassirer, Berlin, 1907. Exhibited at the Berlin Secession in 1910; the Sonderbund-Austerlund, Cologne, in 1912; the Armory Show, New York, in 1913; and the Salon d'Automne and the Salon des Indépendants in 1913. Other exhibitions: Galerie Berthe Weill, Paris, ca. 1910; Brummer Gallery, New York, 1923; Galerie Pierre, Paris, 1924; Galerie Flechtheim, Düsseldorf, 1925; Galerie Bernheim-Jeune, Paris, 1929; Galerie Georges Petit, Paris, 1930; Knoedler & Co., New York, 1930; Galerie Lucy Krohg, Paris, 1931; Israel Museum, Jerusalem, 1958; University Art Museum, Berkeley, California, 1966–67; Musée de Genève, 1970; Perls Galleries, New York, 1984.

SELECTED BIBLIOGRAPHY:
André Warnod. "Pascin". *L'Art d'Aujourd'hui,* vol. 3 (1926), pp. 17–20.
Emile Tériade. "Jules Pascin." *Cahiers d'Art* (December 1926), pp. 287–92.
Georges Charensol. *Pascin.* Paris, 1928.
Paul Morand. *Pascin.* Paris, 1931.
André Warnod. *Pascin.* Monte Carlo, 1945.
Horace Brodsky. *Pascin.* London, 1946.
Alfred Werner. *Pascin.* New York, 1963.
Florent Fels. *Dessins de Pascin.* Paris, 1966.
Tom L. Freudenheim. *Pascin,* exhibition catalogue. Berkeley, 1966.
André Bay. *Adieu Lucy: Le Roman de Pascin.* Paris, 1984.

RATTNER, ABRAHAM
(1895–1978)

Rattner was born in Poughkeepsie, New York. In 1914 he enrolled at the Corcoran School of Art in Washington, D.C. and in 1917 at the Pennsylvania Academy of Fine Arts in Philadelphia. Toward the end of World War I, he served for a short while in the U.S. Army in France. In 1921 Rattner moved to Paris, where he studied at the Ecole des Beaux-Arts with Cormon, at the Académie de la Grande Chaumière with the sculptor Antoine Bourdelle, and at the Académie Ranson. In 1922 he lived and painted in Giverny, outside of Paris;

the following year he moved to Montmartre. Rattner became a member of the Minotaure Group in 1926. When the Nazis occupied Paris in 1940, he returned to the United States, settling in New York. During the late 1940s he occasionally taught at the New School for Social Research and in the 1950s at the Art Students League. In 1956 Rattner set up his own school in East Hampton. He died in New York in 1978.

SELECTED EXHIBITIONS:

Exhibited at both the Salon d'Automne and the Salon des Indépendants for the first time in 1924, and at the Salon du Printemps in 1925. First one-person exhibition at the Galerie Bonjean, Paris, 1935. Other exhibitions: Julien Levy Gallery, New York, 1936, 1939, 1941; Paul Rosenberg & Co., New York, from 1942 on; Baltimore Museum of Art, Baltimore, 1946–47; Whitney Museum of American Art, New York, 1959; Kennedy Galleries, New York, 1969; Galerie Weill, Paris, 1969, 1978, 1981.

SELECTED BIBLIOGRAPHY:

Pierre Reverdy. *Abraham Rattner.* Julien Levy Gallery, New York, 1935.
Abraham Rattner. "An American from Paris." *Magazine of Art* (December 1945), pp. 311–15.
Jo Gibbs. "Rattner, Colorist." *Art Digest* (February 1, 1948), p. 11.
Henry Miller. "Rattner Portfolio." *College Art Journal* (Spring 1956), pp. 182–86.
John I. H. Baur. *Four American Expressionists.* Whitney Museum of American Art, New York, 1959.
Allen Leepa. *Abraham Rattner.* New York, 1977.
Piri Halasz. "Directions, Concerns and Critical Perceptions of Paintings Exhibited in New York 1940–1949: Abraham Rattner and His Contemporaries." Unpublished Ph.D. dissertation, Columbia University, New York, 1982.

ROSAM, WALTER
(1884–1916)

Rosam was born in Hamburg, Germany. Around 1902 he started to study painting in his hometown and then in Berlin, where he met Fritz Ahlers-Hestermann and Franz Nölken. He arrived in Paris in May 1907 and was greeted by his fellow Germans at the Café du Dôme; there, Rosam, Alhers-Hestermann, and Nölken became known as the "three from Hamburg." That year Rosam entered the newly opened Matisse Academy. He spent the summers of 1910–11 in the south of France at Le Lavandou and in Italy at Forte dei Marmi. In 1912 he moved with his friend Hestermann

to Meulan-Hardricourt but was back in Paris the following year. At the outbreak of World War I, Rosam enlisted in the German Army. He died in a Russian military hospital on August 14, 1916.

SELECTED EXHIBITIONS:

Pariser Begegnungen 1904–1914, Wilhelm Lehmbruck Museum, Duisburg, Germany, 1965.

SELECTED BIBLIOGRAPHY:

Rudolf Grossmann. "Dômechronik." *Kunst und Kunstler* vol. 20 (January 1922), pp. 29–32.
Pariser Begegnungen 1904–1914, exhibition catalogue. Duisburg, 1965.
Barbara and Erhard Göpel. *Hans Purrmann, Schriften.* Wiesbaden, Germany, 1961.

SOUTINE, CHAIM
(1893–1943)

Soutine was born in the small town of Smilovitchi, Lithuania, of a very poor family; his father was a mender of clothes. His early inclination for painting, which went against the Jewish tradition, was strongly opposed by his family. In 1906 he and Michel Kikoïne attended a painting school in nearby Minsk and then from 1910 to 1913 the school of fine arts in Vilna, where they met Pinchus Krémègne. Around 1912, Soutine joined Kikoïne and Krémègne in Paris and moved into La Ruche. There in Montparnasse, he met Chagall, Zadkine, and other artists. Together with Kikoïne he enrolled at the Ecole des Beaux-Arts and studied with Cormon. In 1915 Lipchitz introduced Soutine to Modigliani. The following year Soutine signed a contract with the art dealer Leopold Zborowski. During World War I, he enlisted in work brigades digging trenches but was soon discharged for health reasons, after which he moved to the Cité Falguière, where Lipchitz, Modigliani, and Miestchaninoff were his neighbors. In 1918 he spent a brief time with Modigliani on the Riviera at Cagnes. He spent much of the next three years in the village of Céret in the French Pyrenees, with occasional trips to Cagnes. Upon his return to Paris in 1922, Soutine destroyed many of his Céret canvases. In 1923 he was discovered by the American collector Albert C. Barnes, who bought many of his paintings. Promoted further by the art dealer and collector Paul Guillaume, Soutine suddenly achieved fame and financial security. During the next few years he moved constantly, residing in different parts of Paris as well as in Cagnes. In 1927 he met the Castaings, collectors who became his patrons after Zborowski's death in 1932. In 1938 Soutine moved into

a studio in Montparnasse on the same street as Chana Orloff. At the outbreak of World War II, he was living with Gerda Groth, a German refugee, in Civry near Auxerre; as foreigners they were forbidden to leave the town. Soutine received permission to return to Paris in 1940 for medical reasons (an ulcer condition). The following year, having refused to leave France for America, he had to flee Paris and go into hiding in a village in the Indre-et-Loire region. All of this aggravated his ulcer and in 1943, the day after having successfully evaded the Germans and making his way back to the capital, he died in a Paris hospital. He was buried in Montparnasse Cemetery.

SELECTED EXHIBITIONS:
First one-person exhibition at Galerie Bing, Paris, 1927. Other exhibitions: Arts Club, Chicago, 1935; Valentine Gallery, New York, 1936, 1937, 1939; memorial exhibition, Galerie de France, Paris, 1945; Galerie Zak, Paris, 1949; The Museum of Modern Art, New York, 1950–51; Perls Galleries, New York, 1953 and 1969–70; Galerie Charpentier, Paris, 1959; Tate Gallery, London, 1963; Los Angeles County Museum of Art, 1968; Musée de l'Orangerie, Paris, 1973; Marlborough Gallery, New York, 1976; Hayward Gallery, London, 1982; Galleri Bellman, New York, 1984.

SELECTED BIBLIOGRAPHY:
Albert C. Barnes. "Soutine." *Arts à Paris* (November 1924), pp. 6–8.
Waldemar George. "Soutine." *L'Amour de l'Art* (November 1926), pp. 367–70.
_____ . *Artistes Juifs: Soutine.* Paris, 1928.
Elie Faure. *Soutine.* Paris, 1929.
Maximilien Gauthier. "Notices bio-bibliographiques: Soutine." *L'Art Vivant* (May 1930), pp. 417–31.
Waldemar George. "Soutine et la violence dramatique." *L'Amour de l'Art* (June 1933), pp. 150–52.
Raymond Cogniat. *Soutine.* Paris, 1945.
Chana Orloff. "Mon ami Soutine." *Evidences* (November 1951), pp. 17–21.
Monroe Wheeler. *Soutine,* exhibition catalogue. New York, 1950.
Emile Szittya. *Soutine et son temps.* Paris, 1955.
Maurice Tuchman. *Soutine 1893–1943.* exhibition catalogue. Los Angeles, 1968.
Alfred Werner. *Chaim Soutine.* New York, 1975.
Esti Dunow. "Chaim Soutine 1893–1943." Unpublished Ph. D. dissertation, New York University, 1981.
Hayward Gallery. *C. Soutine 1893–1943,* exhibition catalogue. London, 1982.

SPIRO, EUGEN
(1874–1972)

Spiro was born in Breslau, Germany; his father was a cantor at the Storsch Synagogue. From 1892 to 1894 he studied at the Breslau academy under Albrecht Bräuer. In 1895 Spiro went to study at the Munich academy under Franz Stuck and came under the influence of Munich Jugendstil. From 1899 to 1904 he resided in Breslau, during which time he participated in both the Munich and Vienna Secessions; from 1904 to 1906 he lived in Berlin. Spiro arrived in Paris in 1906, started frequenting the Café du Dôme along with the other Germans in Montparnasse, and taught at the Académie Moderne. At the outbreak of World War I, forced to return to Germany, he worked as a draftsman for the cartographic unit of the German Army. During the 1920s he lived in Germany and traveled to Italy and the United States. In 1933 the Nazis forbade him to work and exhibit. Two years later Spiro returned to Paris, where he became the co-founder and president of the Union des Artistes Libres. In 1940 he went into hiding in the south of France. Very ill, he still managed to escape to the United States with his wife. From then on Spiro lived in upstate New York, teaching at the Wayman-Adams School of Painting in Elizabethtown. He died in New York in 1972.

SELECTED EXHIBITIONS:
Exhibited at the Salon d'Automne for the first time ca. 1906. First one-person show at Galerie St. Etienne, New York, 1943. Other exhibitions: Galerie St. Etienne, New York, 1945, 1946, 1949, 1974; La Galerie des Arts, Nice, 1953; Galerie Wolfgang Gurlitt, Munich, 1957; *Pariser Begegnungen 1904–1914,* Wilhelm Lehmbruck Museum, Duisburg, Germany, 1965; retrospective exhibition, Berlin Museum, 1969; retrospective exhibition, Galerie Von Abercron, Cologne, 1978.

SELECTED BIBLIOGRAPHY:
Pariser Begegnungen 1904–1914, exhibition catalogue, Duisburg, 1965.
Berlin Museum. *Eugen Spiro,* exhibition catalogue. Berlin, 1969.
Galerie Von Abercron. *Eugen Spiro,* exhibition catalogue. Cologne, 1978.

WEBER, MAX
(1881–1961)

Max Weber was born in Bialystok, Poland, the son of a tailor. In 1886 his father emigrated to America and

settled in Brooklyn, where he was soon joined by the rest of the family. From 1898 to 1900 Weber studied at Pratt Institute. During the next few years he taught in various schools in Virginia and Minnesota. He arrived in Paris in 1905, enrolling at the Académie Julian, where he met the painter Dunoyer de Segonzac. The following year he enrolled as a free student at the Académie Colarossi and at the Académie de la Grande Chaumière. In 1907 he helped organize the Matisse Academy. Weber became friends with the Douanier Rousseau, who hosted a farewell banquet for him just before he returned to America at the end of 1908. Back in New York, he gravitated to the artists associated with Alfred Stieglitz's Photo-Secession Gallery "291." From 1914 to 1918 Weber taught at the Clarence H. White School of Photography and at the Art Students League of New York. In 1919 he moved with his family to Great Neck, Long Island. Later on he taught as a visiting professor in various art schools around the United States and received numerous awards. He died in Great Neck in 1961.

SELECTED EXHIBITIONS:
Exhibited at both the Salon des Indépendants and the Salon d'Automne for the first time in 1906. First one-person show at the Haas Gallery, New York, 1909. Other exhibitions: Gallery "291," New York, 1911; Galerie Bernheim-Jeune, Paris, 1924; The Museum of Modern Art, New York, 1930; Paul Rosenberg & Company, New York, from 1942 on; Whitney Museum of American Art, New York, 1949; The Jewish Museum, New York, 1956; Rose Art Museum, Brandeis University, Waltham, Mass., 1966–67; Forum Gallery, New York, 1975, 1979, 1981; *The Golden Door: Artist-Immigrants of America, 1876–1976*, Hirshhorn Museum and Sculpture Garden, Washington, D.C., 1976; The Jewish Museum, New York, 1983.

SELECTED BIBLIOGRAPHY:
Alfred H. Barr, Jr. *Max Weber*, exhibition catalogue. New York, 1930.
Lloyd Goodrich. *Max Weber*, exhibition catalogue. New York, 1949.
Sandra Leonard. *Henri Rousseau and Max Weber*. New York, 1970.
Percy B. North. "Max Weber: The Early Paintings 1905–1920." Unpublished Ph.D. dissertation, University of Delaware, 1974.
Alfred Werner. *Max Weber*, New York, 1975.
Percy B. North. *Max Weber: American Modern*. The Jewish Museum, New York, 1983.

ZACK, LÉON
(1892–1980)

Léon Zack was born in Nizhni Novgorod (now Gorki), Russia. After studying at the University of Moscow, he left for Paris in 1920, stopping for a while in Florence and then in Berlin, where he worked on ballet costumes and sets. Zack visited Paris briefly in the fall of 1920 and moved there permanently in 1923. That year he became a founding member of the Salon des Surindépendants. At the outbreak of World War II, Zack fled Paris and went into hiding in a remote village in the Isère region. Back in Paris in 1945, he resumed painting and working on costumes and set designs; he also developed an interest in religious art, producing murals, sculptures, and stained glass for Alsatian churches. Zack lived in Paris until his death in 1980.

SELECTED EXHIBITIONS:
Exhibited at both the Salon des Indépendants and the Salon d'Hiver for the first time in 1920–21, and at the Salon d'Automne and the Salon des Surindépendants in 1923. First one-person exhibition at Galerie d'Art Contemporain, Paris, 1926. Other exhibitions: Galerie Percier, Paris, 1927; Galerie Bonjean, Paris, 1930; Galerie des Quatre Chemins, Paris, 1932; Galerie Wildenstein, Paris, 1935; Galerie Katia Granoff, Paris, 1946; Galerie Klébert, Paris, 1955 and 1957; Waddington Galleries, London, 1959.

SELECTED BIBLIOGRAPHY:
Pierre Courthion. *León Zack*. Paris, 1961.
L. Quénot. *Léon Zack avant 1939*. M.A. thesis, University of Paris, 1979.

ZADKINE, OSSIP
(1890–1967)

Zadkine was born in Smolensk, Russia, the son of a university professor. At the age of sixteen he left his family to go to London, where he took courses at various art schools. Zadkine arrived in Paris in 1909 and enrolled at the Ecole des Beaux-Arts, where he studied with Injalbert. In 1910 he moved into La Ruche in Montparnasse; soon after that he met Apollinaire, Max Jacob, Picasso, Brancusi, and Lipchitz. After spending two years at La Ruche, Zadkine moved to a studio in the Rue de Vaugirard. In 1914 he joined the army and served in the ambulance corps; in Reims in December 1917 he was gassed and then hospitalized. Back in Paris in 1918, Zadkine met Modigliani and Kisling. In 1928 he moved to a more spacious studio in the Rue d'Assas near Montparnasse. Fleeing the Nazis, Zadkine

embarked in 1941 from Lisbon for New York, where he lived for the duration of the war. During his last year in New York, he taught sculpture at the Art Students League. In 1945 Zadkine returned to Paris, where he lived until his death in 1967.

SELECTED EXHIBITIONS:
Exhibited at both the Salon d'Automne and the Salon des Indépendants for the first time in 1911. Other exhibitions: *Modigliani, Kisling, Zadkine*, Lyre et Palette, Paris, 1918; Zadkine's studio, Paris, 1918; Galerie de la Licorne, Paris, 1918; Galerie Barbazanges, Paris, 1921 and 1926; Galerie Druet, Paris, 1927; Musée des Beaux-Arts, Brussels, 1933; *Artists in Exile*, Pierre Matisse Gallery, New York, 1942; *European Artists in Exile*, Whitney Museum of American Art, New York, 1945; Musée d'Art Moderne de la Ville de Paris, 1949; Wallraf Richartz Museum, Cologne, 1960; Kunsthaus, Zurich, 1965; Musée Rodin and Musée d'Art Moderne de la Ville de Paris, 1972.

SELECTED BIBLIOGRAPHY:
Maurice, Raynal. *Ossip Zadkine*. Rome, 1921.
André de Ridder. *Zadkine*. Paris, 1929.
Pierre Hambourg. *Zadkine*. Paris, 1928.
Nino Frank, "Zadkine." *L'Art Vivant* (September 15, 1930), pp. 746–47.
André Warnod. "Portraits d'artistes: Zadkine". *Comoedia*. (March 17, 1933).
Raymond Cogniat. *Zadkine*. Paris, 1958.
————— . *Hommage à Zadkine*, exhibition catalogue. Paris, 1972.
Ionel Jianou. *Zadkine*. Paris, 1979.
Marie-Claude Dane. *Musée Zadkine: Sculptures*. Paris, 1982.

ZAK, EUGÈNE
(1884–1926)

Zak was born in Mogilno, Poland, the son of an engineer. His family moved to Warsaw in 1892. He arrived in Paris around 1900 and enrolled at the Ecole des Beaux-Arts, where he studied with Gérome. The following year Zak traveled in Italy, then went for a short period to Munich, where he studied at the fine arts academy. He returned to Paris in 1904 and lived there for the next ten years. From 1914 to 1916. Zak stayed in the south of France, in Nice and in Vence. He spent the next four years in Poland, then one year in Berlin. He finally came back to Paris in 1922. He died suddenly of a heart attack in 1926 and was buried in Montparnasse Cemetery. In 1929 his widow opened the Galerie Zak in Paris, specializing in the Jewish artists of Montparnasse.

SELECTED EXHIBITIONS:
Exhibited at the Salon des Indépendants for the first time in 1904 and subsequently at the Salon de la Société des Beaux-Arts. Memorial exhibitions at Galerie Bing and the Salon des Indépendants in 1926. Other exhibitions: Galerie Bernheim, Paris, 1927; Brummer Gallery, New York, 1927; Buffalo Museum of Art, Buffalo, N.Y., 1928; Leicester Gallery, London, 1929; *Mané-Katz et son temps*, Petit Palais, Geneva, 1969.

SELECTED BIBLIOGRAPHY:
H. A. Martinie, "Eugène Zak." *Art et Décoration* (June 1926), pp. 158–60.
André Salmon. *Eugène Zak*. Galerie Bing, Paris, 1926.
Edmond Jaloux. "Eugène Zak." *L'Amour de l'Art* (May 1927), pp. 167–70.
S. Kahozorska. *Eugenjusz Zak*. Warsaw, 1927.
Maximilien Gauthier. *Eugène Zak*. Paris, n.d. [1928?].

LENDERS TO THE EXHIBITION

Marie-José Baudinet-Mondzain
Catherine Cozzano
Wiera Dobrinsky
Alex Maguy Glass
Bernard Goldberg
Joseph H. Hazen
The Joseph H. Hirshhorn Estate
Simon and Marie Jaglom
Mr. and Mrs. R. Stanley Johnson
E. Justman
Dr. Ernest Kafka
Kisling Collection
Edythe and Saul Klinow
Krishna Foundation and Carol and Alan
 Kallman
Morice Lipsi
Mme. Morice Lipszyc (born Hildegard Weber)
Mrs. Jacqueline Matalon-Samson
Mr. and Mrs. Arnold Neustadter
Sabine Streiff Oishi
Mr. and Mrs. Kurt Olden
The Henry and Rose Pearlman Foundation
Marika Rivera Phillips (daughter of Marevna and Diego
 Rivera)
Private Collection, Italy
Private Collection, Switzerland
Esther Gentle Rattner
Nicole Rousset-Altounian, Galerie N.R.A.
Helen Serger
Mr. and Mrs. Joseph Randall Shapiro

Berlin Museum, West Germany
The Brooklyn Museum, New York
Civico Gabinetto Dei Disegni, Castello Sforzesco, Milan
Clemens Sels Museum, Neuss, West Germany

Göteborgs Konstmuseum, Sweden
The Institute for Advanced Study,
 Princeton
Kibbutz Lohamei Haghetaot, Israel
Mané-Katz Museum, Haifa
The Metropolitan Museum of Art, New York
The Minneapolis Institute of Arts, Minnesota
Mishkan Leomanut, Museum of Art, Ein Harod, Israel
Mount Holyoke College Art Museum,
 South Hadley, Massachusetts
Musée d'Art Moderne de la Ville de Paris, France
Musée des Deux Guerres Mondiales, Paris
Musée National d'Art Moderne, Centre Georges Pompidou,
 Paris
The Museum of Modern Art, New York
Petit Palais, Geneva
Pfalzgalerie, Kaiserslautern, West Germany
Philadelphia Museum of Art, Pennsylvania
The Phillips Collection, Washington, D.C.
Santa Barbara Museum of Art, California
Stedelijk Van Abbemuseum, Eindhoven, The Netherlands
The Tel Aviv Museum, Israel
University of São Paulo, Brazil
Wadsworth Atheneum, Hartford

Forum Gallery, New York
Galerie Aleph, Paris
Galerie Beyeler, Basel
Galerie Levy, Hamburg
Galerie Vallois, Paris
Marlborough Fine Art, London
Marlborough Gallery, New York
Perls Galleries, New York
Tiroche Gallery, Tel Aviv

CATALOGUE OF THE EXHIBITION

CHECKLIST

Height precedes width precedes depth
Inches rounded to the nearest quarter
Centimeters rounded to the nearest tenth
*Illustrated in catalogue

1. Abraham Berline
Front Stalag 122, Compiègne,
1942
watercolor on paper
9½ × 6¼ in. (24 × 16 cm.)
Musée des Deux Guerres
Mondiales, Paris

* 2. Walter Bondy
The "Pavillon Bleu" at St.-Cloud, 1907
oil on canvas
35½ × 27½ in. (90 × 70 cm.)
Catherine Cozzano Collection,
Paris

3. Marc Chagall
The Samovar, 1911
oil on canvas
13 × 18 in. (33 × 45.7 cm.)
Simon and Marie Jaglom
Collection

4. Marc Chagall
The Passy Bridge and the Eiffel Tower, 1911
oil on canvas
23¾ × 31½ in. (60.3 × 80 cm.)
The Metropolitan Museum of
Art, New York,
The Robert Lehman Collection, 1975

5. Marc Chagall
The Poet with Birds, 1911
oil on burlap
28½ × 39 in. (72.4 × 99 cm.)

The Minneapolis Institute of
Arts,
Bequest of Putnam Dana
MacMillan

6. Marc Chagall
Maternity, 1912
gouache on paper
10¾ × 7¼ in. (27.3 × 18.4 cm.)
Helen Serger Collection, New
York

* 7. Marc Chagall
Study for (or after?) *Paris through the Window (1913),*
n.d.
gouache on paper
19 × 18½ in. (48 × 47 cm.)
Galerie Beyeler, Basel

8. Marc Chagall
The Painter and the Angel, n.d.
pastel on canvas
13 × 9½ in. (33 × 24 cm.)
Private collection, Switzerland

* 9. Marc Chagall
Jew with Torah, 1925
gouache on paper
26¾ × 20 in. (68 × 51 cm.)
The Tel Aviv Museum,
Gift of the artist, 1931

10. Marc Chagall
Sukkot, 1926
gouache on paper
20¼ × 26 in. (51.4 × 66 cm.)
Mr. and Mrs. Arnold Neustadter
Collection

11. Jacques Chapiro
Landscape with Peasants, 1924
oil on board
18½ × 29½ in. (47 × 75 cm.)
Petit Palais, Geneva

12. Bela Czobel
Man in a Straw Hat, 1906
oil on canvas
23 × 23¾ in. (58.4 × 60.3 cm.)
Mr. and Mrs. R. Stanley
Johnson Collection

* 13. Sonia Delaunay
Philomène, 1907
oil on canvas
16 × 13 in. (40.6 × 33 cm.)
Edythe and Saul Klinow
Collection

14. Isaac Dobrinsky
View of La Ruche, 1930
oil on canvas
32 × 24 in. (81 × 60 cm.)
Wiera Dobrinsky Collection

* 15. Isaac Dobrinsky
Portrait of Wiera Dobrinsky,
1933
oil on canvas
18 × 13 in. (46 × 33 cm.)
Wiera Dobrinsky Collection

* 16. Henri Epstein
Two Girls Sewing, n.d.
oil on canvas
25½ × 32 in. (64.8 × 81.3 cm.)
Tiroche Gallery, Tel Aviv,
Israel

* 17. Adolphe Féder
Bather in the Studio, ca. 1915
oil on canvas
46½ × 38¼ in. (118.1 × 97.2 cm.)
Tiroche Gallery, Tel Aviv,
Israel

* 18. Adolphe Féder
Self-Portrait with Yellow Star, at Drancy, 1943
charcoal and pastel on paper
18 × 13¼ in. (45.7 × 33.7 cm.)

Kibbutz Lohamei Haghetaot, Israel

19. Jacques Gotko
Even though . . ., 1942
watercolor and ink on paper
5½ × 7½ in. (14 × 19 cm.)
Musée des Deux Guerres
Mondiales, Paris

* 20. Jacques Gotko
New Year's Day, 1943
watercolor on paper
15¾ × 12 in. (40 × 30 cm.)
Musée des Deux Guerres
Mondiales, Paris

* 21. Léopold Gottlieb
Return from Fishing, 1925
oil on canvas
32¼ × 39¾ in. (82 × 101 cm.)
Petit Palais, Geneva

22. Isaac Grünewald
Male Model Seen from the Back, 1908
sepia on paper
10½ × 8 in. (27 × 20.4 cm.)
Göteborgs Konstmuseum,
Göteborg, Sweden

* 23. Alice Halicka
The Jewish Quarter, Cracow,
ca. 1920–26
oil on canvas
21¼ × 18½ in. (54 × 47 cm.)
Petit Palais, Geneva

24. Alice Halicka
Market Scene in the Jewish Quarter, ca. 1920–26
gouache on paper
13½ × 10¾ in. (34.3 × 27.3 cm.)
Tiroche Gallery, Tel Aviv,
Israel

* 25. Alice Halicka
La Place de la Concorde, 1938
oil on canvas
37¾ × 57½ in. (96 × 146 cm.)
Musée National d'Art
Moderne, Centre Georges
Pompidou,
Paris

* 26. Henri Hayden
Commedia dell'Arte Characters, 1914
oil on canvas
47¾ × 39½ in. (121 × 100 cm.)

Petit Palais, Geneva

27. Henri Hayden
Paris Street Scene, 1914
oil on canvas
36¼ × 29 in. (92.1 × 73.7 cm.)
Tiroche Gallery, Tel Aviv,
Israel

28. Henri Hayden
The Cabaret Boum-Boum,
1920
watercolor on paper
11½ × 17¾ in. (29 × 45 cm.)
Petit Palais, Geneva

* 29. Henri Hayden
The Three Musicians, 1920
oil on canvas
69¼ × 69¼ in. (176 × 176 cm.)
Musée National d'Art
Moderne, Centre Georges
Pompidou,
Paris

30. Léon Indenbaum
Head, 1918
bronze
10¾ × 10¾ × 11¾ in.
(27 × 27 × 30 cm.)
Mrs. Jacqueline Matalon-
Samson Collection

31. Max Jacob
Animated Street in Paris, n.d.
gouache on paper
9¾ × 13½ in. (24.5 × 34 cm.)
Petit Palais, Geneva

* 32. Max Jacob
At the Opera, ca. 1930
gouache on board
11 × 13½ in. (28 × 34.6 cm.)
Musée National d'Art
Moderne, Centre Georges
Pompidou, Paris

* 33. Georges Kars
The Bathers, 1912
oil on canvas
39½ × 31¾ in. (100.3 × 80.7 cm.)
Tiroche Gallery, Tel Aviv,
Israel

34. Georges Kars
Utrillo Reclining and Playing the Flute, 1923
ink and watercolor on paper
16 × 20 in. (40.5 × 50.5 cm.)
Musée National d'Art

Moderne, Centre Georges
Pompidou, Paris

35. Georges Kars
Help the Refugees, 1943
charcoal on paper
19½ × 17 in. (49.5 × 43.2 cm.)
Kibbutz Lohamei Haghettaot,
Israel

* 36. Michel Kikoïne
La Ruche, 1913–14
oil on canvas
18 × 13 in. (46 × 33 cm.)
Petit Palais, Geneva

37. Isis Kischka
Compiègne, 1942
watercolor on paper
11 × 16¼ in. (28 × 41.5 cm.)
Musée des Deux Guerres
Mondiales, Paris

* 38. Moïse Kisling
Portrait of André Salmon, 1912
oil on canvas
39½ × 28¾ in. (100 × 73 cm.)
Kisling Collection

* 39. Moïse Kisling
Portrait of Adolphe Basler,
1914
oil on canvas
36¼ × 28¾ in. (92 × 73 cm.)
Petit Palais, Geneva

* 40. Moïse Kisling
Jean Cocteau in the Studio,
1916
oil on canvas
22¾ × 23½ in. (73 × 60 cm.)
Petit Palais, Geneva

* 41. Moïse Kisling
Kiki in a Red Dress, 1933
oil on canvas
36¼ × 25½ in. (92 × 65 cm.)
Petit Palais, Geneva

* 42. Moïse Kisling
Map of Allied Victories,
1943–45
oil on paper
30¼ × 34¾ in. (77 × 88 cm.)
Kisling Collection

43. Moïshe Kogan
Nude with Crossed Arms, n.d.
terra cotta
17¾ × 6¾ × 1½ in.
(46.6 × 18.6 × 3.8 cm.)
Clemens Sels Museum, Neuss,

West Germany

* 44. Pinchus Krémègne
 View of the Studio at La Ruche, 1920
 oil on canvas
 43¼ × 31 in. (110 × 78.7 cm.)
 Tiroche Gallery, Tel Aviv, Israel

45. Pinchus Krémègne
 Self-Portrait, n.d.
 oil on canvas
 32 × 17¾ in. (81 × 45 cm.)
 Galerie Aleph, Paris

46. Rudolf Levy
 Nude, n.d.
 watercolor and pencil on paper
 11 × 8¼ in. (28 × 21 cm.)
 Galerie Levy, Hamburg

* 47. Rudolf Levy
 Last Self-Portrait, 1943
 oil on cardboard
 16 × 13¼ in. (41 × 33.5 cm.)
 Pfalzgalerie, Kaiserslautern, West Germany

* 48. Jacques Lipchitz
 Horsewoman with Fan, 1913
 bronze
 26¾ × 7¼ × 7¾ in.
 (68 × 18.4 × 19.7 cm.)
 Marlborough Gallery, New York

* 49. Jacques Lipchitz
 Cubist Head, 1915
 bronze
 24¼ × 11¾ × 9½ in.
 (61.6 × 29.9 × 24.1 cm.)
 Marlborough Gallery, New York

* 50. Jacques Lipchitz
 Mother and Child, 1915
 gouache on paper
 15 × 10 in. (38.1 × 25.4 cm.)
 Marlborough Fine Art, London

51. Jacques Lipchitz
 Portrait of Gertrude Stein, 1920
 bronze
 13½ × 7 × 4½ in.
 (34 × 18.1 × 11.1 cm.)
 The Museum of Modern Art, New York,
 Fund given by friends of the artist, 1963

52. Jacques Lipchitz and others
 Death Mask of Modigliani, 1920
 bronze
 9¼ × 5¾ × 4½ in.
 (23.5 × 14.6 × 11.1 cm.)
 The Joseph H. Hirshhorn Estate

53. Jacques Lipchitz
 Flight, 1940
 bronze
 14½ × 14½ × 15½ in.
 (36.8 × 36.8 × 39.4 cm.)
 Joseph H. Hazen Collection

* 54. Jacques Lipchitz
 Arrival, 1941
 bronze
 21 × 20 × 12 in.
 (53.3 × 50.8 × 30.5 cm.)
 The Institute for Advanced Study, Princeton, Gift of Joseph H. Hazen

55. Jacques Lipchitz
 Rape of Europa, IV, 1941
 chalk, gouache, brush and ink on paper
 26 × 20 in. (66 × 50.8 cm.)
 The Museum of Modern Art, New York, Purchase

56. Morice Lipsi
 Nudes, ca. 1922–23
 ivory
 6¾ × 5 × 4.3 in. (17 × 13 × 11 cm.)
 Mme. Morice Lipszyc (born Hildegard Weber) Collection

* 57. Morice Lipsi
 Woman with Goat (The Shepherdess), 1925
 wild cherry wood
 67¼ × 14¼ × 13 in. (171 36 × 33 cm.)
 Morice Lipsi Collection

58. Morice Lipsi
 Musical Group, 1926
 macassar wood
 17¼ × 7 × 3½ in. (44 × 18 × 9 cm.)
 Mme. Morice Lipszyc (born Hildegard Weber) Collection

* 59. Mané-Katz
 Homage to Paris, 1930
 oil on canvas
 89½ × 77½ in. (227.6 × 197.1 cm.)
 Mané-Katz Museum, Haifa,

Israel

69. Louis Marcoussis
 Cubist Still Life, 1917
 oil and gouache on paper mounted on canvas
 12½ × 12¼ in. (31.8 × 31.1 cm.)
 Mr. and Mrs. Joseph Randall Shapiro Collection

* 61. Marevna
 Café de la Rotonde, 1914
 pencil on paper
 10¼ × 8 in. (26 × 20.3 cm.)
 Marika Rivera Phillips (Daughter of Marevna and Diego Rivera) Collection

* 62. Marevna
 Soldier and Woman with Gas Masks, 1914
 oil on wood
 15 × 18 in. (38 × 46 cm.)
 Petit Palais, Geneva

63. Marevna
 Woman with Dog in Café, 1916
 pencil on paper
 8½ × 6¼ in. (21.6 × 15.9 cm.)
 Marika Rivera Phillips (Daughter of Marevna and Diego Rivera) Collection

* 64. Marevna
 Bouquet at the Colombe d'Or, St. Paul-de-Vence, 1942
 oil on canvas
 36¼ × 26½ in. (92 × 67 cm.)
 Petit Palais, Geneva

65. Sigmund Menkès
 Double Portrait, ca. 1926
 oil on canvas
 45¾ × 32 in. (116.2 × 81.3 cm.)
 Tiroche Gallery, Tel Aviv, Israel

66. Oscar Miestchaninoff
 Virgin, 1913
 granite
 25¾ × 16 × 9¼ in.
 (65.4 × 40.6 × 23.5 cm.)
 Santa Barbara Museum of Art, Gift of Mrs. Oscar Miestchaninoff

67. Oscar Miestchaninoff
 Equestrian, 1928

granite
11¼ × 7½ × 11 in.
(28.6 × 19 × 27.9 cm.)
The Metropolitan Museum of
Art, New York, Gift of Mrs.
Oscar Miestchaninoff, 1958

68. Amedeo Modigliani
Portrait of André Salmon, ca.
1914
pencil on paper
7 × 4 in. (18 × 10.6 cm.)
Civico Gabinetto dei Disegni,
Castello Sforzesco, Milan

* 69. Amedeo Modigliani
*Woman, Heads and Jewish
Symbols*, 1915
pencil and watercolor on paper
16¾ × 16 in. (43 × 41 cm.)
Private collection, Italy

70. Amedeo Modigliani
Motherhood, 1916
pencil on paper
14¼ × 10½ in. (36.2 × 26.7
cm.)
The Museum of Modern Art,
New York, The John S.
Newberry Collection

* 71. Amedeo Modigliani
Portrait of Adolphe Basler, ca.
1916
conte crayon on paper
11¾ × 8¾ in. (29.9 × 22.2
cm.)
The Brooklyn Museum, New
York

* 72. Amedeo Modigliani
Portrait of Léon Indenbaum,
1916
oil on canvas
21½ × 18 in. (54.6 × 45.7 cm.)
The Henry and Rose Pearlman
Foundation

73. Amedeo Modigliani
Portrait of Max Jacob, 1916
conté crayon on paper
13½ × 10½ in. (34.5 × 26.5
cm.)
Nicole Rousset-Altounian,
Galerie N.R.A., Paris

74. Amedeo Modigliani
Portrait of Moïse Kisling, 1916
pencil on paper
10¼ × 7¾ in. (26 × 20 cm.)
Alex Maguy Glass Collection,
Paris

* 75. Amedeo Modigliani
Portrait of Chana Orloff, 1916
ink on paper
11¼ × 7 in. (28.5 × 17.5 cm.)
E. Justman Collection, Paris

76. Amedeo Modigliani
Portrait of Léon Bakst, 1917
pencil on paper
23 × 17 in. (58.4 × 43.2 cm.)
Wadsworth Atheneum,
Hartford, Connecticut,
The Ella Gallup Sumner and
Mary Catlin Sumner Collection

* 77. Amedeo Modigliani
Portrait of Jacques Kikoïone, ca.
1917
pencil on paper
14½ × 10 in. (36.8 × 25.5 cm.)
E. Justman Collection, Paris

78. Amedeo Modigliani
Portrait of Jacques Lipchitz,
1917
ink on paper
10¾ × 8¼ in. (27.3 × 21 cm.)
Mishkan Le Omanut,
Museum of Art, Ein Harod,
Israel

* 79. Amedeo Modigliani
Portrait of Oscar Miestchaninoff,
1918
graphite on paper
10¾ × 8¼ in. (27.3 × 21 cm.)
The Museum of Modern Art,
New York, Gift of Mrs. Donald
B. Strauss

* 80. Amedeo Modigliani
Self-Portrait, 1919
oil on canvas
39½ × 25½ in. (100 × 64.5
cm.)
Museu de Arte Contemporânea,
University of São Paulo,
Brazil,
Gift of Yolanda Penteado and
Francisco Matarazzo Sobrinho

81. Simon Mondzain
The Poilu, 1916
pencil on paper (in sketch-
book)
9½ × 6 in. (24 × 15.4 cm.)
Marie-José Baudinet-
Mondzain Collection

* 82. Simon Mondzain
Pro Patria, 1920
pastel on paper
44 × 34¾ in. (111.5 × 88 cm.)

Marie-José Baudinet-
Mondzain Collection

* 83. Elie Nadelman
Standing Nude Figure, ca.
1907
bronze
29¼ × 6½ × 6 in.
(74.3 × 16.5 × 15.2 cm.)
Bernard Goldberg Collection

* 84. Chana Orloff
Equestrian, 1916
wood
30¼ × 21¼ × 9 in.
(77 × 54 × 23 cm.)
E. Justman Collection, Paris

85. Chana Orloff
Maternity, 1917
bronze
21¼ × 4¼ × 4 in.
(54 × 11 × 10 cm.)
Galerie Vallois, Paris

* 86. Chana Orloff
*The Dancers (Sailor and
Sweetheart)*, 1923 (cast 1929)
bronze
38½ × 25 × 17 in.
(97.8 × 63.5 × 43.2 cm.)
Philadelphia Museum of Art,
Purchased: Bloomfield Moore
Fund

* 87. Chana Orloff
*The Accordeonist (Portrait of
Per Krohg)*, 1924 (cast 1929)
bronze
36 × 24 × 18¼ in.
(91 × 60 × 46 cm.)
Galerie Vallois, Paris

88. Chana Orloff
Portrait of Reuvin Rubin, 1926
bronze
26 × 20 × 8 in.
(66 × 50.8 × 20.6 cm.)
The Brooklyn Museum,
Bequest of Frank E. Williams

89. Chana Orloff
Woman with Overcoat (Sonia),
1926
bronze
25 × 15¼ × 17½ in.
(63.5 × 38.7 × 44.5 cm.)
Galerie Vallois, Paris

* 90. Chana Orloff
Portrait of Maria Lani, 1929
bronze
30¾ × 14½ × 25 in.

(78.1 × 37.1 × 63.5 cm.)
Mount Holyoke College Art
Museum, Gift of Mrs. Randall
Chadwick

91. Chana Orloff
Georges Kars on Deathbed,
1945
pencil on paper
16½ × 11½ in. (42 × 29 cm.)
E. Justman Collection, Paris

* 92. Jules Pascin
The Turkish Family, 1907
oil on canvas
24 × 20 in. (61 × 50.8 cm.)
Mr. and Mrs. Kurt Olden
Collection

93. Jules Pascin
*German Painter with Dog in
the Studio,* 1912
oil on canvas
27½ × 22½ in. (69.9 × 57.2
cm.)
Bernard Goldberg Collection

94. Jules Pascin
Woman Seated in the Studio,
1922
oil on canvas
21½ × 18⅛ in. (55 × 46 cm.)
Perls Galleries, New York

* 95. Jules Pascin
*Socrates and His Disciples
Mocked by the Courtesans,* ca.
1921
gouache, oil and crayon on
paper mounted on canvas
61¼ × 86 in. (155.6 × 218.4
cm.) The Museum of Modern
Art, New York, Given anony-
mously in memory of the artist

* 96. Jules Pascin
*Portrait of Pierre Mac Orlan
(The Accordeonist),* 1924
oil on canvas
36 × 28 in. (91.4 × 73 cm.)
Perls Galleries, New York

97. Jules Pascin
The Model in the Studio, 1926
oil on canvas
36 × 28½ in. (91.4 × 72.4 cm.)
Perls Galleries, New York

* 98. Abraham Rattner
Portrait of Bettina Bedwell,
1925
oil on canvas
30 × 50 in. (76.2 × 127 cm.)

Esther Gentle Rattner
Collection

99. Walter Rosam
Self-Portrait, ca. 1910
oil on cardboard
15½ × 11½ in. (38.7 × 29.2
cm.)
Sabine Streiff Oishi Collection

100. Chaim Soutine
Self-Portrait, 1918
oil on canvas
21½ × 18 in. (54.6 × 45.7 cm.)
The Henry and Rose Pearlman
Foundation

101. Chaim Soutine
The Praying Man, 1920
oil on canvas
35 × 21 in. (90 × 54 cm.)
Krishna Foundation and Carol
and Alan Kallman

*102. Chaim Soutine
Portrait of Oscar Miestchaninoff,
1923
oil on canvas
33 × 25½ in. (83 × 65 cm.)
Musée National d'Art
Moderne, Centre Georges
Pompidou, Paris

*103. Chaim Soutine
Portrait of Moïse Kisling, ca.
1925
oil on board
39 × 27¼ in. (99 × 69.2 cm.)
Philadelphia Museum of Art,
Gift of Arthur Wiesenberger

*104. Chaim Soutine
Portrait of Maria Lani, 1929
oil on canvas
29 × 23½ in. (73.7 × 59.7 cm.)
The Museum of Modern Art,
New York, Mrs. Sam A.
Lewisohn Bequest, 1954

*105. Chaim Soutine
Choir Boy, 1930
oil on wood
25¼ × 14¼ in. (64 × 36 cm.)
Dr. Ernest Kafka Collection

106. Chaim Soutine
Children Before a Storm, 1939
oil on canvas
17 × 19½ in. (43.2 × 49.5 cm.)
The Phillips Collection,
Washington, D.C.

107. Eugen Spiro
Self-Portrait, 1907
oil on board
27 × 20 in. (68.5 × 51 cm.)
Berlin Museum, Berlin

*108. Max Weber
*The Apollo in the Matisse
Academy,* 1908
oil on canvas
23 × 18 in. (58.4 × 45.7 cm.)
Forum Gallery, New York

*109. Léon Zack
Mother and Child, 1935
oil on canvas
18 × 21¾ in. (46 × 55 cm.)
Musée National d'Art
Moderne, Centre Georges
Pompidou, Paris

*110. Ossip Zadkine
*The Guitar Player (On the Café
Terrace),* 1920
watercolor on paper
18½ × 12¾ in. (46.8 × 32.7
cm.)
Musée d'Art Moderne de la
Ville de Paris

*111. Ossip Zadkine
Woman with Fan, 1920
bronze
33½ × 13½ × 10½ in.
(85 × 34 × 27 cm.)
Musée National d'Art
Moderne, Centre Georges
Pompidou, Paris

112. Ossip Zadkine
Saint Sebastian, 1929
wood
105½ × 13¾ × 19¾ in.
(268 × 35 × 50 cm.)
Stedelijk Van Abbemuseum,
Eindhoven, The Netherlands

*113. Eugène Zak
Dancer, 1921–22
oil on canvas
45½ × 33¾ in. (116 × 86
cm.)
Petit Palais, Geneva

114. Eugène Zak
Mother and Child, 1925
oil on canvas
36½ × 26 in. (93 × 66 cm.)
Musée National d'Art
Moderne, Centre Georges
Pompidou, Paris

SELECTED GENERAL BIBLIOGRAPHY

Ahlers-Hestermann, Friedrich. "Der Deutsch Künstlerkreis des Café du Dôme in Paris." *Kunst und Kunstler* 16 (1918), pp. 369–401.

Aronson, Chil. *Scènes et visages de Montparnasse.* Paris, 1963.

L'Art vivant d'André Salmon. Galerie Brigitte Schéhadé, Paris, 1981.

Basler, Adolphe. *Le Cafard après la fête, ou l'esthétisme d'aujourd'hui.* Paris, 1929.

Bayard, Jean-Emile. *The Modernists, from Matisse to De Segonzac.* Paris, 1927.

——— . *Montparnasse: Hier et aujourd'hui.* London, 1931.

Bernier, Georges, and Henri Sauguet. *Au Temps du "Boeuf sur le Toit."* Galerie Artcurial, Paris, 1981

Blanche, Jacques-Emile. "La Fin de la peinture française." *L'Art vivant* (April 1929), pp. 297–98.

Blatter, Janet, and Sibyl Milton. *Art of the Holocaust.* New York, 1981.

Brielle, Jacques. "Les Peintres juifs." *L'Amour de l'art* (June 1933), pp. 140–52.

Cabanne, Pierre. *L'Epopée du cubisme.* Paris, 1963.

Chagall, Marc. *Ma Vie.* Paris, 1957.

Chapiro, Jacques. *La Ruche.* Paris, 1960.

Charters, James. *This Must Be the Place.* London, 1934.

Claudel, Paul, et al. *Les Juifs.* Paris, 1937.

Cocteau, Jean, *A Call to Order.* New York, 1974.

Colton, Joel. *Léon Blum: Humanist in Politics.* New York, 1966.

Colton, Joel, et al., *Maria Lani.* Paris. 1929.

Coquiot, Gustave. *Les Indépendants.* Paris, 1921.

Crespelle, Jean-Paul. *La folle Epoque.* Paris, 1968.

——— . *Montparnasse vivant.* Paris, 1962.

——— . *La Vie quotidienne à Montparnasse à la Grande Epoque, 1905–1930.* Paris, 1976.

The Cubist Circle. Art Gallery, University of California, Riverside, 1971.

Dorival, Bernard. *Les Etapes de la peinture française contemporaine.* 3 vols. Paris, 1946.

Douglas, Charles. *Artists' Quarters: Reminiscenses of Montmartre and Montparnasse.* London, 1941.

Emigrés français en Allemagne/Emigrés allemands en France, 1685–1945. Institut Goethe, Paris, 1983.

Fels, Florent. *L'Art vivant.* 2 vols. Paris, 1950.

Feuchtwanger, Lion. *The Devil in France: My Encounter with Him in the Summer of 1940.* New York, 1941.

Fry, Varian. *Surrender on Demand.* New York, 1945.

Fuss-Amore, Gustave, and Maurice des Ombiaux. *Montparnasse.* Paris, 1925.

Gauthier, Maximilien. "La Belle et triste Histoire de La Ruche des arts." *Gazette des beaux-arts* 74, no. 6 (October 1969), pp. 219–28.

Gee, Malcolm. "Dealers, Critics, and Collectors of Modern Paintings: Aspects of the Parisian Art Market Between 1910 and 1930." Ph.D. dissertation, Courtauld Institute of Art, University of London, 1977; published New York, 1981.

George, Waldemar. *Les Artistes juifs de l'école de Paris.* Geneva, 1959.

——— . "Sculpteurs de ce temps: Exégèse de quelques lieux communs." *L'Amour de l'art* (October 1924), pp. 377–92.

Ghez, Oscar. *Memorial in Honor of Jewish Artists Victims of Nazism.* University of Haifa, Israel, 1978.

Giacommetti, Nesto. *Têtes de Montparnasse.* Paris, 1933.

Gindertael, R. V. *Modigliani et Montparnasse.* Paris, 1976.

Göpel, Erhard, and Barbara Göpel. *Hans Purrmann: Schriften.* Wiesbaden, Germany, 1961.

Granoff, Katia. *Histoire d'une galerie.* Paris, 1949.

Grossmann, Rudolf. "Dômechronik." *Kunst und Künstler* 20 (1922), pp. 29–32.

Halicka, Alice. *Hier (Souvenirs).* Paris, 1946.

Herbert, Robert L., et al. *The Société Anonyme and the Dreier Bequest at Yale University: A Catalogue Raisonné.* New Haven, Conn., 1984.

Hoog, Michel. *Catalogue de la collection Jean Walter et Paul Guillaume.* Musée de l'Orangerie, Paris, 1984.

Jackman, Jarrell C., and Carla M. Borden. *The Muses Flee Hitler: Cultural Transfer and Adaptation, 1930–1945.* Washington, D.C., 1983.

Kahnweiler, Daniel-Henry. *My Galleries and Painters.* London, 1971.

Kampf, Avram. *Jewish Experience in the Art of the Twentieth Century.* South Hadley, Mass., 1984.

Leblond, M. A. *Peintres de race.* Paris, 1909.

Marevna. *Life with the Painters of La Ruche.* Translated by Natalia Heseltine. London, 1974.

McCabe, Cynthia Jaffee. *The Golden Door: Artist-Immigrants of America, 1876–1976.* Hirshhorn Museum and Sculpture Garden, Smithsonian Institution, Washington, D.C., 1976.

Marrus, Michael R., and Robert O. Paxton. *Vichy France and the Jews.* New York, 1981.

Mauclair, Camille. *Les Métèques contre l'art français.* Paris, 1930.

Oeuvres d'artistes juifs morts en deportation. Galerie Zak, Paris, 1955.

Paris–Berlin, 1900–1933. Centre Georges Pompidou, Paris, 1978.

Paris–Moscou, 1900–1930. Centre Georges Pompidou, Paris, 1979.

Paris–New York. Centre Georges Pompidou, Paris, 1977.

Pariser Begegnungen, 1904–1914. Wilhelm Lehmbruck Museum, Duisberg, Germany, 1965.

Raynal, Maurice. *Modern French Painters.* New York, 1928.

Rosenblum, Robert. *Cubism and Twentieth-Century Art.* New York, 1976.

Rosenberg, Harold. "The Art World: Jews in Art." *The New Yorker,* December 22, 1975, pp. 64–68.

Roth, Cecil, ed. *Jewish Art: An Illustrated History.* New York, 1961.

Salmon, André. *Montparnasse.* Paris, 1950.

———. *Souvenirs sans fin.* 3 vols. Paris, 1955, 1956, and 1961.

Schramm, Hanna. *Vivre à Gurs: Un camp de concentration français 1940–1941.* Paris, 1979.

Silver, Kenneth E. "*Esprit de Corps:* The Great War and French Art, 1914–1925." Ph.D. dissertation, Yale University, 1981.

Spiritual Resistance, 1940–1945: Art from Concentration Camps. Traveling exhibition: The Baltimore Museum of Art, Maryland; The Jewish Museum, New York; et al., 1978.

Stein, Gertrude. *The Autobiography of Alice B. Toklas.* New York, 1933.

———. *Paris France.* New York, 1940.

Université de St.-Etienne. *L'Art face à la crise: L'art en occident 1929–1939.* St.-Etienne, France, 1980.

Vanderpyl, Fritz. *Peintres de mon epoque.* Paris, 1931.

Vergine, Lea. *L'altra metà dell'avanguardia 1910–1940.* Milan, 1980.

Warnod, André. *Les Berceaux de la jeune peinture.* Paris, 1925.

———. *Ceux de la Butte.* Paris, 1947.

———. "L'Ecole de Paris." *Comoedia* (November 15, 1925).

———. "Les Russes de Montparnasse." *L'Avenir* (March 23, 1924).

Warnod, Jeanine. *La Ruche et Montparnasse.* Paris and Geneva, 1978.

Weill, Berthe. *Pan! dans l'oeil! ou trente ans dans les coulisses de la peinture contemporaine 1900–1930.* Paris, 1933.

Wilenski, R. H. *Modern French Painters.* New York, 1960.

The Jewish Museum

Board of Trustees

Officers
James L. Weinberg, *Chairman*
Gertrude Fogelson, *Honorary Chairman*
Minnie Nathanson, *Vice-President*
Miriam A. Handler, *Vice-Chairman*
Stuart Silver, *Vice-Chairman*
Herbert Somekh, *Vice-Chairman*
Richard D. Isserman, *Treasurer*
Axel Schupf, *Assistant Treasurer*
Nathan Kogan, *Secretary*
Ellen Liman, *Assistant Secretary*
David Galton, *Assistant Secretary*
Ann Applebaum, *Assistant Secretary*

Members
Estanne Abraham
Martin Blumenthal
Dr. Gerson D. Cohen (ex-officio)
Peter Feinberg
Arnold Frankel (ex-officio)
E. Robert Goodkind
Eugene M. Grant
Leonard Greenberg

Marilyn Moed (ex-officio)
Morris W. Offit (ex-officio)
Rabbi Bernard S. Raskas
Betty Ratner
Burton P. Resnick
Romie Shapiro
Ethel Sincoff
Marian B. Scheuer Sofaer
Sanford Solender
Lesta Summerfield Stacom
Isaac Toubin
Tom B. Waldeck
Sandra Weiner
Mildred Weissman
Sylvia Zenia Wiener
Seymour Zises

Honorary Members
Stanley I. Batkin
Herbert E. Jacobs
Dr. Abram Kanof
Earl Morse
Maurice Nessen
Prof. Meyer Schapiro

Director, Joan Rosenbaum

RITTER LIBRARY
BALDWIN-WALLACE COLLEGE
WITHDRAWN